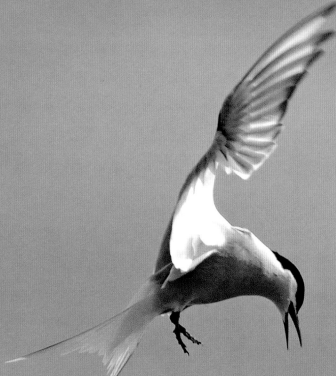

SEABIRDS
of the World

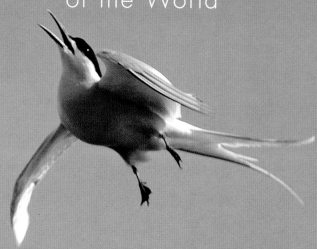

First published in 2016 by Reed New Holland Publishers Pty Ltd
London • Sydney • Auckland

The Chandlery, Unit 704, 50 Westminster Bridge Road, London SE1 7QY, UK
1/66 Gibbes Street, Chatswood, NSW 2067, Australia
5/39 Woodside Avenue, Northcote, Auckland 0627, New Zealand

www.newhollandpublishers.com

A record of this book is held at the British Library and the National Library of Australia.

ISBN 978 1 92151 767 9

Managing Director: Fiona Schultz
Publisher and Project Editor: Simon Papps
Designer: Thomas Casey
Production Director: Olga Dementiev
Printer: Toppan Leefung Printing Limited

1 3 5 7 9 10 8 6 4 2

PAGE 1 Arctic Terns (*Sterna paradisaea*).
PAGE 3 Arctic Tern (*Sterna paradisaea*) wing-tips and tail.
PAGES 4–5 Common Guillemots (*Uria aalge*).

Keep up with New Holland Publishers on Facebook
www.facebook.com/NewHollandPublishers

SECRET REALM OF THE OCEANS' WANDERERS

SEABIRDS
of the World

DAVID TIPLING

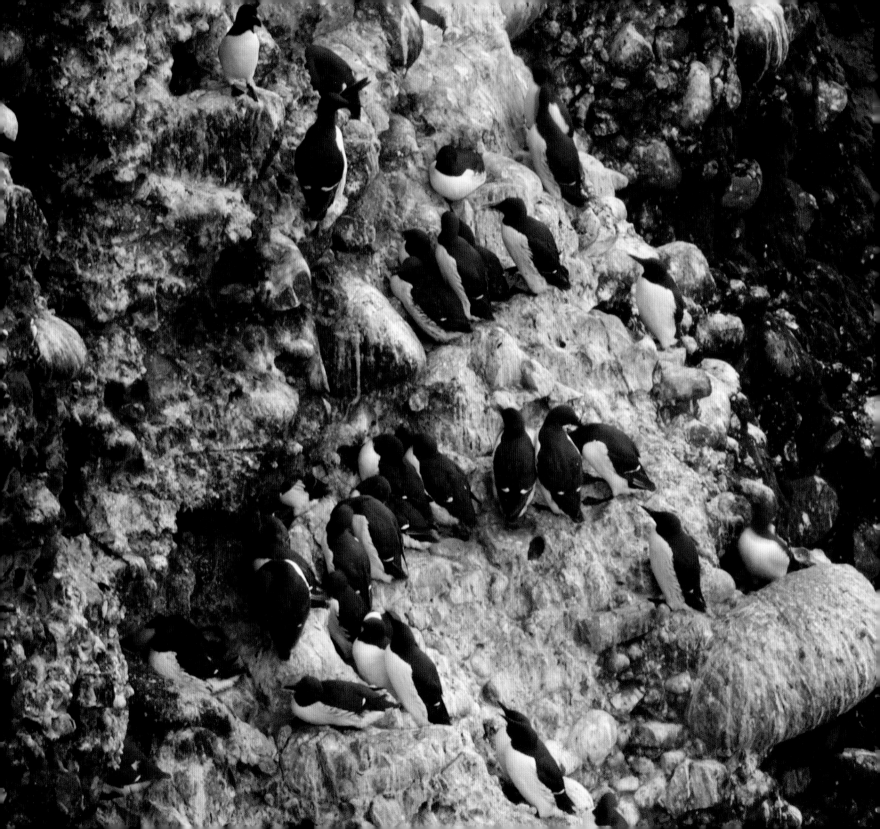

CONTENTS

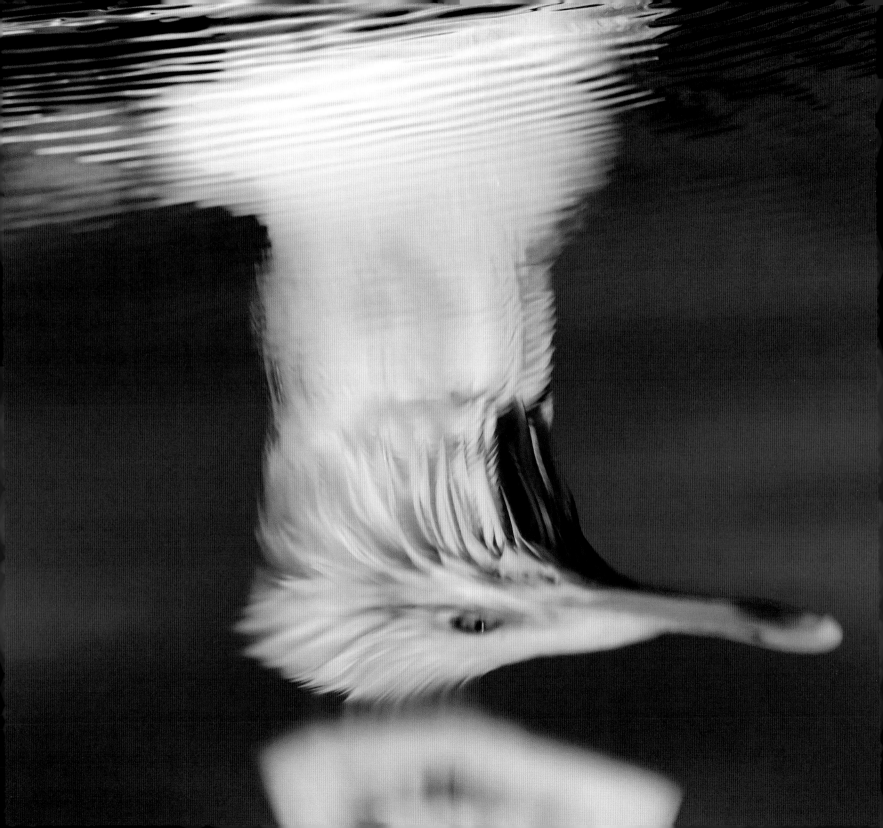

INTRODUCTION

Standing on deck in a heavy swell is challenging, and even more so as I try to track an erratically flying bird through the viewfinder of my camera. I cannot but smile however, because this is no ordinary individual. It is the size of a sparrow and it seems completely remarkable that it lives in the middle of the ocean. We are 196km (122 miles) south-west of the Isles of Scilly, off the south-west tip of the UK, with seabird expert Peter Harrison. As we watch a second then a third, fourth, fifth and finally a sixth bird flutters so close that we can see the yellow webs of its feet; a Wilson's Storm-Petrel.

It is August 1988 in a part of the Atlantic known as 'The Wilson's Triangle' and we have been drawn here specifically for this encounter. As we watch the storm-petrel one of the passengers is hauled by his friends from below and shown the birds before he vomits again over the side. Then he crawls back down. He was not seen again until we reached Penzance three days later. For him the journey was his worse nightmare. For me it was a revelation.

That trip aboard *MV Chalice* sowed a seed. I found it remarkable that a bird weighing no more than an AA battery and breeding in the far south of the Southern Hemisphere was here now, thousands of miles away on a great journey. In a few weeks this pocket-sized creature would be back on its Austral breeding territory preparing to raise young. Another seabird, the Arctic Tern, travels even greater distances, breeding in the Arctic and wintering at the other end of our planet. That species sees more daylight than any other living animal.

LEFT The head of a European Herring Gull (*Larus argentatus*) reflected in the waters of a Norwegian Fjord.

OVERLEAF Atlantic Puffin (*Fratercula arctica*) with a bill full of sandeels.

Biologists over the past two decades have started to reveal the secret lives of seabirds. Ever lighter-weight satellite technology attached to birds' bodies on their breeding grounds has revealed how many species make extraordinary journeys. Grey-headed Albatrosses have been tracked circumnavigating the globe in just a few days. Sooty Shearwaters on their annual migration around the Pacific Ocean have been shown to travel a staggering 64,050km (39,800 miles).

These astonishing oceanic journeys illustrate how we live on a blue planet. That point was brought home to us by an image taken on 7th December 1972 on the Apollo 17, from 45,000km (28,000 miles) above the Earth. To the astronauts it appeared to be the size of a marble and overwhelmingly blue. In fact this image became famous as 'The Blue Marble', and is one of the most iconic pictures of our time. It illustrates beautifully the fact that 72 per cent of the Earth is covered in salt water.

Species that live in a marine environment and which are commonly referred to as seabirds all come to land to breed. But there is a single exception. Emperor Penguins breed on sea ice and only rarely set foot on terra firma. Some species breed together in vast numbers, creating spectacles that astonish us with their bursting vitality. They include the seabird cliffs of the northern hemisphere which hum with life in high summer. In the far south penguins crowd on to beaches in their tens, sometimes hundreds, of thousands. Across the Equator tropical islands, such as those in the Galápagos archipelago, offer both abundance and diversity. There are many species that breed in huge numbers, but are largely invisible, because they nest in burrows and come ashore only at night. It is only when you visit such colonies under cover of darkness that you get a sense of their scale.

Many of the larger species do not reach sexual maturity for a few years. Before they breed most of their time will be spent at sea and when they finally start to come ashore birds such as the larger albatrosses will perform courtship rituals with their potential suitors. When they do find a mate, that bond may last for most of their lives. Some species have very sporadic breeding success. Factors that include weather, predation and food availability will often determine whether the single chick is successfully raised. The birds overcome this variable breeding success through their longevity. Manx Shearwaters have been recorded to live for at least 55 years, while Atlantic Puffins may live for 20 years or more.

Predation of eggs, chicks and even adults can be a major factor in the decline of some species. Sadly a number of our most endangered seabirds are in a perilous state owing to predators that we have introduced to their nursery locations. Rats, cats, pigs and even mice have had devastating effects in some places, notably the islands in the South Pacific and South Atlantic. On New Zealand predator control dominates the country's conservation effort and a number of petrel and shearwater species have been brought back from the brink of extinction by eradicating introduced mammals. On South Georgia the largest ever effort to rid an island of rats was finally completed in early 2015.

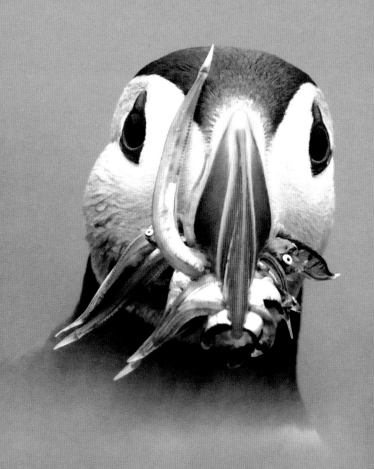

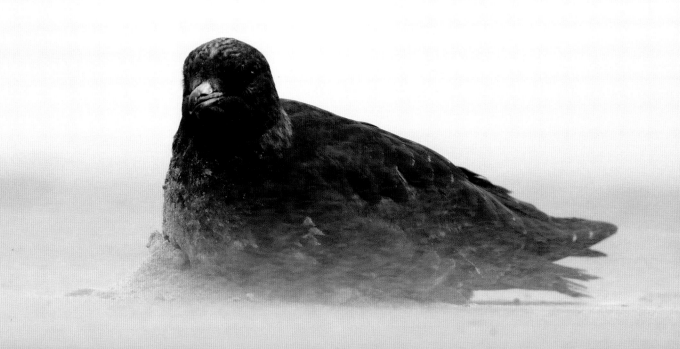

Our relationship with seabirds runs deeper than with almost any other family of birds. We have harvested them and their eggs for food and plundered them for their oil. They have helped guide sailors across our oceans, become embedded in folklore and supernatural superstition and some have been bestowed great symbolic status, even when wiped from the Earth, as in the case of the extinct Great Auk. Yet still today we are pushing numerous seabird species towards oblivion, whether through by-catch on trawlers or simply by emptying the oceans of the food on which these birds depend. Seabirds need our help more than ever.

This book is a celebration in pictures of their lives. I have included only those that are considered true seabirds, which spend a considerable part of their lives breeding or foraging in the marine environment. They include the Sphenisciformes (penguins) and Procellarliformes, a large order of pelagic seabirds that include some of the world's great nomads – the albatrosses, petrels and shearwaters, storm-petrels and diving-petrels. Next come the Pelecaniformes, the order that includes tropicbirds, frigatebirds, gannets, boobies and cormorants. Within this group is a number of non-marine species that I have omitted for the above reasons. Similarly the last order, the Charadriformes, is a large diverse group that includes many landbirds. But I have included from among this order most of the gulls, terns, skimmers, skuas and auks.

Capturing the images that appear on these pages has been a lifetime's work. Some of the oldest were taken 30 years ago. The vast majority, however, particularly from the South Atlantic, have been taken over the past decade. It is only very recently, with digital technology and lightweight fast-focusing telephoto lenses, that photographing seabirds at sea has been made substantially easier. Nonetheless few subjects are as challenging. And for those of you who have never tried it, I would liken the effort needed to track a storm-petrel the size of a sparrow over a churning sea from a moving boat, to that required for photographing a land bird in flight … as you run on the spot!

LEFT An exhausted Arctic Skua (*Stercorarius parasiticus*) sits out a storm on a beach in northern Britain.

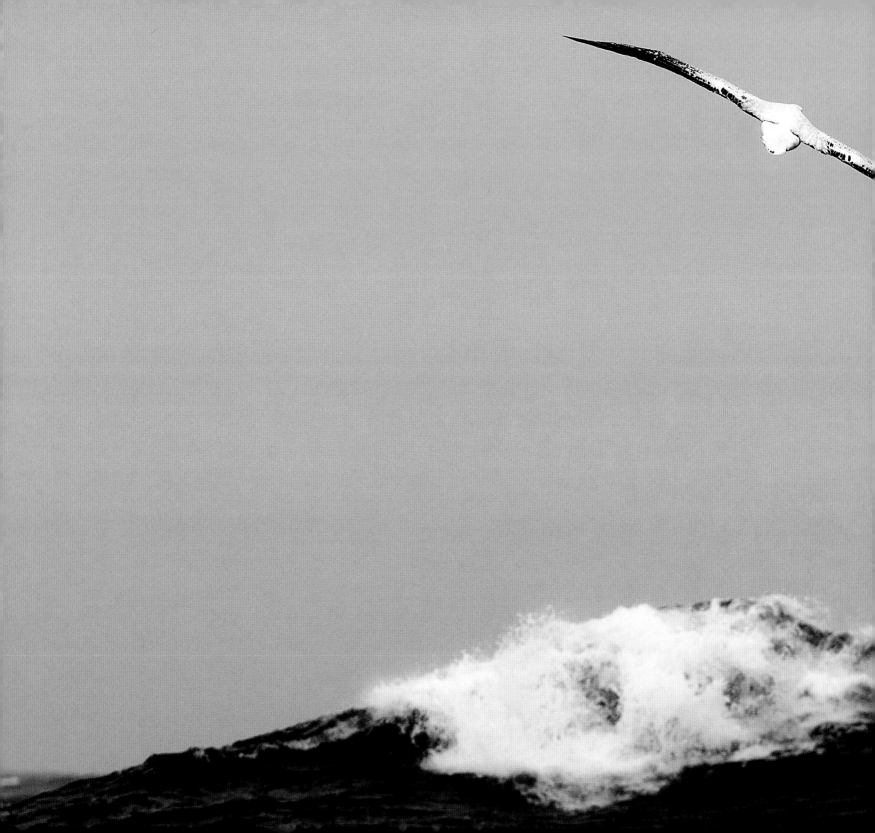

AT SEA

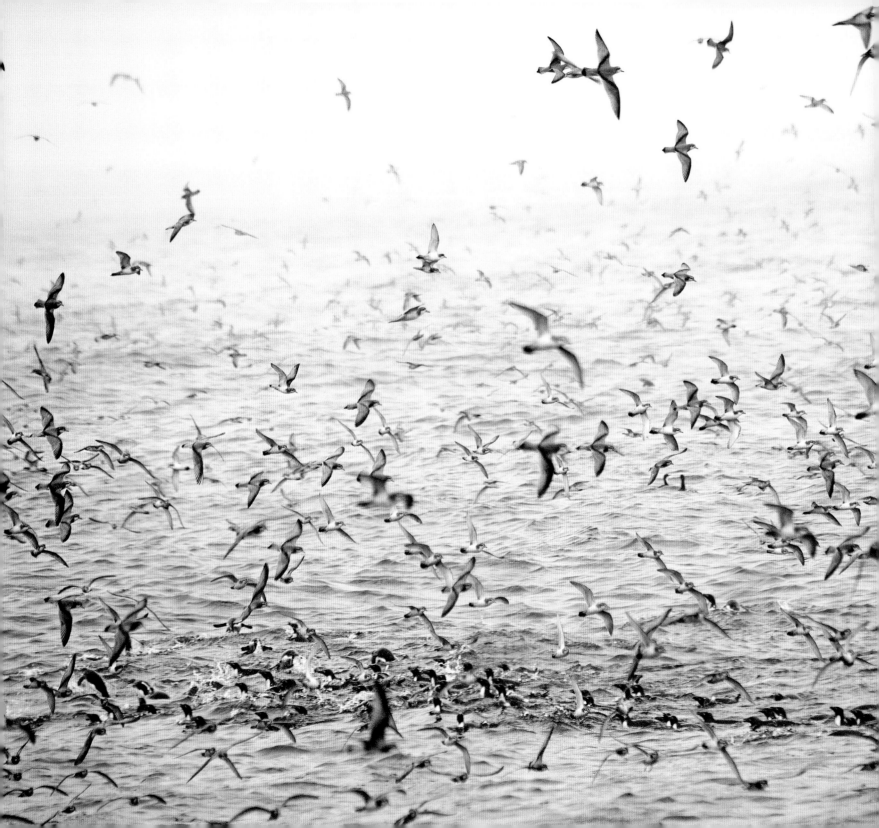

LEFT

ANTARCTIC PRION AND MACARONI PENGUIN

Pachyptila desolata and *Eudyptes chrysolophus*

Oceans are vast blue deserts but, like all deserts, there are oases – places that teem with life. One such spot lies at the meeting point of warm and cold water north of Antarctica. The Polar Front or Antarctic Convergence, as it is known, is like a big mixing bowl with the nutrient-rich waters of the south circulating with the warmer waters from the north. Together they create perfect conditions for the phytoplankton to bloom, which in turn leads to enormous shoals of krill. Just north of South Georgia this rich bounty had attracted a swarm of Antarctic Prions and Macaroni Penguins. Looming out of a mist that is typical for the convergence, we were suddenly confronted by tens and perhaps hundreds of thousands of birds – a breathtaking sight.

OVERLEAF

WILSON'S STORM-PETREL

Oceanites oceanicus

The storm-petrel is a mere speck against the swells of the Southern Ocean. With an estimated population in excess of 50 million pairs, this is one of the most abundant species of seabird on our planet.

This image was taken 160km (100 miles) from South Georgia. To frame the bird I braced myself in a doorway as our boat was tossed in 7m (20ft) swells and a 40-knot headwind. At latitudes known as 'the furious fifties' due to their extreme weather, this Wilson's Storm-Petrel, no heavier than a pack of cards, flew with ease into the teeth of the gale.

PREVIOUS PAGES A Wandering Albatross (*Diomedea exulans*) glides effortlessly over the Southern Ocean.

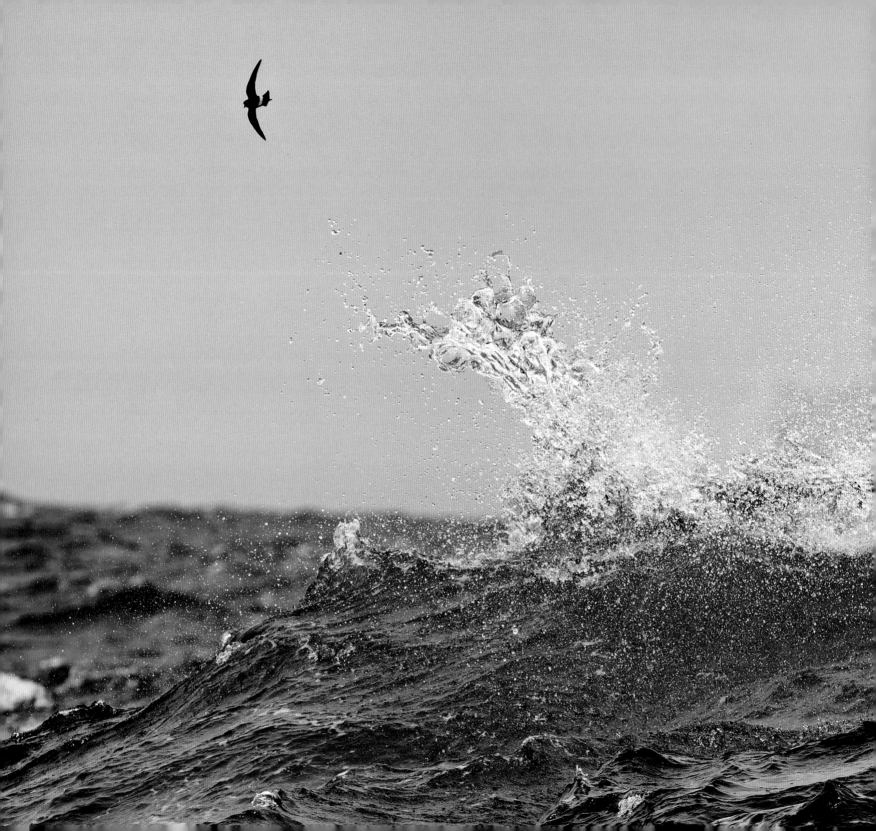

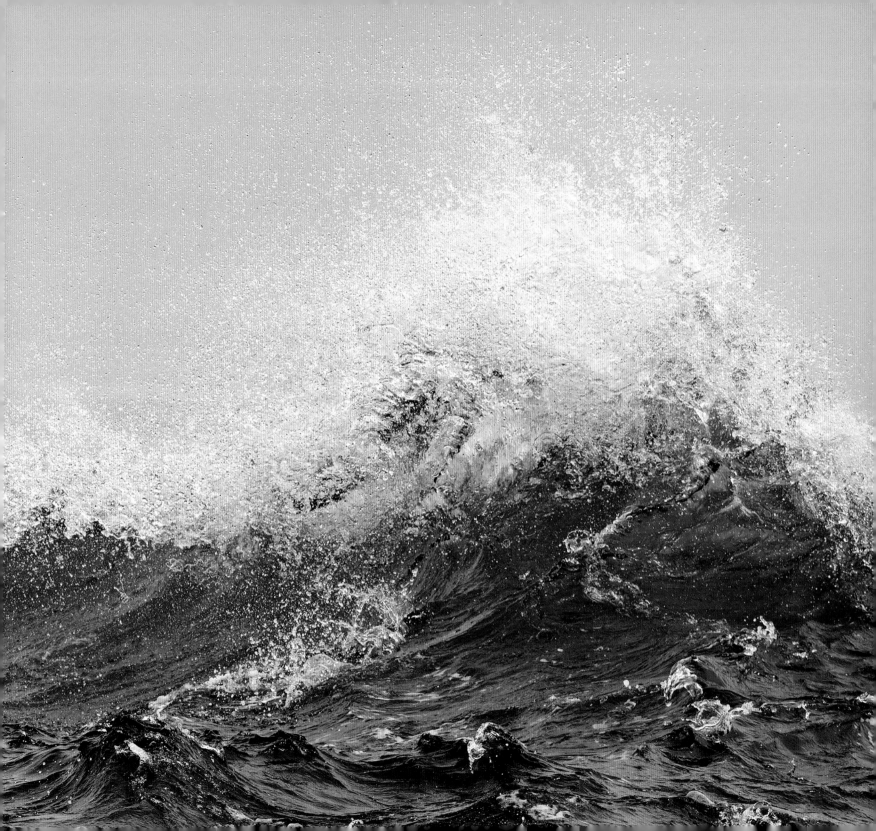

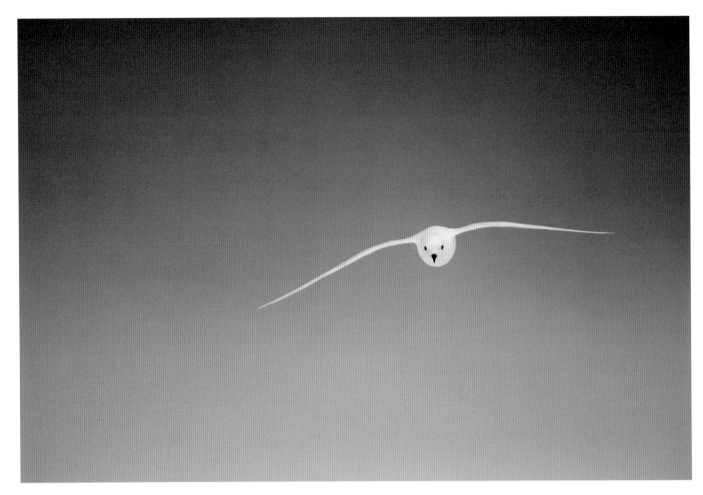

SNOW PETREL

Pagodroma nivea

The Snow Petrel, perhaps the loveliest of all seabirds, has the most southerly breeding range of any bird on Earth. Some have even been sighted at the South Pole and nest on scree slopes in inland Antarctica. My first encounter came on the Dawson-Lambton Glacier while camping at a colony of Emperor Penguins (*Aptenodytes forsteri*). A lone individual flew straight at me, circled round and disappeared over the great white desert that is the Antarctic Plateau.

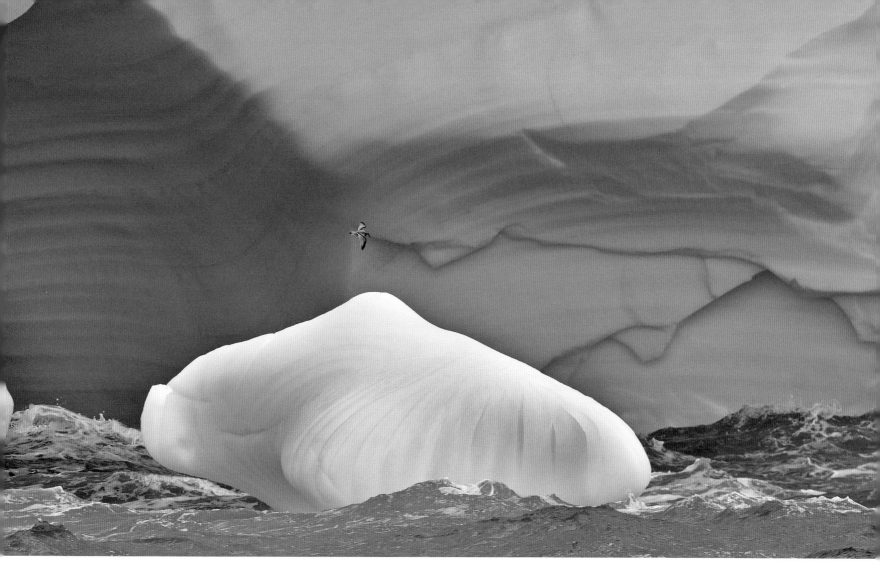

ANTARCTIC PRION
Pachyptila desolata

A prion flies alongside a cathedral of ice. Our ship held station for two hours by this vast tabular iceberg adrift in the Southern Ocean as we photographed its deep blue spurs and pillars while the birds swept past its 50km (30 mile) long western flank.

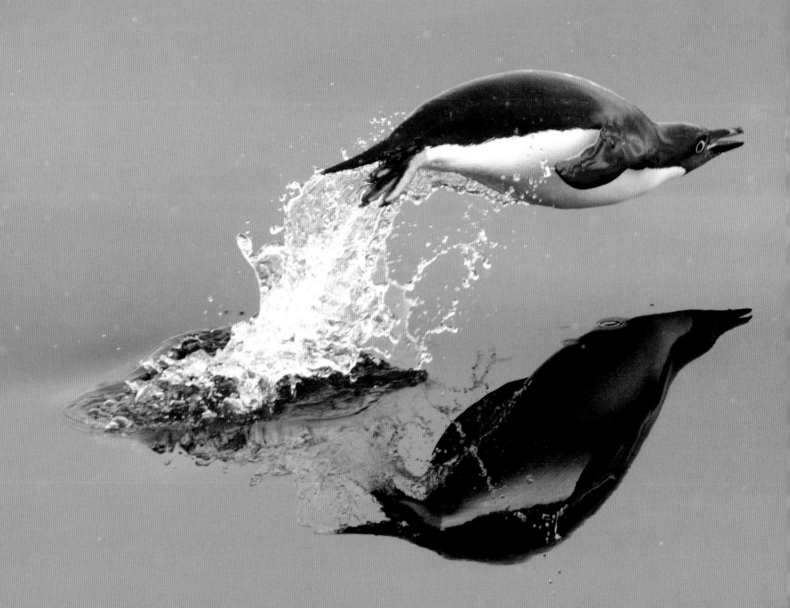

ADÉLIE PENGUIN
Pygoscelis adeliae

Porpoising across a mirror-calm sea, this penguin heads for home. This technique is most often practised when leaving or returning close to a breeding colony, perhaps as an escape strategy to avoid predators such as Leopard Seals (*Hydrurga leptonyx*).

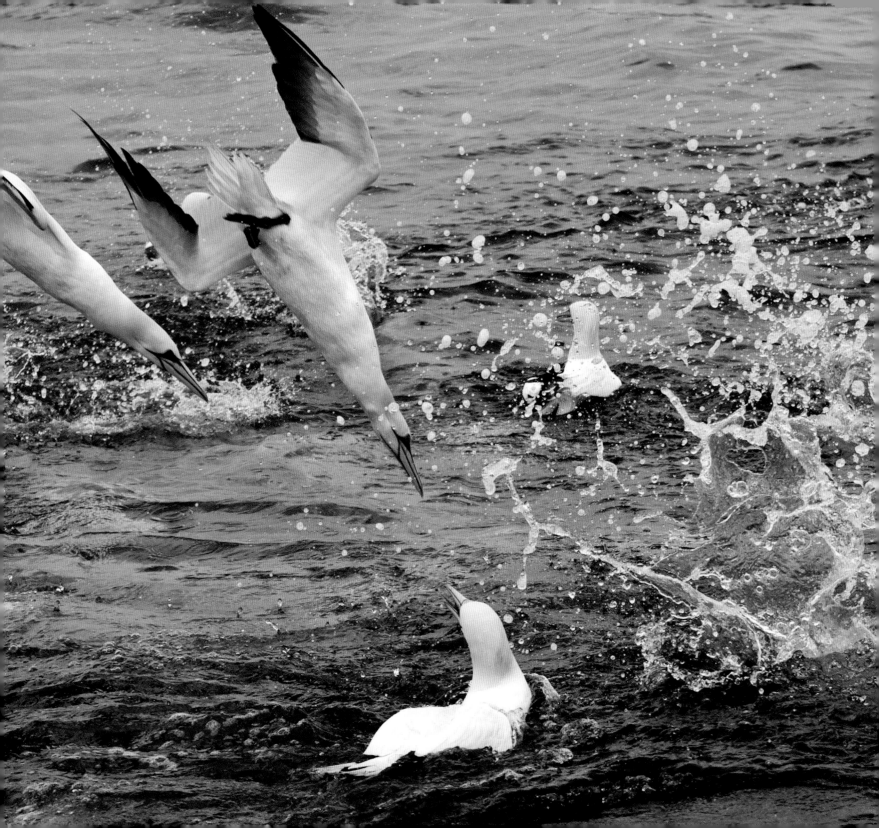

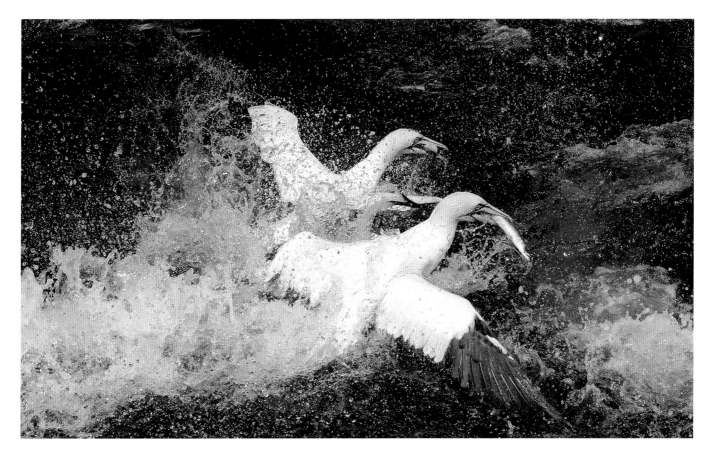

NORTHERN GANNET

Morus bassanus

Arrow-like gannets plunge into a shoal of Atlantic Mackerel (*Scomber scombrus*) off Scotland's Shetland Islands. A spongy, bubble wrap-like layer of tissue behind the bird's bill helps to absorb the shock of hitting the water at nearly 100km/h (60mph). Nostrils located inside the mouth and eyes set to give binocular vision are adaptations to ensure the gannets have an accurate aim. When prey is near the surface they dive at an oblique angle. When plunge-diving from a greater height a depth of 10m (35ft) may be achieved. If they need to go deeper or chase prey they propel themselves under water with their wings. In the image above the gannets emerge from the water and attempt to get airborne while clutching mackerel in their serrated bills.

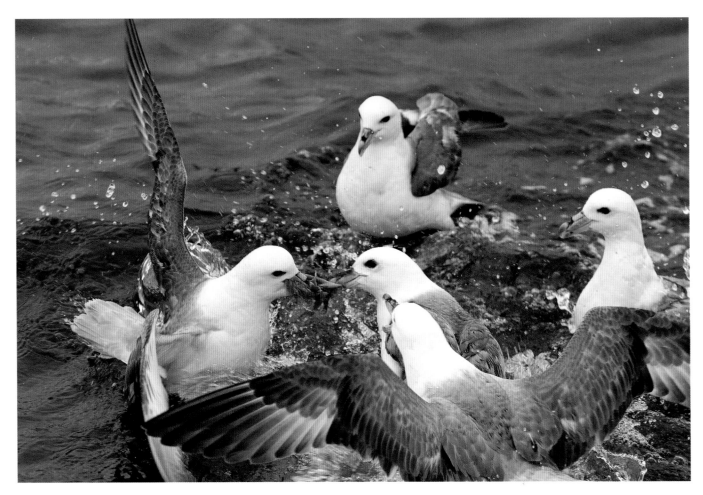

NORTHERN FULMAR
Fulmarus glacialis

Fulmars have a highly developed sense of smell. Their brain's olfactory lobe contains twice as many mitral cells (olfactory-processing cells) as are found in rats, and six times as many as mice. It is no surprise, therefore, that fulmars are often first on the scene to scavenge offal and fish scraps tossed from trawlers.

GLAUCOUS, ICELAND AND EUROPEAN HERRING GULLS
Larus hyperboreus, L. glaucoides and *L. argentatus*

A mixed flock of gulls gathers around a trawler off the coast of Arctic Norway. Members of the genus *Larus* have adapted well to living alongside humans, whether on land or at sea.

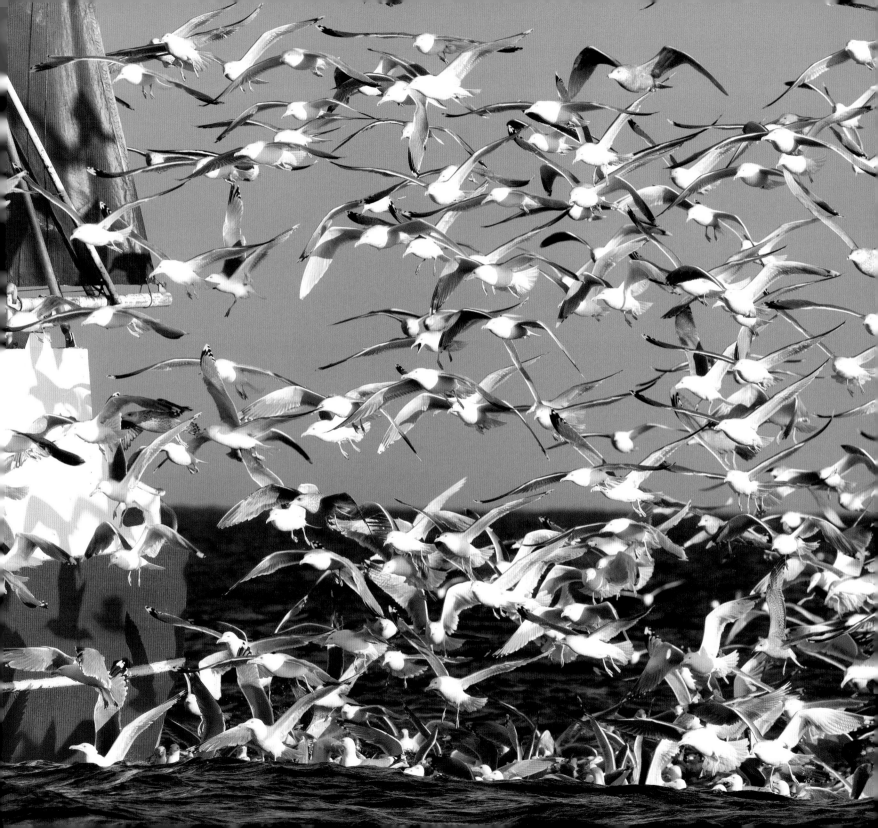

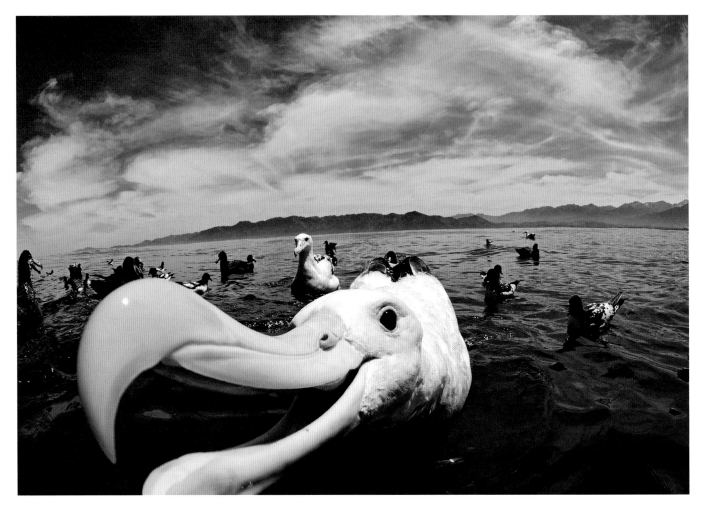

GIBSON'S ALBATROSS
Diomedea antipodensis gibsoni

On the north-east coast of New Zealand's South Island lies Kaikoura, a mecca for those keen on seeing and photographing oceanic seabirds up close. Whales, dolphins and seabirds, which spend most of their lives far from land, are attracted inshore by a food bonanza. This is created by upwelling currents from the Hikurangi Trench, a deep sea canyon that extends just offshore from the town of Kaikoura. This Gibson's Albatross reached out to peck at my wide-angle lens as I leant over the side for a low-angle shot.

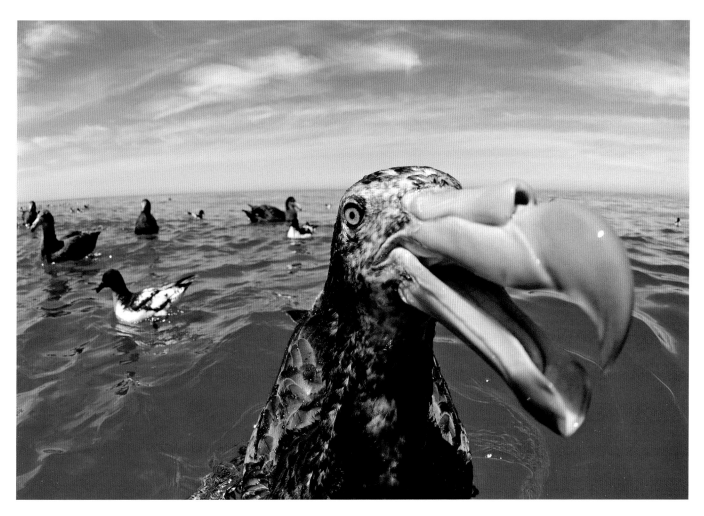

NORTHERN GIANT PETREL
Macronectes halli

Northern Giant Petrels have formidable-looking bills designed not only to feed on marine prey but also on carrion that they scavenge ashore. This individual was photographed using an aptly named fisheye lens off the town of Kaikoura in New Zealand. It was drawn close by the fish offal that was thrown from our boat.

SOUTHERN GIANT PETREL

Macronectes giganteus

Two immature Southern Giant Petrels squabble over food near Kaikoura in New Zealand. Such confrontations are commonplace when giant petrels come together to feed. Perhaps this is why trawler men often refer to them as 'sea vultures'. They are the largest members of the Procellaridae (petrel and shearwater family) with 2m (6.5ft) wingspans.

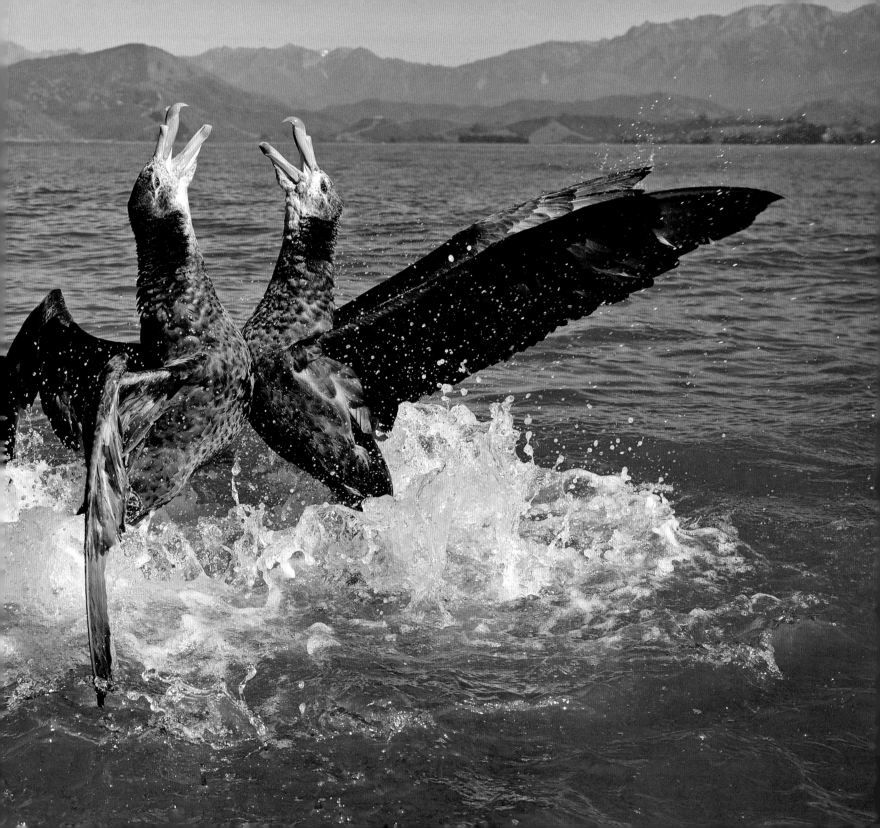

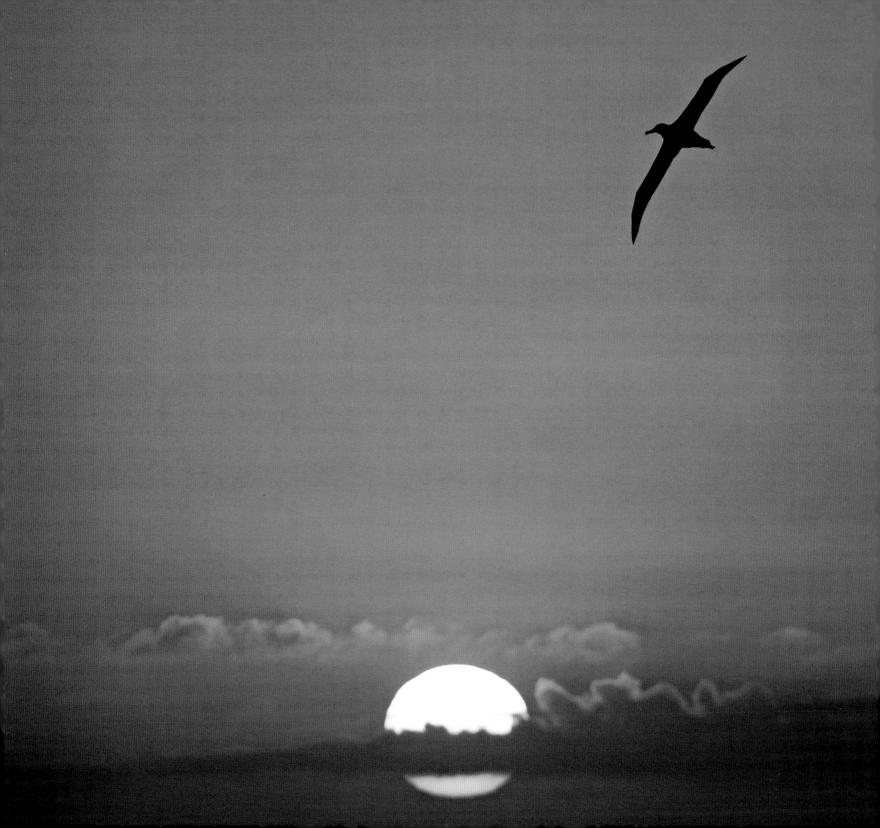

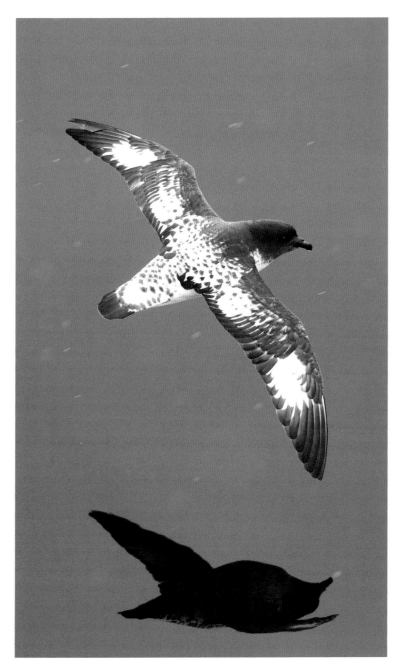

FAR LEFT

SOUTHERN ROYAL ALBATROSS
Diomedea epomophora

As the sun sets off the coast of Tierra del Fuego, at South America's southern tip, an albatross shears into the sky. Albatross flight has an elegant beauty that is extraordinarily energy efficient. Dynamic soaring, as it has come to be known, entails the albatross rising into the wind before turning and swooping with the air current for up to 100m (350ft). This may transport them up to three times faster than the prevailing wind speed, thus explaining how these great ocean wanderers can travel such vast distances in relatively short periods.

LEFT

CAPE PETREL
Daption capense

A Cape Petrel flashes past the stern of our ship, perfectly reflected on a mirror-calm Southern Ocean. The beautifully patterned plumage gives this petrel its other common name of Pintado, the Spanish word for 'painted'.

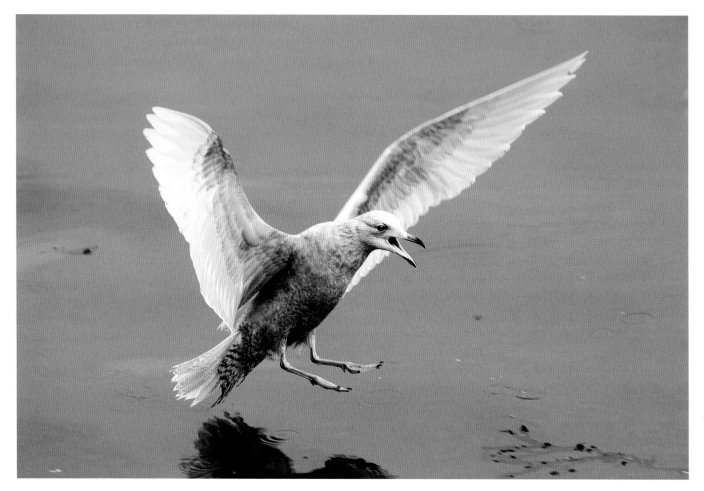

ABOVE

ICELAND GULL
Larus glaucoides

A young gull swoops on a potential meal. This individual spent the winter around the quay at North Shields near Newcastle, England. A plentiful supply of scraps from the fish market and from visitors ensured it was well fed.

RIGHT

BLACK SKIMMER
Rhynchops niger

Late April off the coast of New York and a flock of skimmers is migrating back to its breeding colony, having spent the winter far to the south in the Caribbean or the Gulf of Mexico.

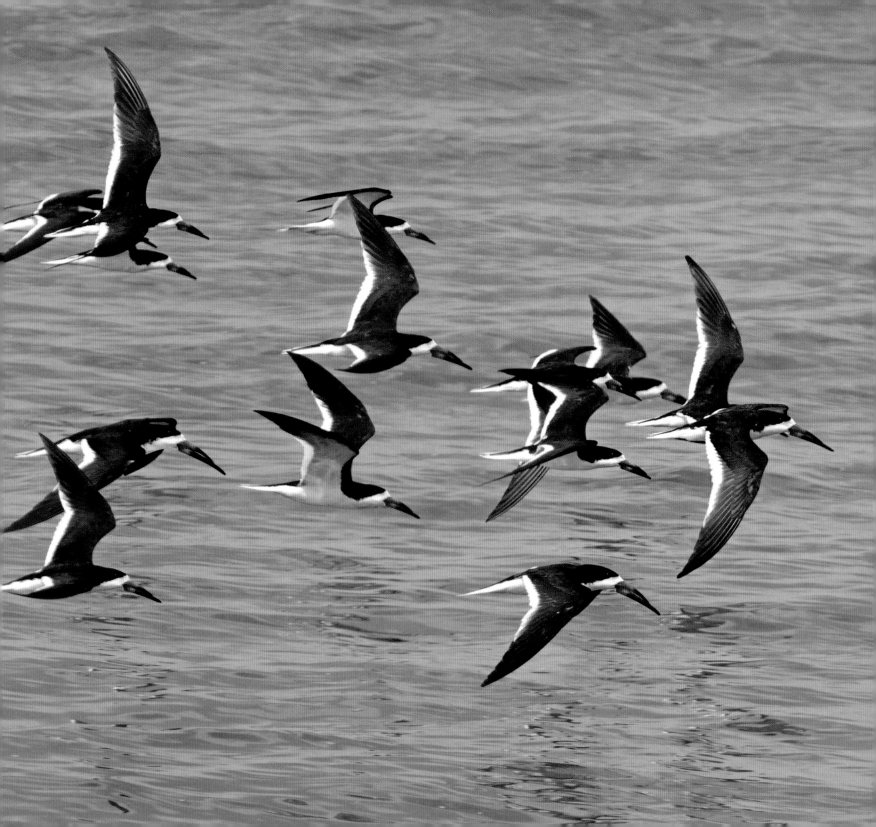

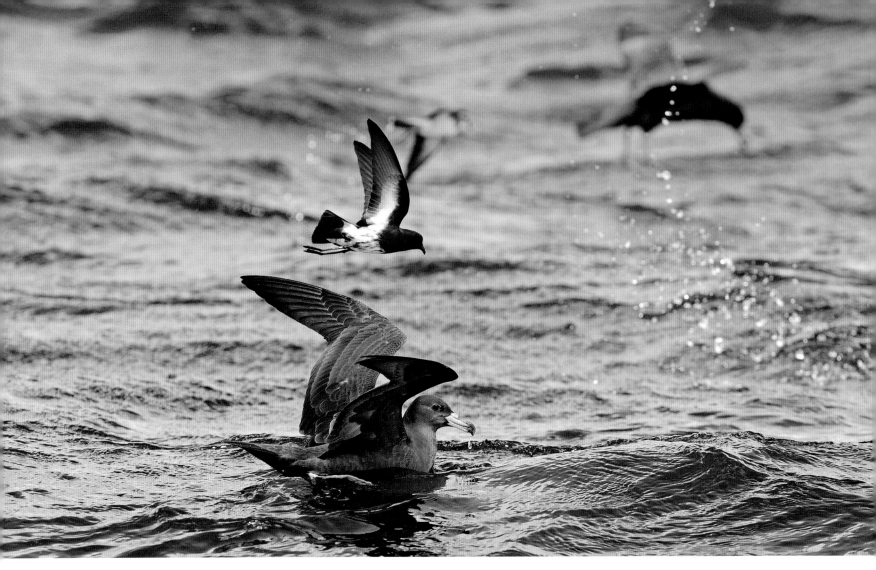

NEW ZEALAND STORM-PETREL
Fregetta maorianus

Once considered extinct, this species was known from just three skins collected in the 1820s. In 2003 Sav Saville and Brent Stephenson were in the Hauraki Gulf off New Zealand's North Island, when they found what they were sure was this lost species. Today it is relatively easy to sail into the gulf and find the bird, as I did when I photographed this individual (centre left in the picture), which was feeding among several Flesh-footed Shearwaters (*Ardenna carneipes*).

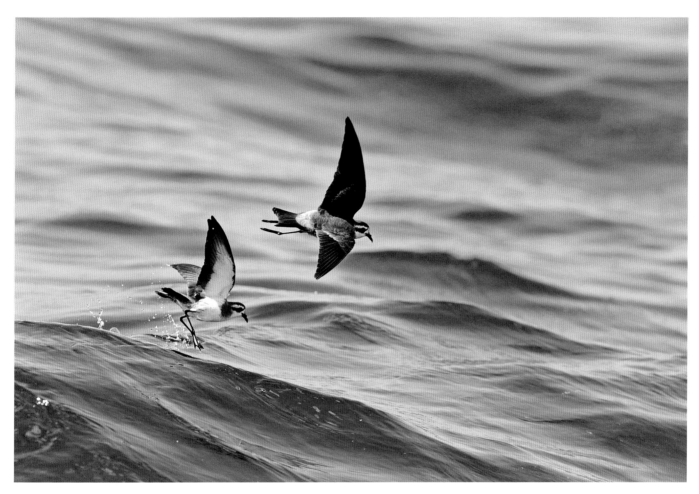

WHITE-FACED STORM-PETREL
Pelagodroma marina

This storm-petrel, which is also known as the Frigate Petrel, feeds by pattering across the ocean's surface, seizing surface plankton and small fish and crustaceans. The habit of walking on water led fishermen and sailors to refer to this and other storm-petrel species as 'the Jesus Christ bird'.

FAIRY PRION
Pachyptila turtur

A Fairy Prion hunts for food on the ocean surface. This is the smallest of the prions and its erratic flight made it a challenge to photograph, especially in a heavy swell.

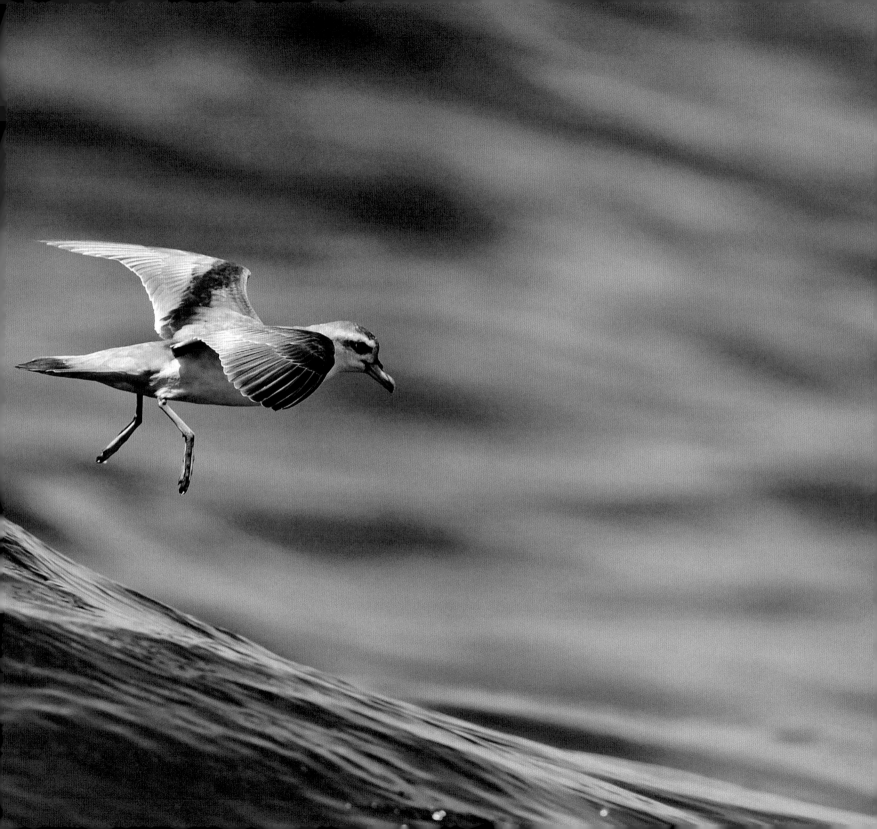

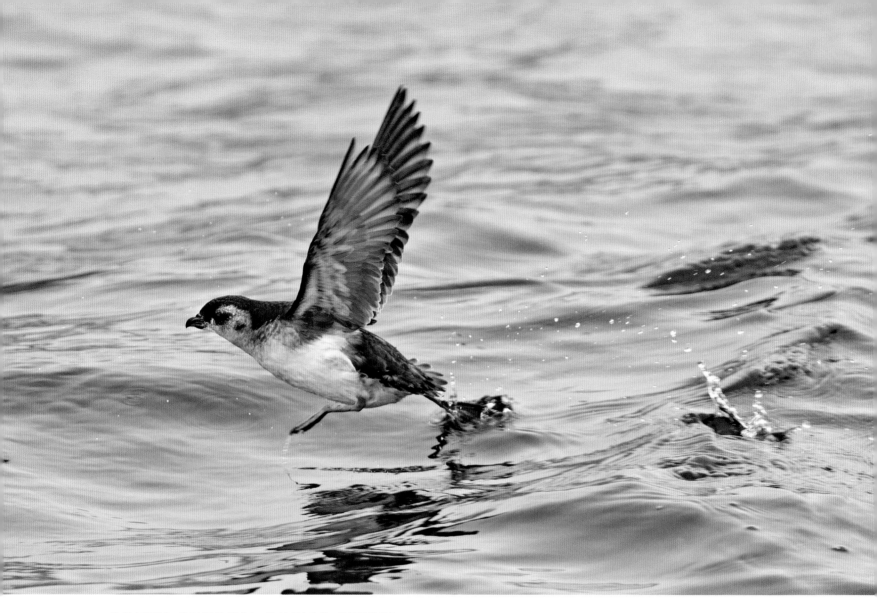

SOUTH GEORGIA DIVING-PETREL
Pelecanoides georgicus

Bursting quail-like from the ocean surface, a diving-petrel takes to the air. Smaller than a Starling, the tiny seabird commonly plunges to depths of 20m (70ft) or more. It is very similar to the Common Diving-Petrel (*Pelecanoides urinatrix*), but has a thin black line down the back of its tarsi that helps to identify it.

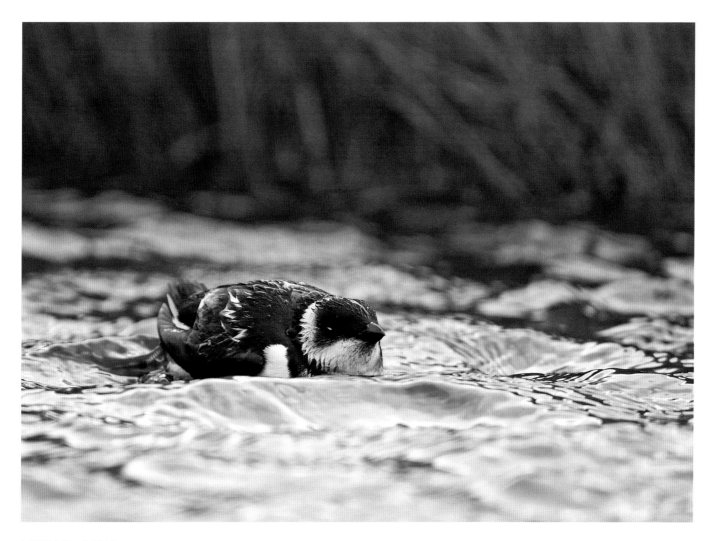

LITTLE AUK
Alle alle

Hunched and dejected, a Little Auk has been blown from the North Sea on to a coastal pool on England's Norfolk coast. Little Auks breed in their millions in huge colonies in the Arctic. In autumn they disperse south and can get caught in strong gales that result in hundreds and sometimes thousands being pushed into the North Sea. During these events they are watched by many birders as they stream past popular seawatching locations.

BLACK-HEADED GULL
Chroicocephalus ridibundus

Freezing the action in a picture can often deprive the viewer of a sense of movement. I have used a slow shutter speed in the region of one-fifteenth of a second to create a sense of motion in an attempt to illustrate the frantic squabbling among these hungry gulls.

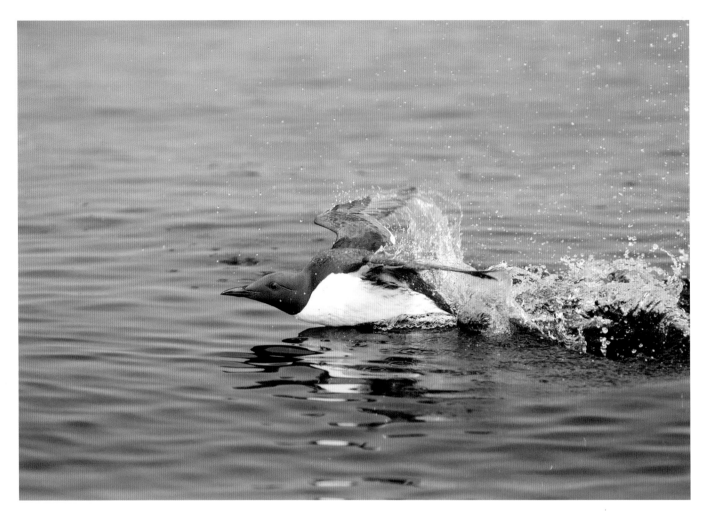

COMMON GUILLEMOT
Uria aalge

With their narrow wings and rounded bodies, auks are not particularly graceful fliers. This Common Guillemot (also known as the Common Murre) bounced over the surface before coming to a halt. Auks dive from the surface and use their wings to propel them underwater. The wing design is therefore a trade-off between optimum shape for efficient pursuit underwater and the customary requirements of effective flight. This has resulted in a lack of aerial finesse when it comes to take-off or landing.

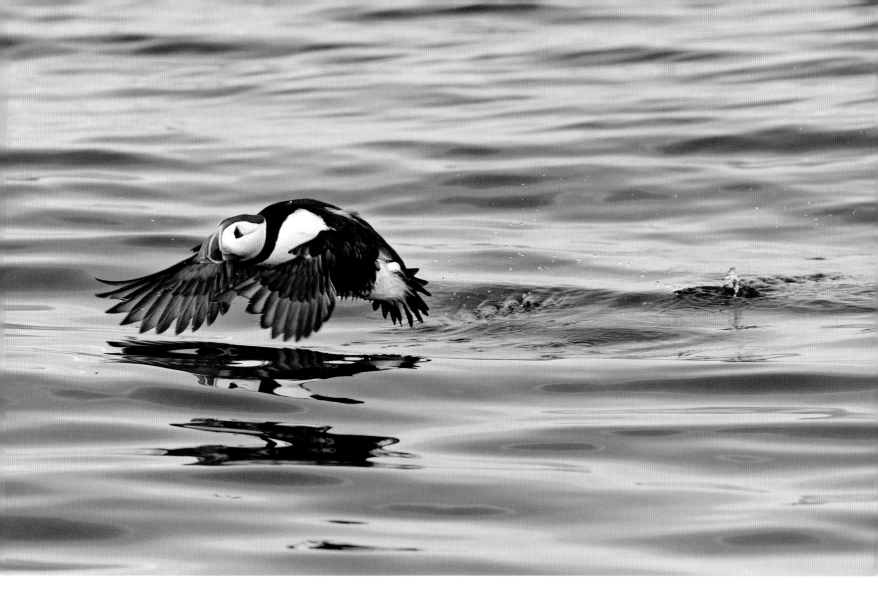

ABOVE
ATLANTIC PUFFIN
Fratercula arctica

Auks typically run across the water to get airborne. This puffin was photographed off the Farne Islands that lie off England's Northumberland coast.

OVERLEAF
HUTTON'S SHEARWATER
Puffinus huttoni

A Hutton's Shearwater off the coast of New Zealand's South Island. Endemic to New Zealand, this species is very similar to Fluttering Shearwater (*Puffinus gavia*) but possesses a 'flatter' head and a much longer bill.

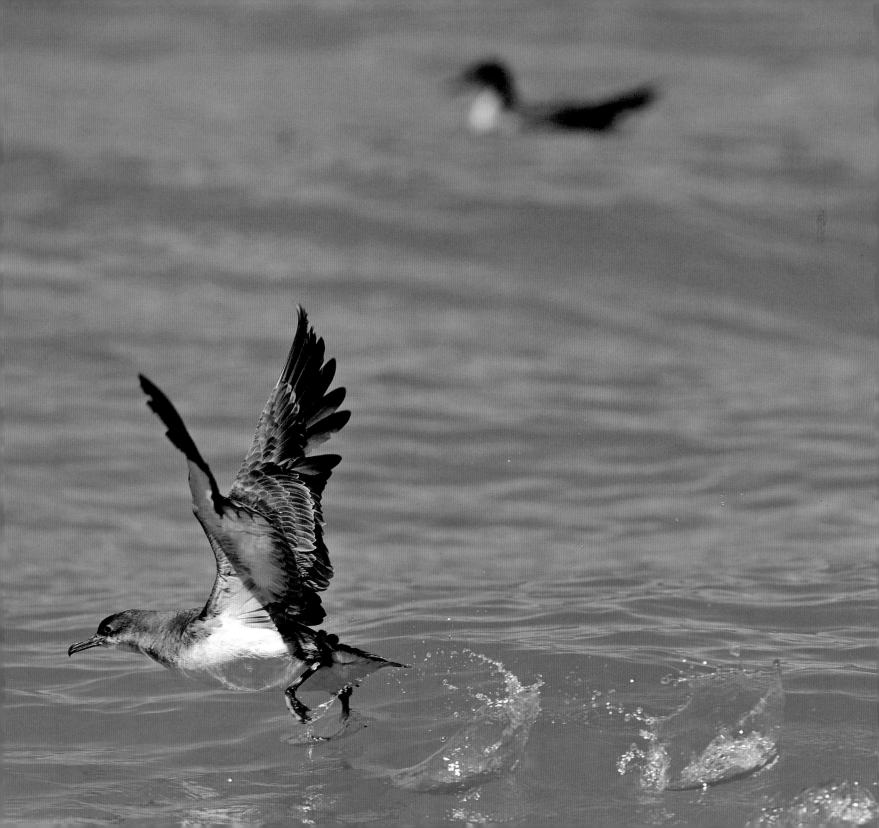

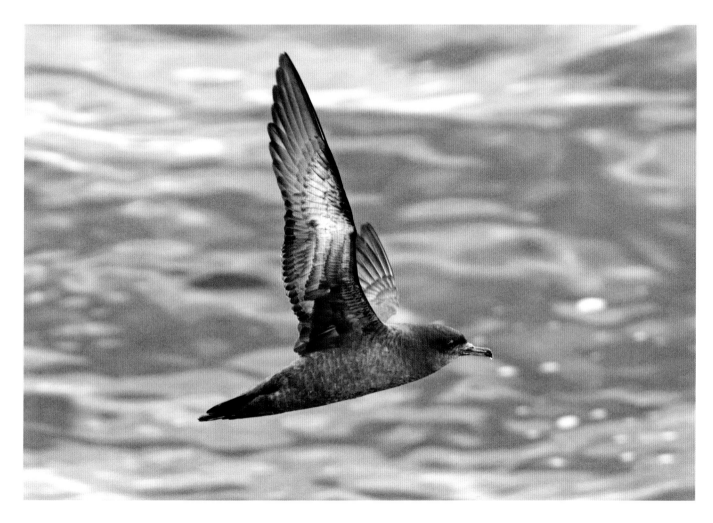

SOOTY SHEARWATER
Ardenna grisea

This species is one of the ocean's great travellers. Recent satellite tracking of individuals from New Zealand has revealed that they fly more than 60,000km (37,000 miles) annually, and average more than 480km (300 miles) per day. Their remarkable migration takes them to the north Pacific, as far as Alaska, before returning to breed. In the Atlantic, birds that breed in the Falkland Islands reach as far north as Norway.

THE MATING
GAME

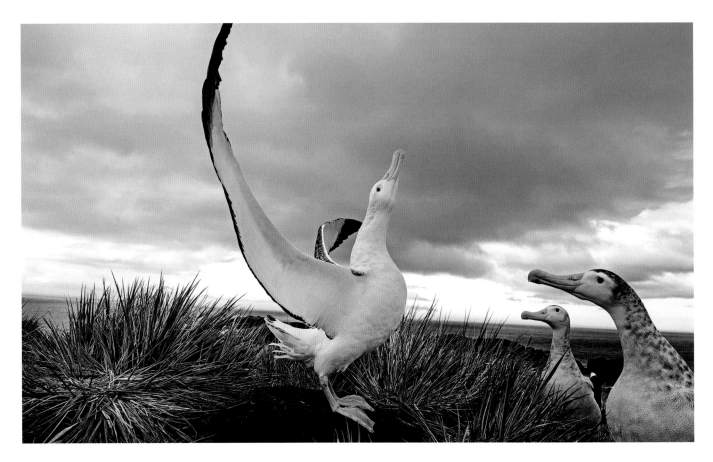

PREVIOUS PAGES
LIGHT-MANTLED ALBATROSS
Phoebetria palpebrata

Among all the species in its family the grace of the Light-mantled Albatross is unrivalled. The aerial courtship dance entails flying in perfect formation, with both birds moving in complete synchrony. This pair was photographed against the face of South Georgia's Fortuna Glacier. Shackleton and his party crossed that glacier on their epic trip over the island to get help at Stromness whaling station.

ABOVE
WANDERING ALBATROSS
Diomedea exulans

Look at me! An immature albatross displays to two interested young females on Albatross Island in the Bay of Isles, South Georgia. Wanderers take up to nine years to reach sexual maturity. During their early years they visit colonies to practice displaying and search for a mate, which they may then stay with for life.

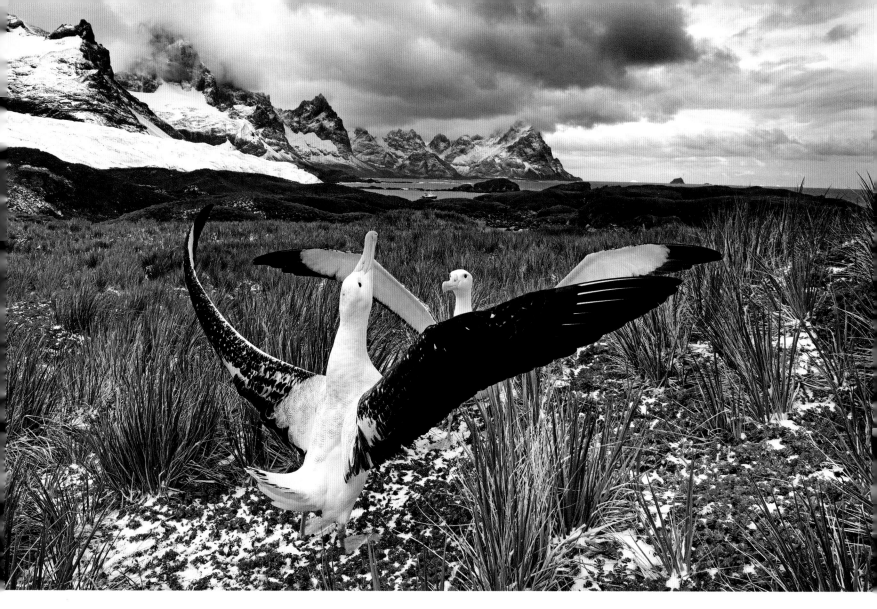

WANDERING ALBATROSS
Diomedea exulans

A pair of Wandering Albatrosses with a wingspan of 3m (10ft) dance in a courtship display at Trollhul on South Georgia's south-west coast. On reaching South Georgia, Captain Cook thought he may have arrived in Antarctica.

But when he got to the end of this small island he soon realised that he had not discovered the great white continent and named the promontory you see in this image as Cape Disappointment.

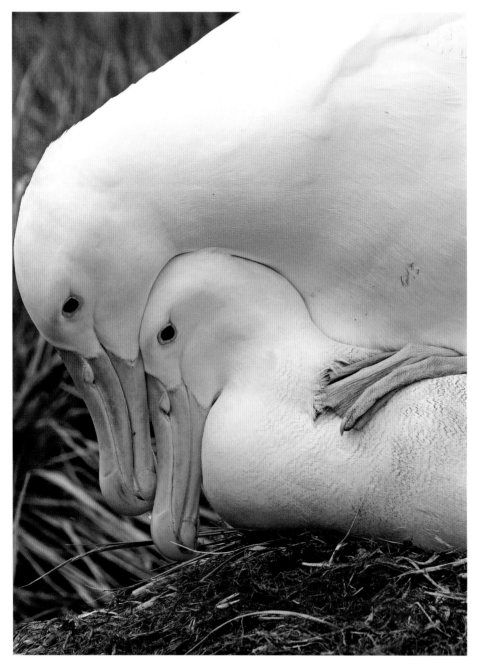

LEFT

WANDERING ALBATROSS

Diomedea exulans

Mating can require a good sense of balance in the male. Here the deeper, shorter bill of the male can easily be compared to that of the female. This feature is a good way of sexing individuals of this species even when they are not copulating.

RIGHT

WANDERING ALBATROSS

Diomedea exulans

This picture was taken late in the evening. The courtship display is one of the most extraordinary of any seabird. A complex series of vocalisations, ranging through pops, growls and primeval screams, accompanies an elaborate dance that climaxes in the wings being held outstretched in heraldic pose.

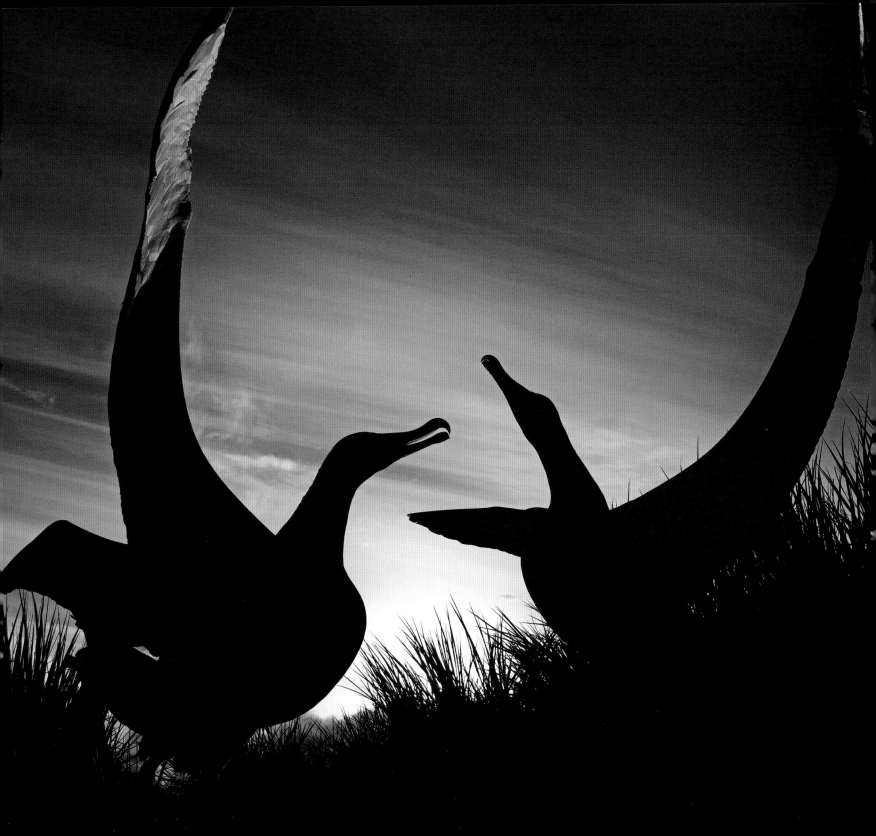

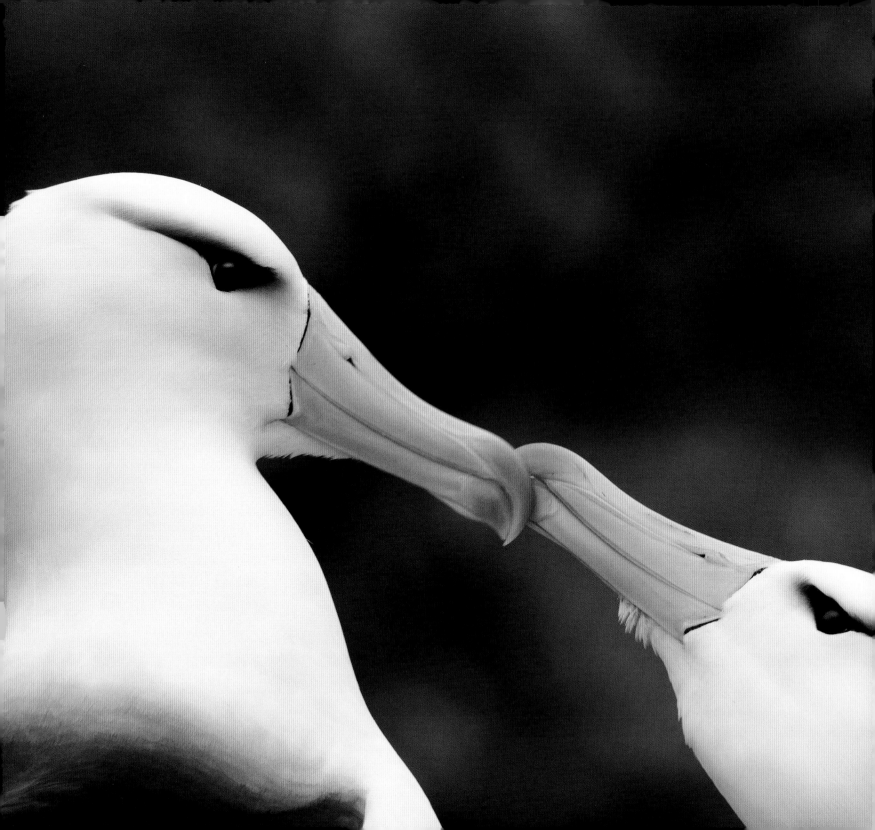

BLACK-BROWED ALBATROSS
Thalassarche melanophris

This pose, known as 'pointing', is commonly used by Black-browed Albatrosses when one individual approaches another. This species, in common with all the mollymawks (medium-sized albatrosses that form the genus *Thalassarche*), has a wide repertoire of postures related to courtship and communication.

OVERLEAF

BLACK GUILLEMOT
Cepphus grylle

Large groups of Black Guillemots gather at favoured spots along cliffs or on large boulders. These sites are stages for social interaction throughout the breeding season. I photographed these birds as they pompously strutted their stuff at Mousa in Scotland's Shetland Islands. Their thin whistle-like calls could easily be heard above the roar of the crashing waves below.

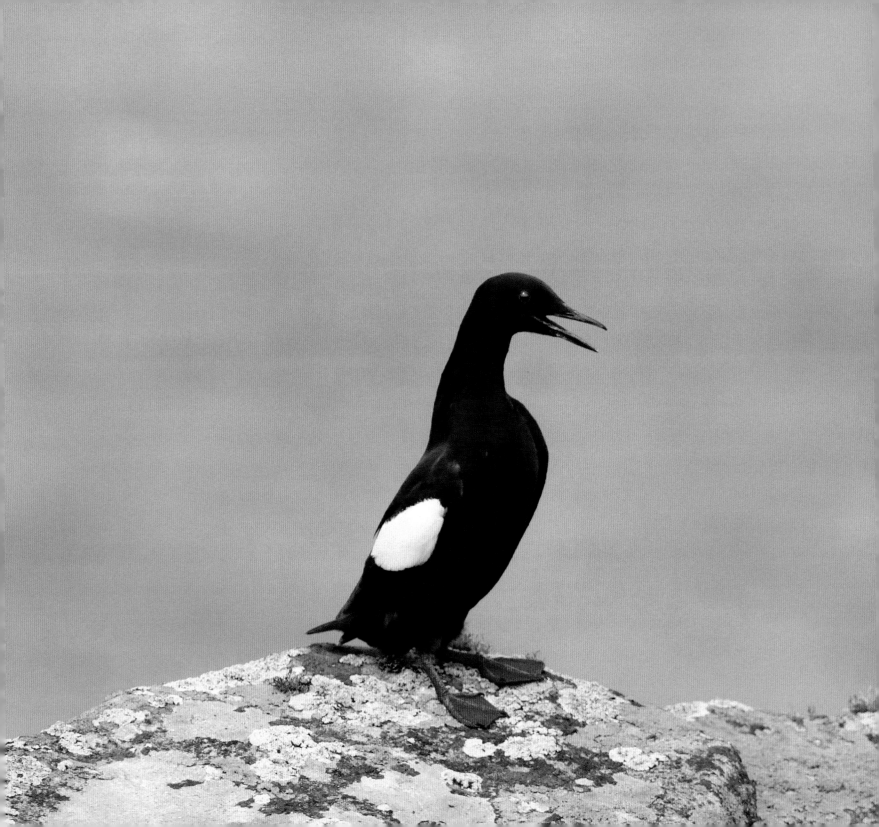

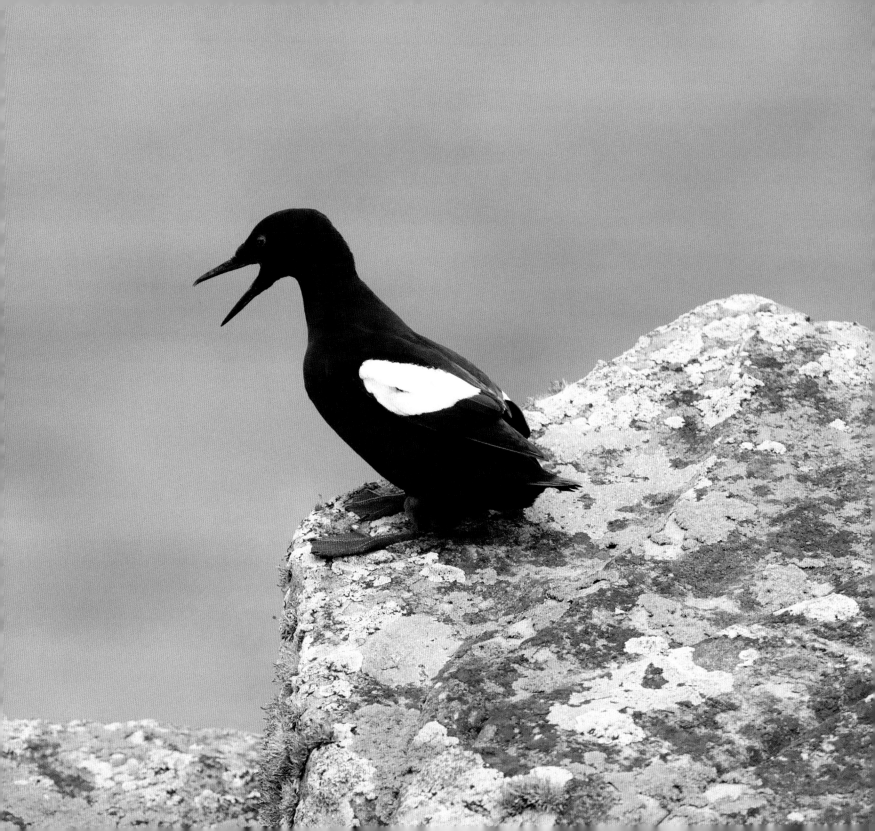

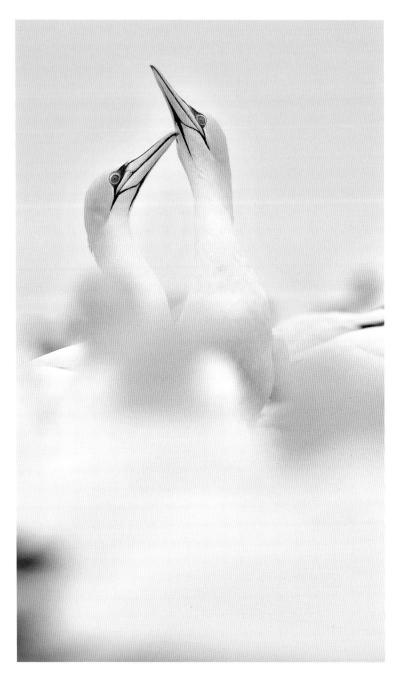

LEFT

AUSTRALASIAN GANNET
Morus serrator

Gannets frequently reaffirm the pair bond during the breeding season within their densely packed colonies. This couple was at Cape Kidnappers on New Zealand's North Island.

RIGHT

GREAT SKUA
Stercorarius skua

These birds advertise their territory to others by leaning forward and calling with wings outstretched. Each time another skua flies overhead or close by, either one or both birds in a pair will initiate the display. Here a male displays to a passing skua at Britain's northernmost tip, Hermaness, on the Shetland Island of Unst.

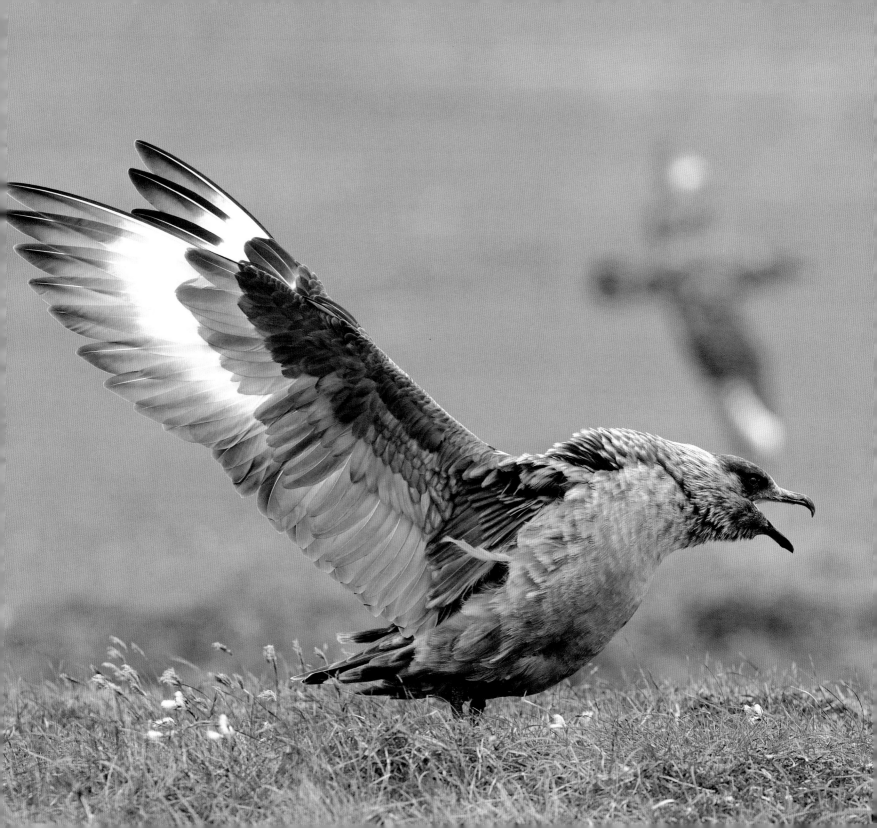

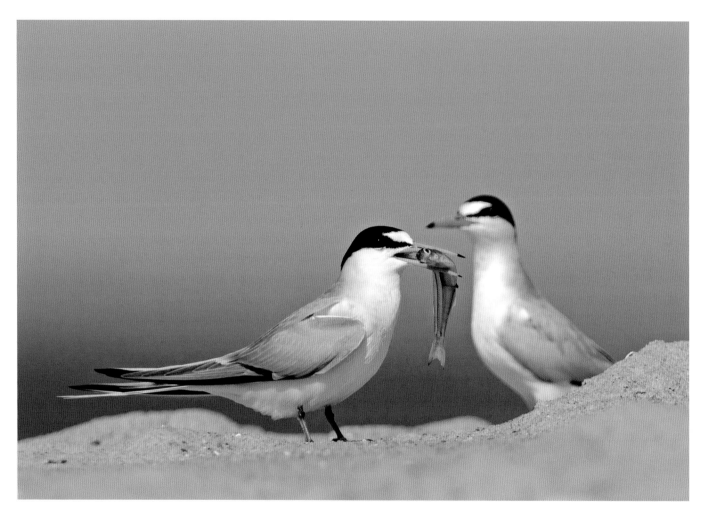

LEAST TERN
Sternula antillarum

Some male seabirds will offer fish to their mate when courting. In this case a Least Tern hopes to show off his ability to provide for a family and such offerings also help the female achieve good breeding condition. This individual, however, was not having much luck with his chosen mate. At each attempt to pass her the fish, she spurned his advances and walked away. She eventually flew off leaving him looking very dejected.

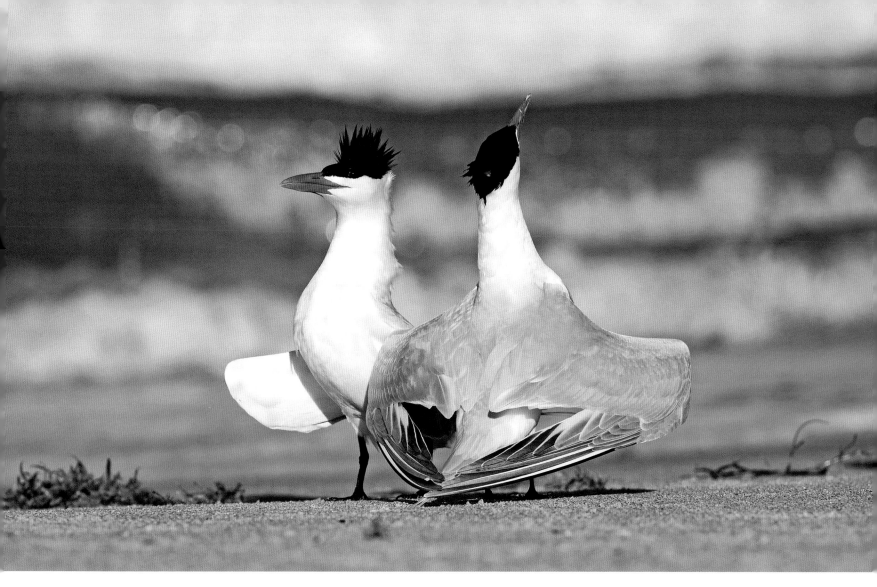

ROYAL TERN
Thalasseus maximus

This large tern, which is found in the Americas and Africa, has an elegant courtship. This pair, their crests raised on a Florida beach, strut around each other with dignified grace.

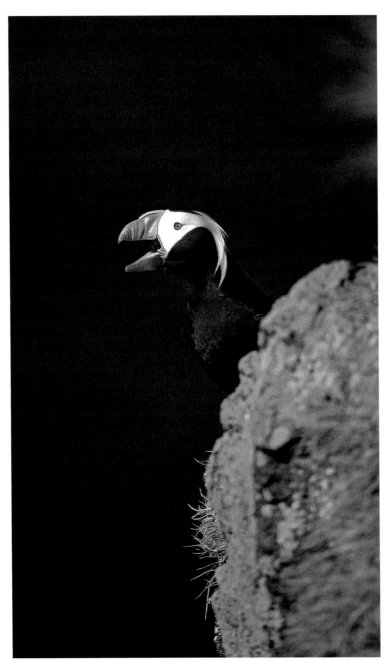

LEFT

TUFTED PUFFIN
Fratercula cirrhata

Silky yellow head plumes and a bright red bill ensure Tufted Puffins do not go unnoticed on their breeding cliffs. This picture was taken on St Paul Island in Alaska's Pribilof Islands on a very rare day of sunshine.

RIGHT

ATLANTIC PUFFIN
Fratercula arctica

Atlantic Puffin courtship involves a lot of head-wagging and bill-rubbing. Individuals return to the same burrows and rekindle old pair bonds. As this pair courted on a Scottish cliff top, a third bird looked on perhaps feeling a little left out.

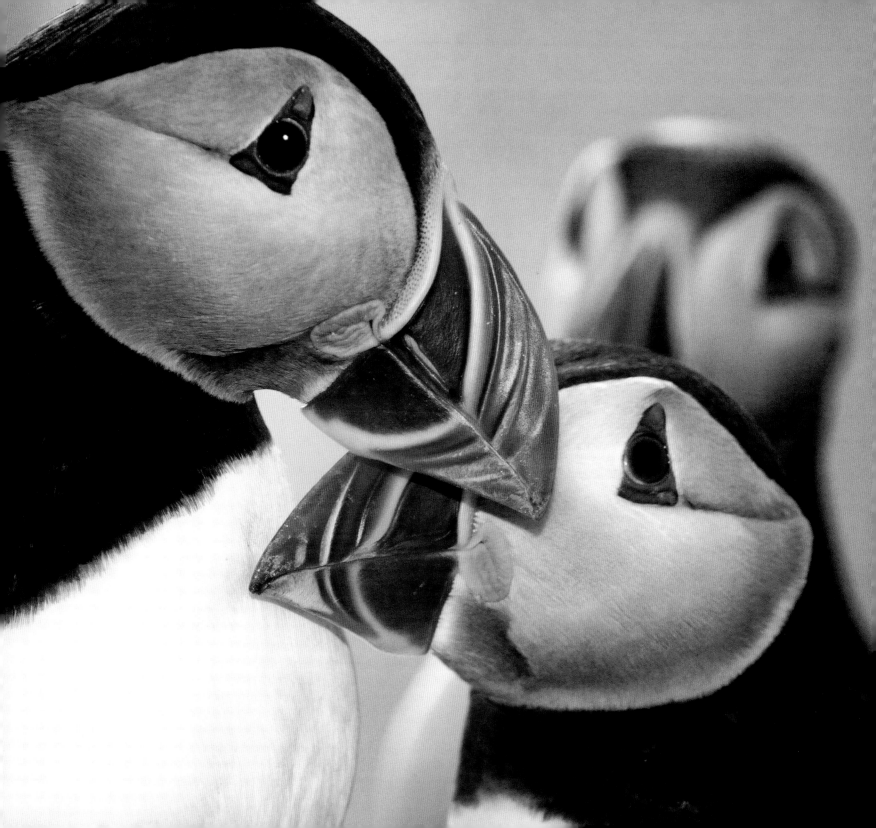

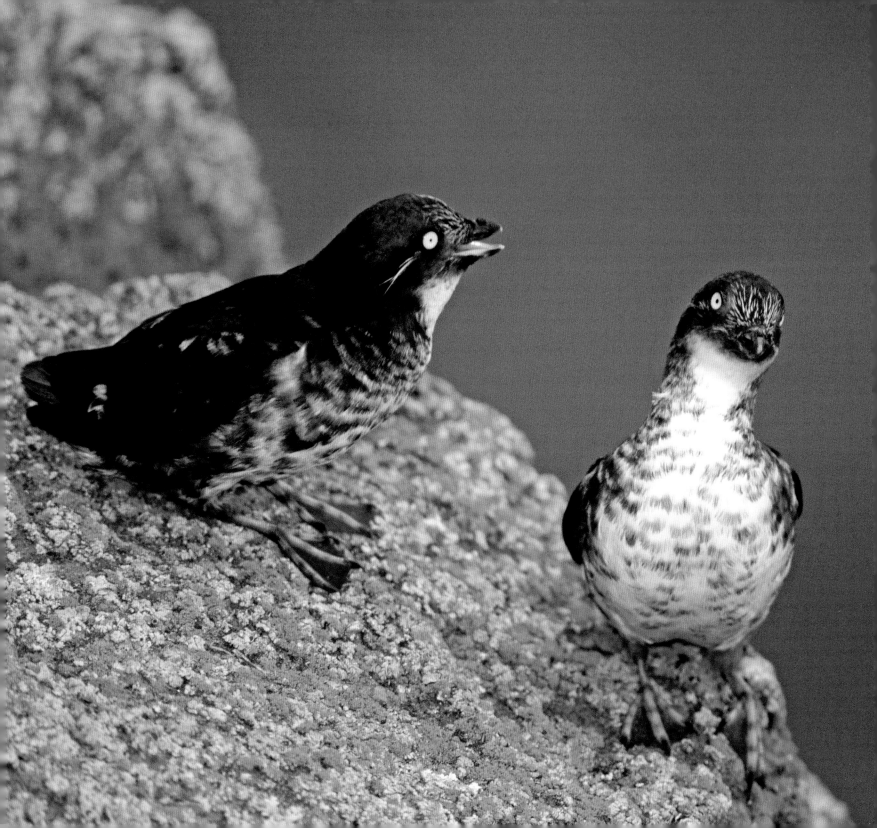

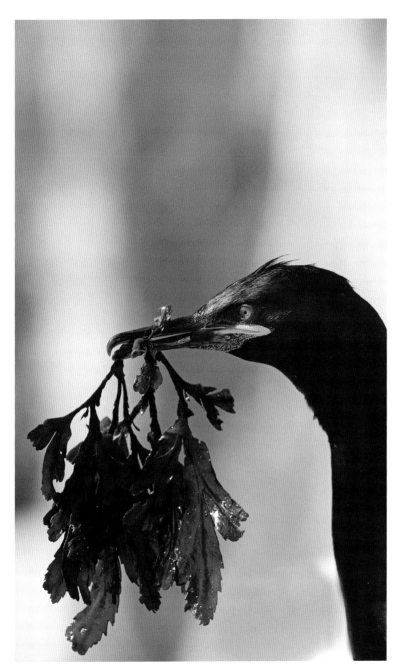

FAR LEFT

LEAST AUKLET

Aethia pusilla

Little bigger than a sparrow, this auklet from the Pacific weighs less than 110g (4oz), yet consumes up to 90 per cent of its body weight each day. They breed in huge colonies numbering up to a million birds. The current world population is estimated to be in the region of nine million. Although it is not threatened, the introduction of Arctic Foxes and rats on to some of the islands where the species breeds has exterminated some colonies and seriously affects others.

LEFT

EUROPEAN SHAG

Phalacrocorax aristotelis

A shag returning to a nest with a bunch of seaweed. The male will select a nest site but both birds share nest-building duties.

EUROPEAN SHAG

Phalacrocorax aristotelis

A pair of shags call excitedly as the male clambers on to the female to mate. Males are known to pair with more than one female and mate fidelity from one year to the next is not particularly high.

CRESTED AUKLET

Aethia cristatella

A pair of Crested Auklets at their nest site on the cliffs of St Paul on the Alaskan Pribilof Islands. Research indicates that the longer a bird's crest, the more displays and the higher the level of sexual interest shown by prospective mates. During courtship, individuals rub their faces into their partner's nape, which is scented and smells, to the human nose, of tangerines. The scented secretion is known to be effective at repelling ticks but is also likely to play a part in courtship. The odour may be sending signals about social status and fitness, which are key elements in mate selection.

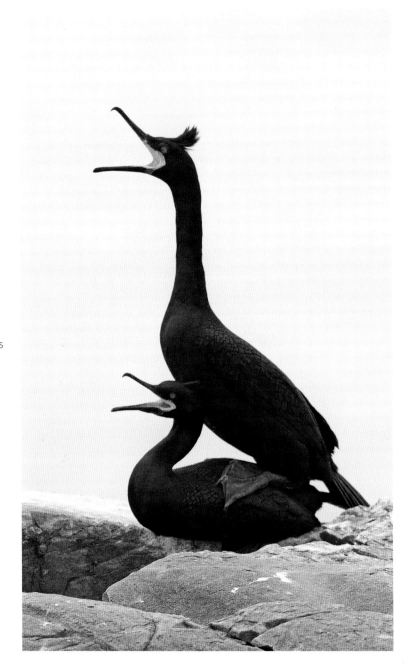

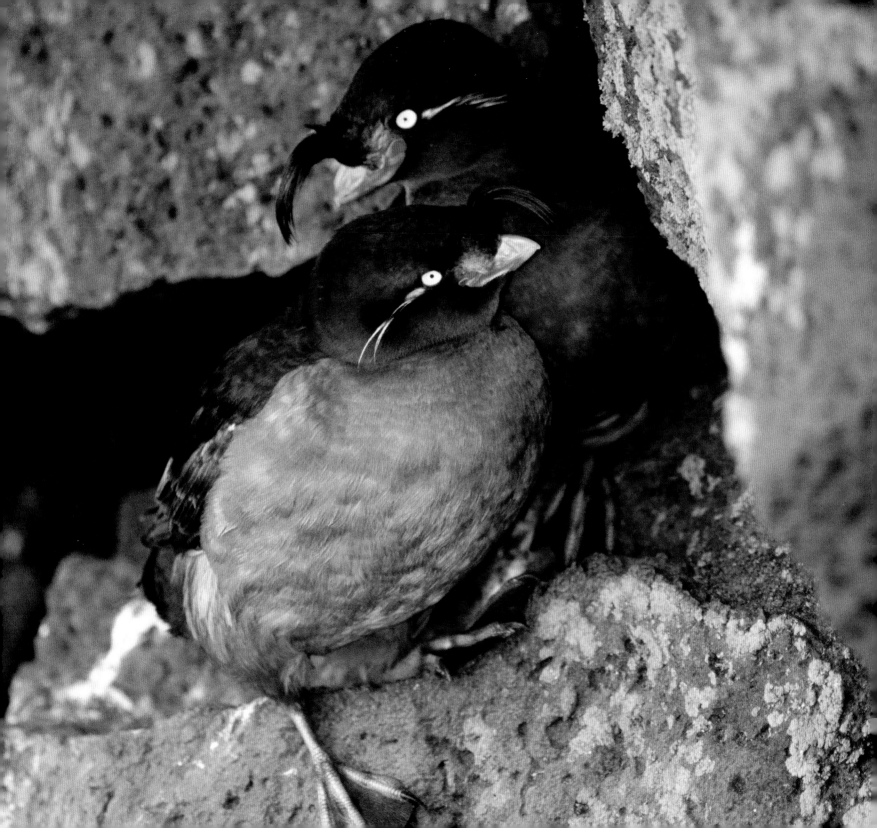

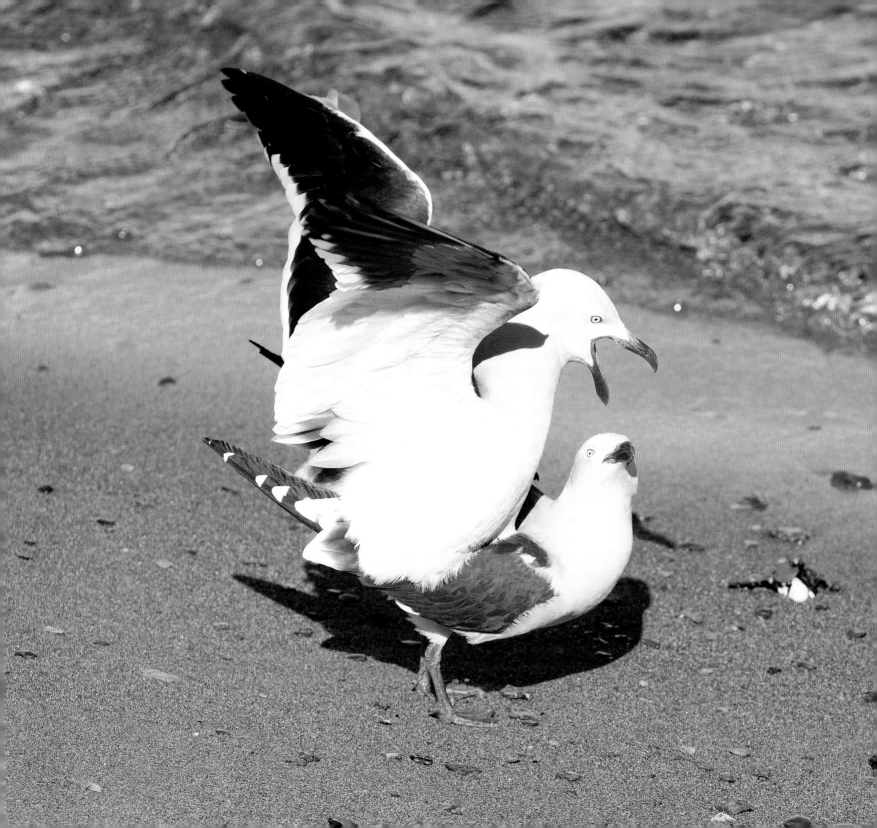

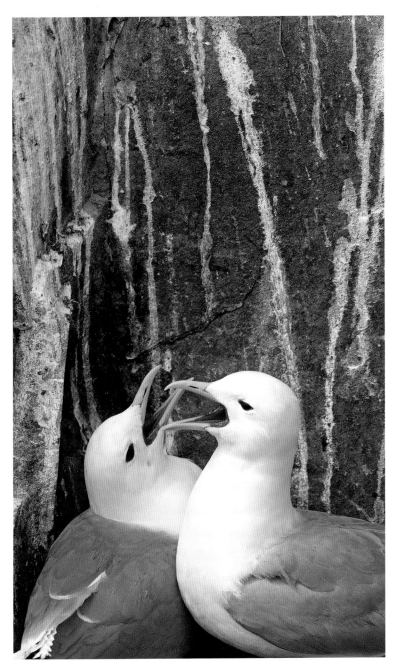

FAR LEFT
DOLPHIN GULL
Leucophaeus scoresbii

A pair of Dolphin Gulls mate on the shores of the Beagle Channel in Tierra del Fuego.

LEFT
BLACK-LEGGED KITTIWAKE
Rissa tridactyla

Signalling recognition and receptiveness, this pair of kittiwakes bob their heads and make the distinctive 'kitt-i-wake kitt-i-wake' calls when re-uniting on their cliff ledge.

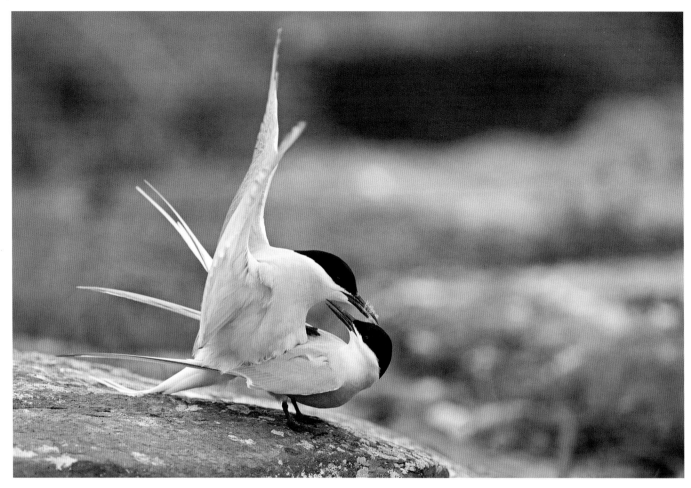

ABOVE

ABOVE

ARCTIC TERN
Sterna paradisaea

Arctic Terns mate only after an elaborate series of courtship rituals that include sky chases and display flights during which the male carries a fish.

RIGHT

ATLANTIC PUFFIN
Fratercula arctica

Territorial skirmishes among these birds are not uncommon. These individuals were fighting in what appeared to be a dispute over ownership of a burrow on a Scottish cliff.

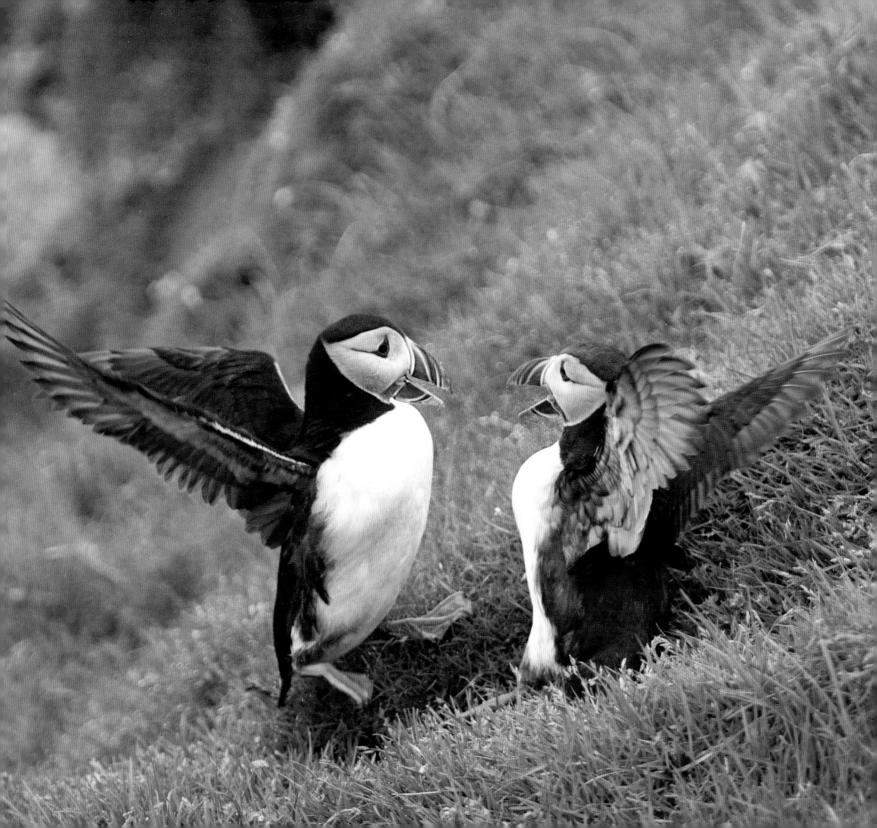

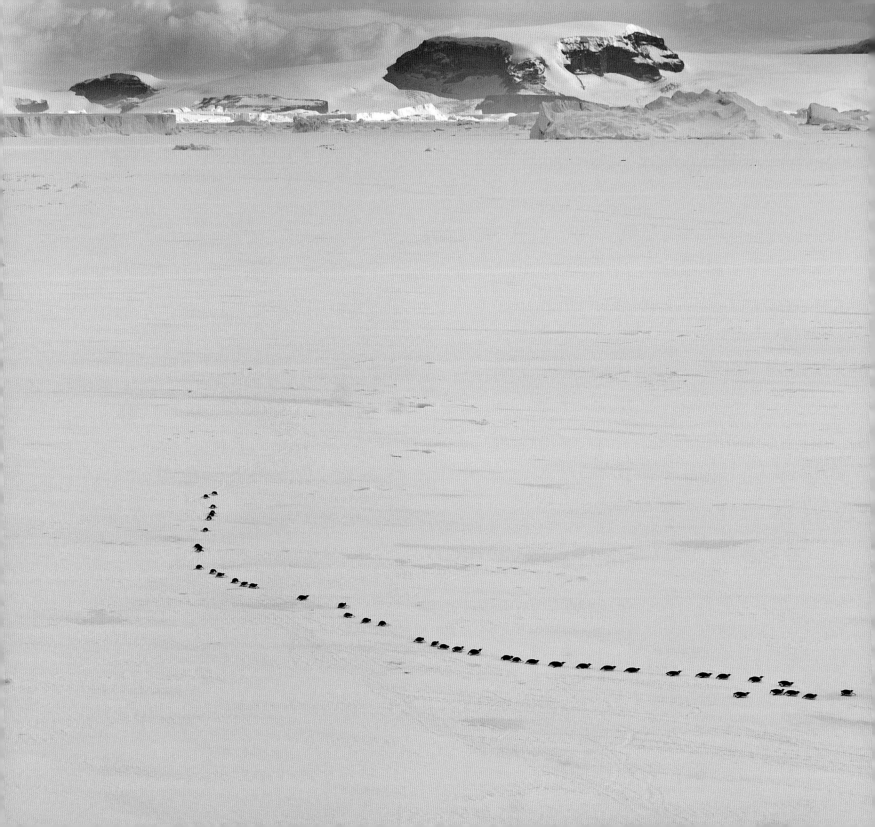

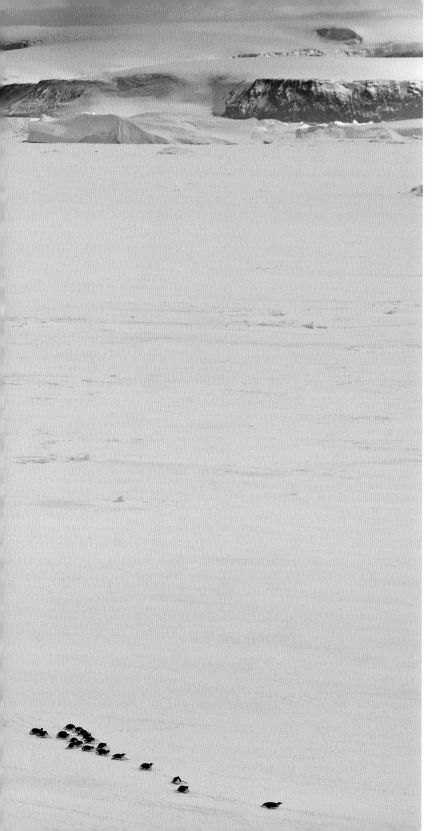

EMPEROR PENGUIN
Aptenodytes forsteri

Once courtship is over and the female has laid her egg, it is passed to the male and the females leave the colony. They make the long trek back to the open ocean, a journey that may be many miles across sea ice. The males will be left alone huddled in the harshest weather imaginable until, one day in early spring, the females return to start the hard work of rearing their chick.

FAMILY LIFE

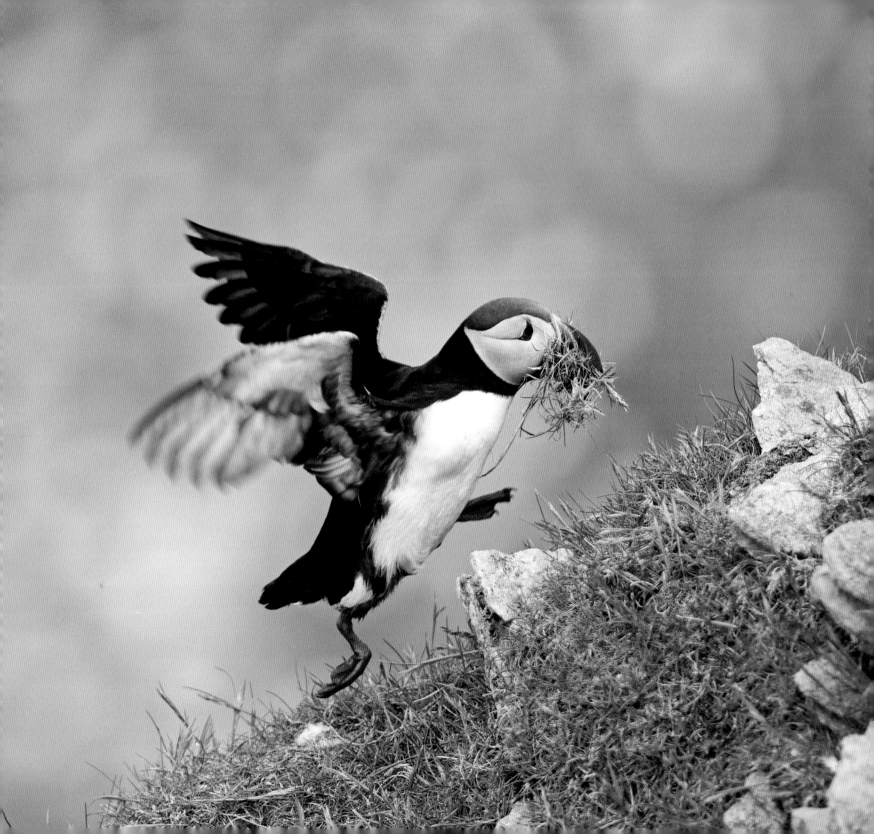

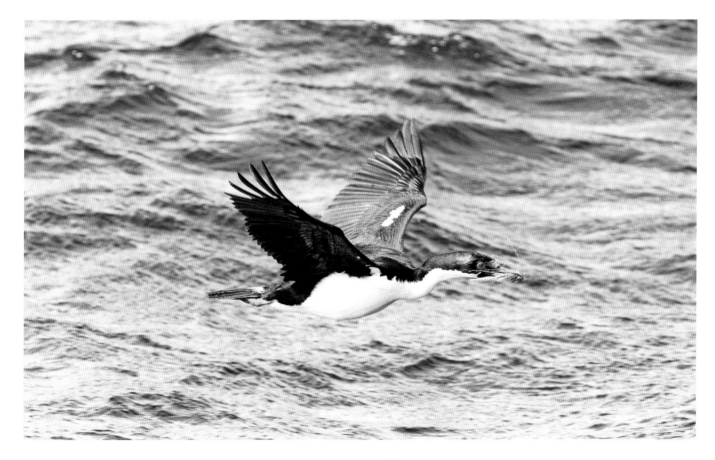

LEFT
ATLANTIC PUFFIN
Fratercula arctica

These puffins attempt to use the same burrow each year. On arrival they will clean it out, make any necessary repairs, then line the chamber with grass, feathers and any other suitable material they may pick up on the cliff top.

PREVIOUS PAGES An Australasian Gannet (*Morus serrator*) lifts off from Cape Kidnapper's on New Zealand's North Island.

ABOVE
IMPERIAL SHAG
Phalacrocorax atriceps

Some species of seabird have a complex taxonomy and this is one of them. It is known by many common names including Imperial Shag or Blue-eyed Shag, depending on which subspecies is being considered. This bird was flying along the Beagle Channel carrying nest material back to a breeding colony close to the town of Ushuaia, Argentina.

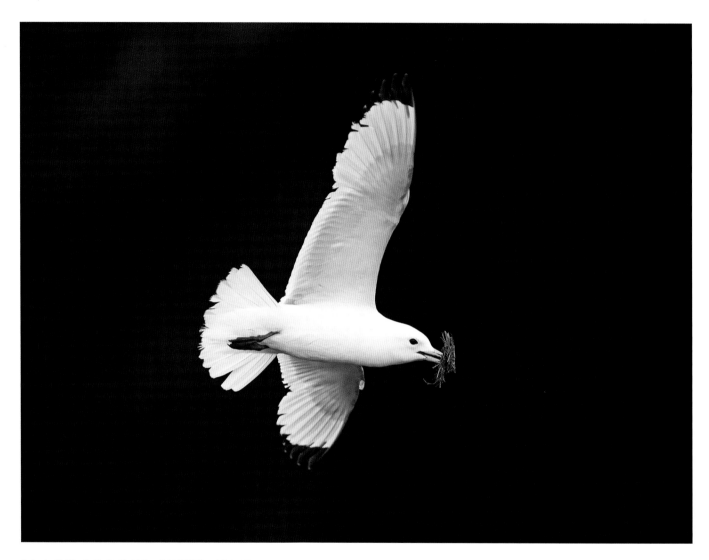

BLACK-LEGGED KITTIWAKE

Rissa tridactyla

A kittiwake carries a clump of dried grass back to its nest, which will have a mud base on which seaweed and other plant material is placed.

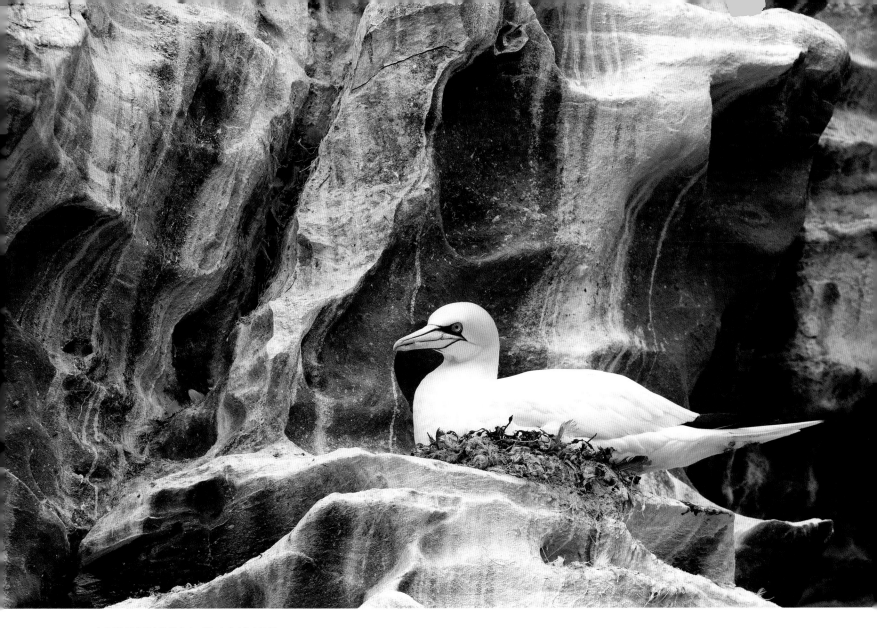

NORTHERN GANNET
Morus bassanus

Eroding rock shelves on the sandstone cliffs of Noss in Shetland offer high-rise living for around 10,000 pairs of gannets. Copious amounts of guano glue the feathers and dried seaweed of this nest together. Throughout the breeding season gannets can be found collecting floating material from below the cliffs to shore up their nests.

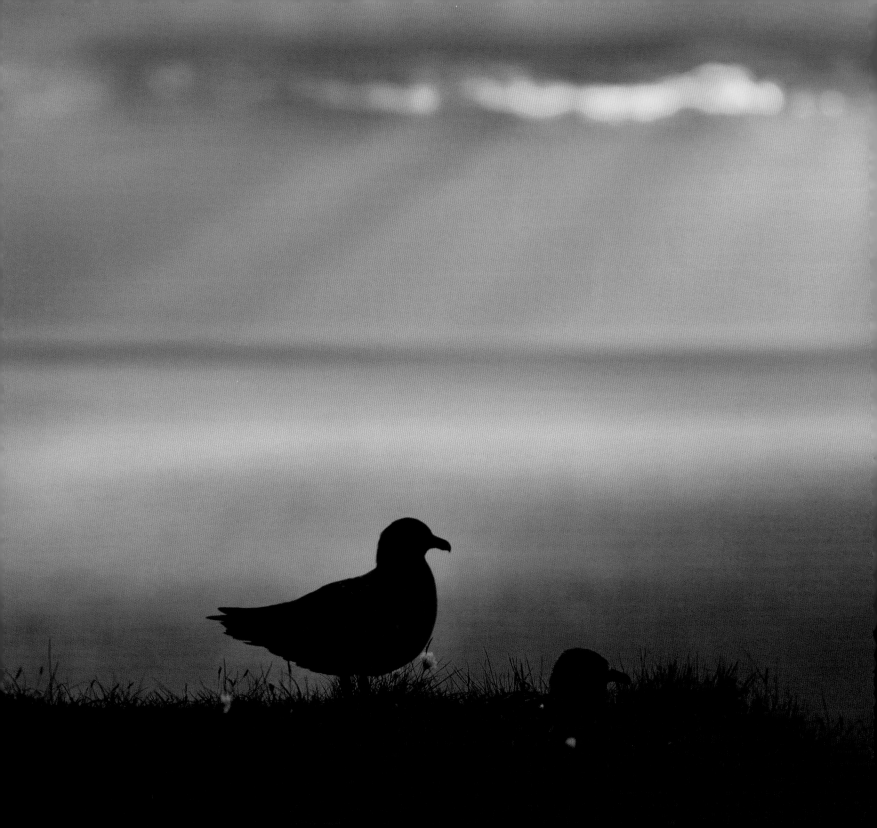

LEFT

GREAT SKUA
Stercorarius skua

A female skua incubates her two eggs in a scraped-out
hollow while the male stands guard. As the sun started to
sink I sat photographing this pair silhouetted on their grassy
knoll above the Atlantic Ocean on a rare windless evening
at Hermaness National Nature Reserve, Britain's most
northerly point.

OVERLEAF

WANDERING ALBATROSS
Diomedea exulans

Male and female Wandering Albatrosses share incubation of
their single egg for around 78 days. This incubating female
was photographed on Albatross Island, South Georgia,
and is a relatively young bird. Wanderers breed bi-annually
unless their nest attempt fails, in which case they may try
again the following year.

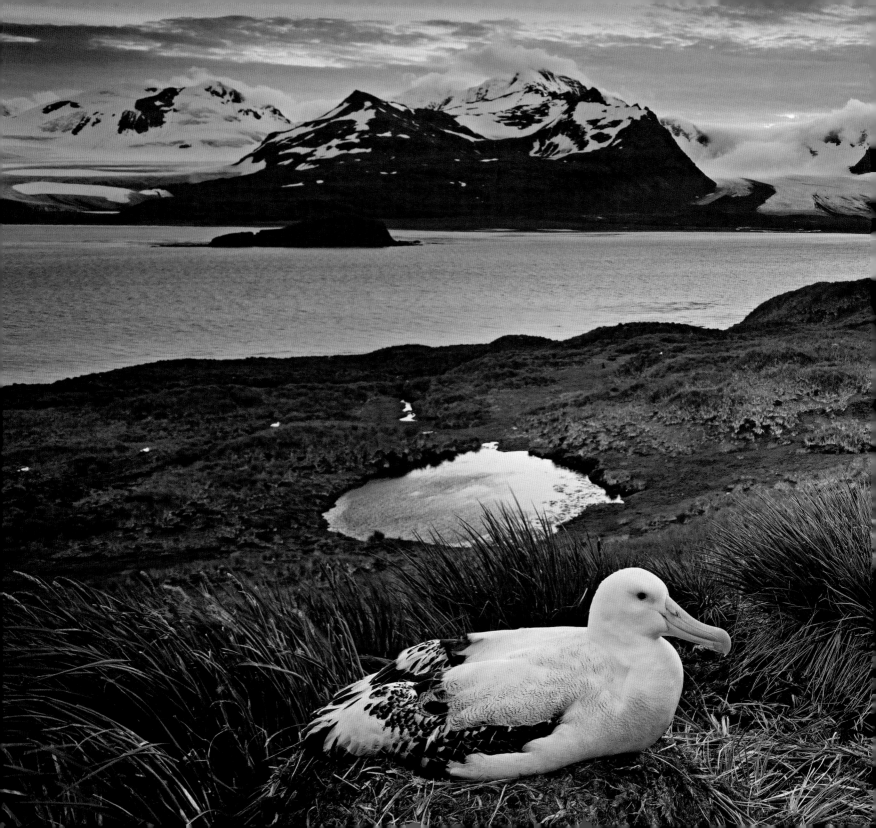

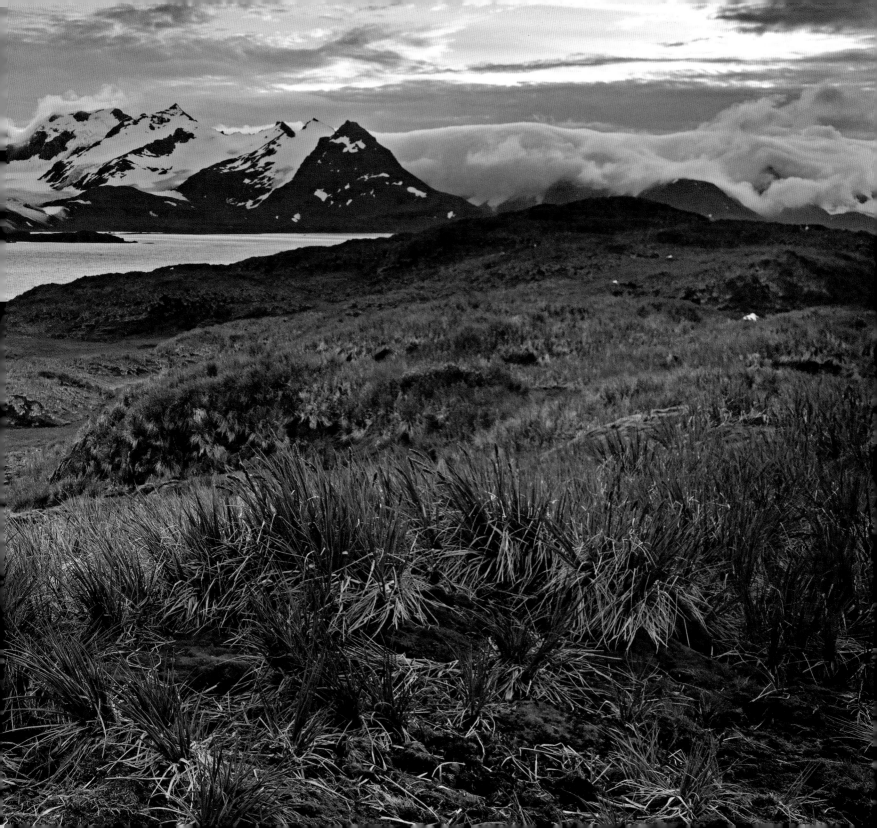

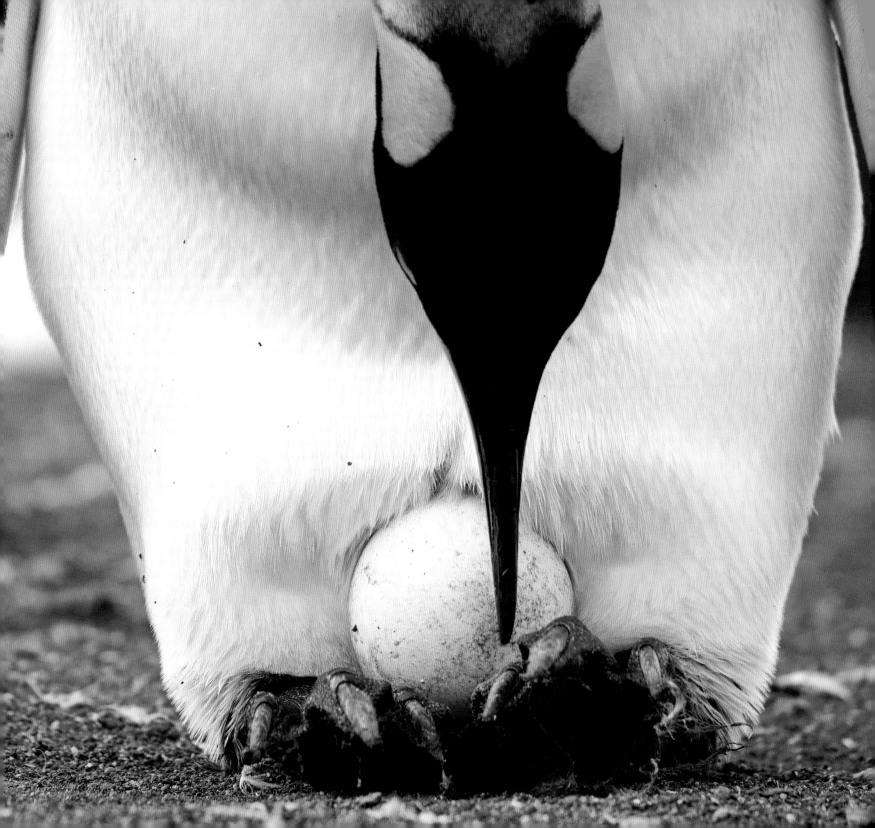

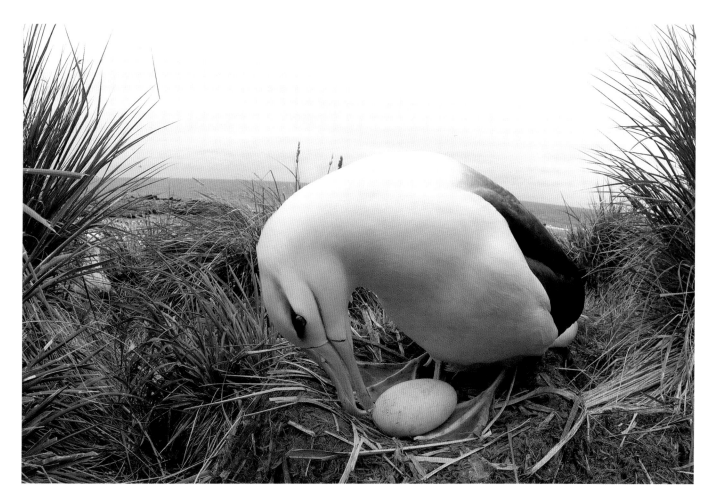

KING PENGUIN
Aptenodytes patagonicus

Instead of building a nest, these penguins incubate their egg under their warm belly, lodged by their feet, which are tilted slightly upwards. Each incubating bird stands within a tiny territory just pecking distance from its neighbours. This adult is turning its egg.

BLACK-BROWED ALBATROSS
Thalassarche melanophris

From the first signs of chipping most albatross chicks take around four days to extricate themselves from their shell. This egg at a nest within the spectacular Steeple Jason Island colony in the Falklands was just starting to hatch.

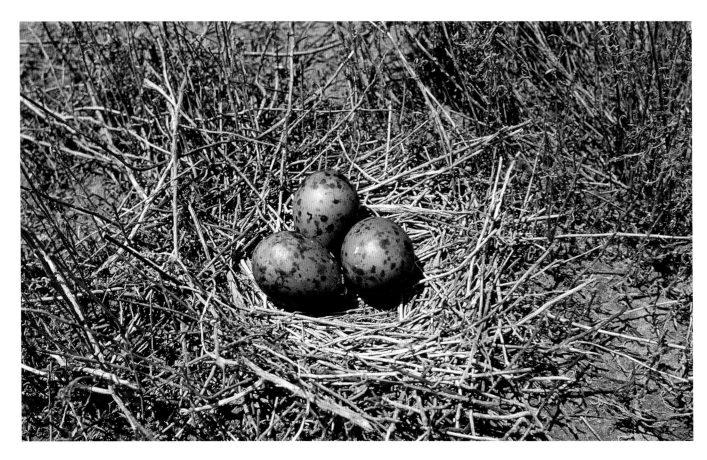

SAUNDERS'S GULL
Saundersilarus saundersi

The harvesting of gulls' eggs has ancient roots and has been relentless in many regions of the world. It still occurs in some places and is still a threat to the rare Saunders's Gull, which breeds along the eastern seaboard of China, South Korea and south-western Japan. This nest and eggs were under the protection of a nature reserve warden, trying to stop the local fishermen from collecting the eggs for food.

BROWN SKUA
Stercorarius antarcticus

Every seabird colony has its attendant predators to take advantage of poorly guarded eggs or chicks. Moments before I took this image in the Falkland Islands, this skua had swooped into a Gentoo Penguin (*Pygoscelis papua*) colony and snatched its prize. The bird patrolled the edge of this colony, which was the 'patch' that was defended against any other skua wanting to muscle in on its territory.

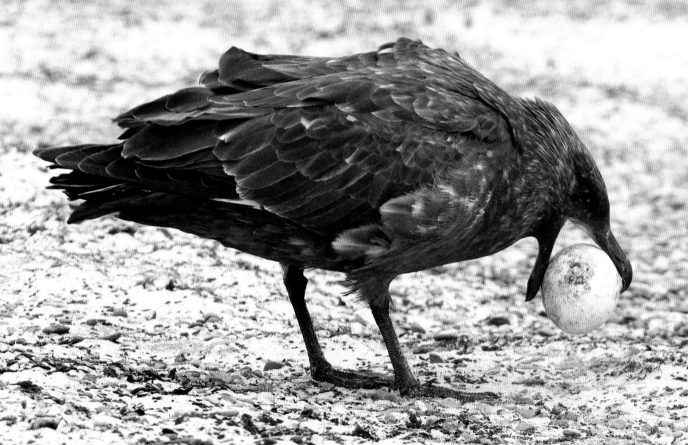

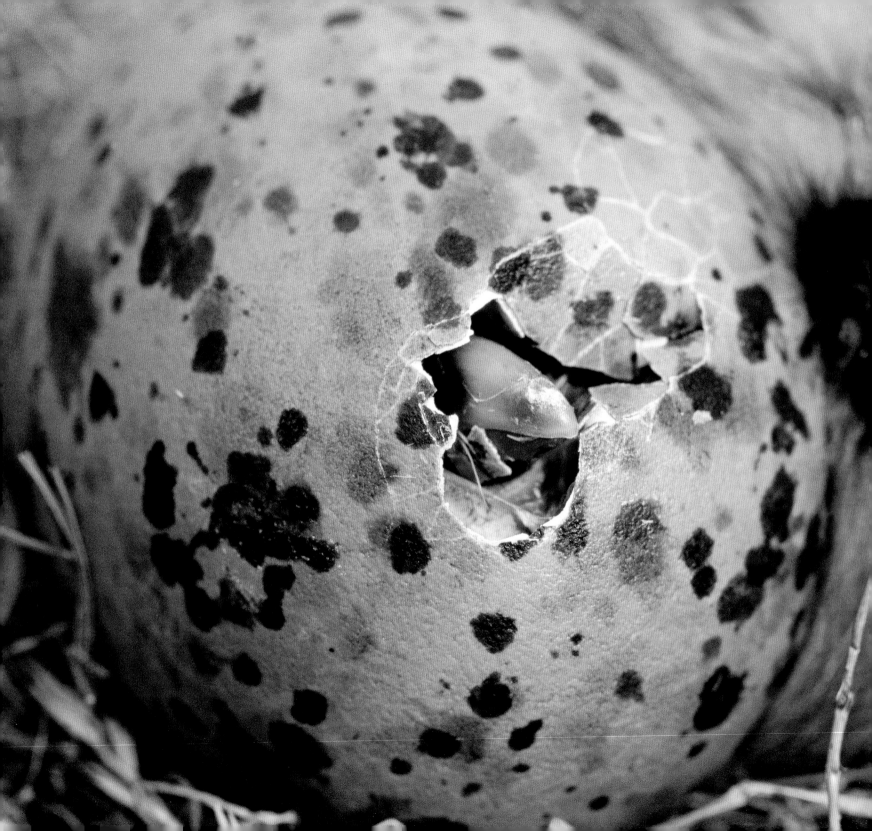

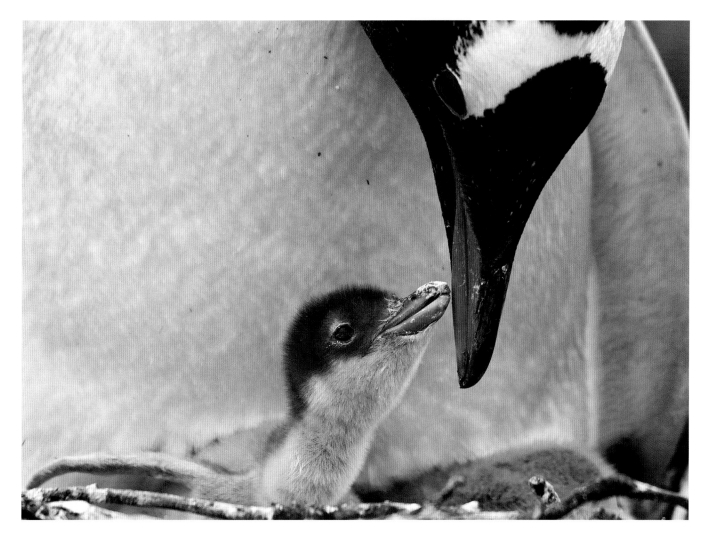

LEFT

EUROPEAN HERRING GULL
Larus argentatus

A gull chick chips away from inside its egg. The whitish shiny area on top of the bill is the egg tooth, which is used to break a hole in the egg.

ABOVE

GENTOO PENGUIN
Pygoscelis papua

These penguin chicks take around three months to fledge from hatching. This chick is just a few days old.

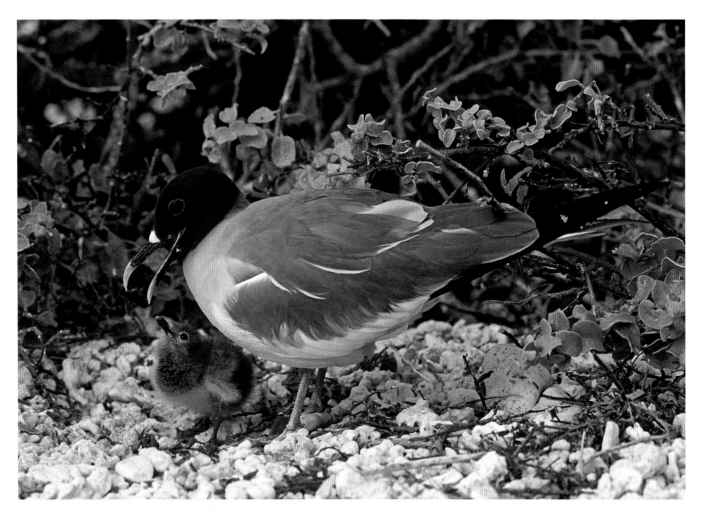

SWALLOW-TAILED GULL
Creagrus furcatus

This Galápagos Islands endemic, photographed on Hood Island, is regurgitating squid to its expectant chick. The species breeds throughout the year, laying a single egg. It feeds on squid and fish that come to the surface at night. To aid prey-location Swallow-tailed Gulls have large eyes that possess a tapetum lucidum, tissue at the back of the eye which reflects light back through the retina. This increases the amount of light available to photoreceptor cells and provides enhanced night vision.

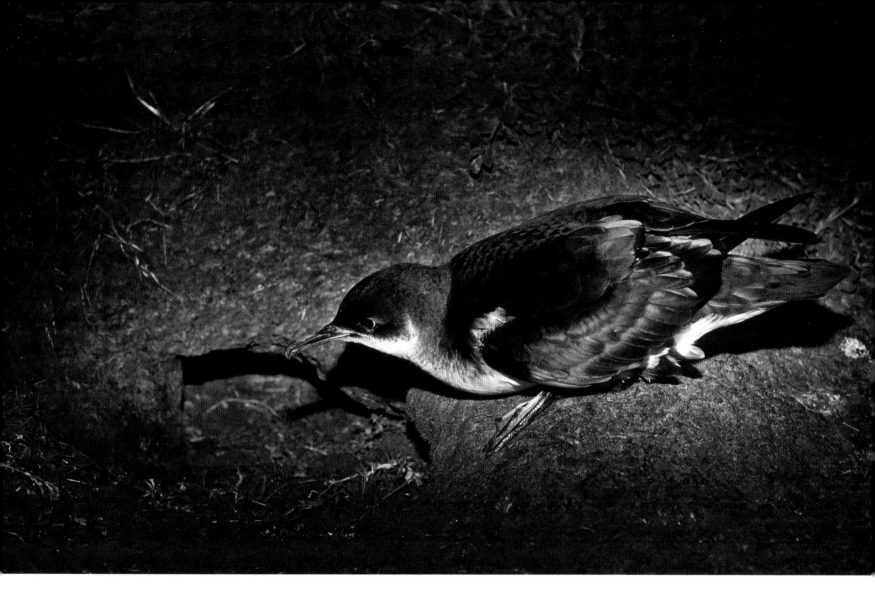

MANX SHEARWATER
Puffinus puffinus

Howls, screams and demonic-sounding cackles might make you wonder if an army of witches has invaded when you stand in the midst of a Manx Shearwater colony. This bird is returning to its nest burrow on the Welsh island of Skokholm to feed a chick that may have been patiently waiting for food for more than 24 hours.

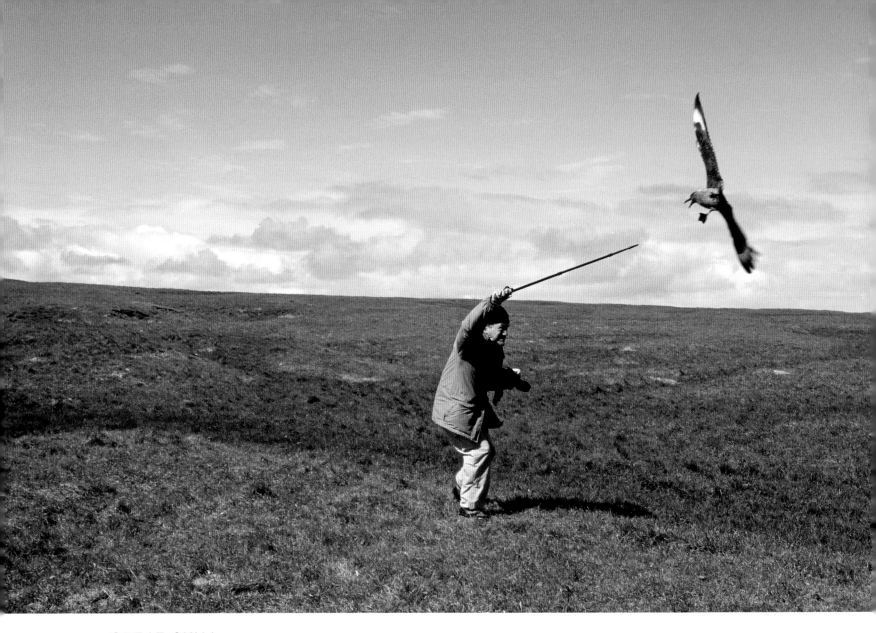

GREAT SKUA
Stercorarius skua

Many seabird species will vigorously defend their nest and young from intruders, including humans. Great Skuas are notorious for their often violent and well-targeted attacks on any unfortunate who ventures too close to a nest.

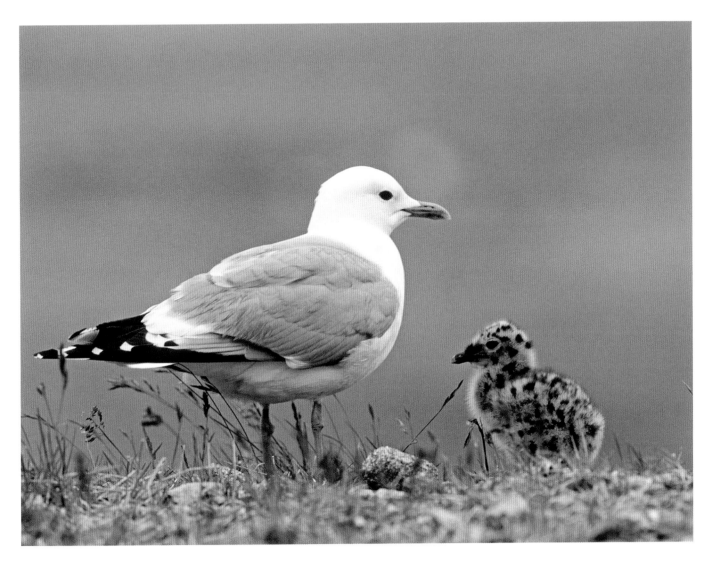

COMMON GULL

Larus canus

Gull and tern chicks are well camouflaged to protect them from predators when they are left alone. This young Common Gull at a colony in Finland has its parent on guard, but a couple of days after hatching it is capable of wandering around. The species is also known as Mew Gull.

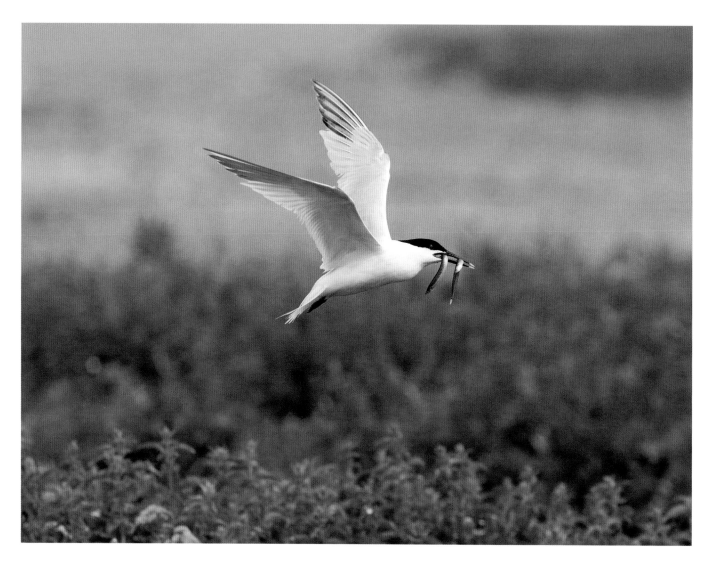

SANDWICH TERN

Thalasseus sandvicensis

An adult tern with two sandeels swoops in over the
colony towards its nest and chicks.

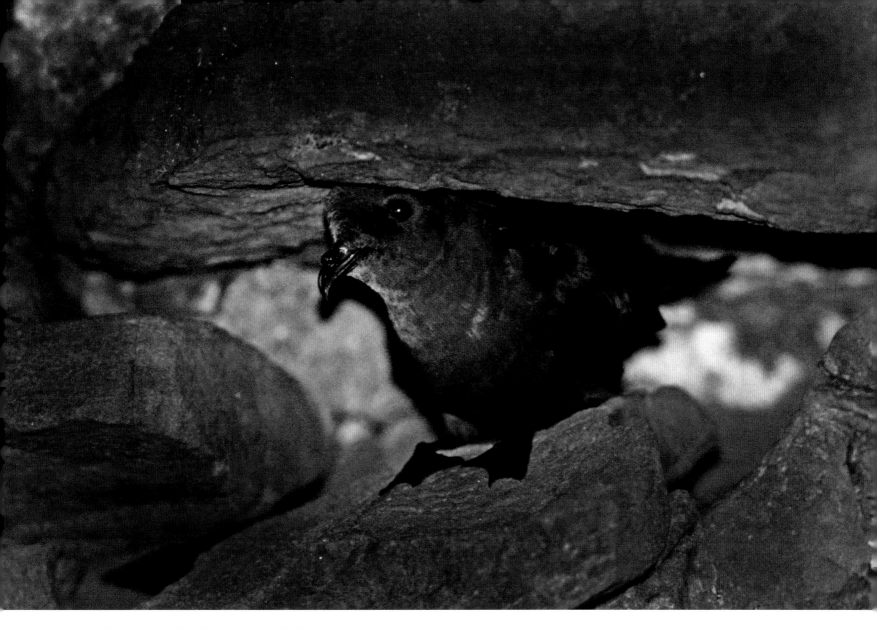

EUROPEAN STORM-PETREL
Hydrobates pelagicus

A storm-petrel peers from its nest cavity within Mousa Broch, a fortified Iron Age tower. I have spent many nights on Mousa photographing the storm-petrels as they flutter around the broch. Birds awaiting their partners vocalise from nest chambers with a call that is likened to a fairy being sick! These sights and sounds create an extraordinary atmosphere.

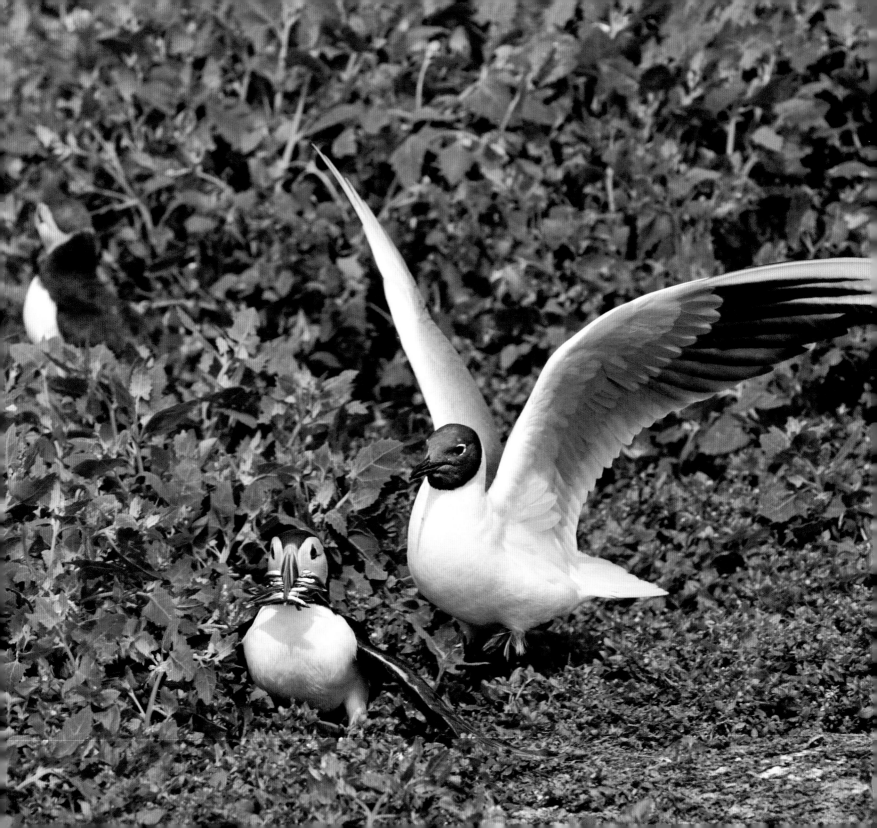

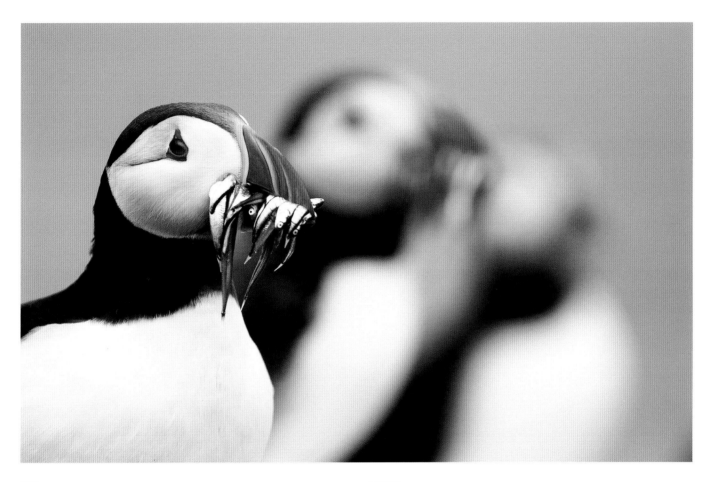

ATLANTIC PUFFIN AND
BLACK-HEADED GULL

Fratercula arctica and *Chroicocephalus ridibundus*

The robbing of food by one bird from another is known as kleptoparasitism and is common at seabird colonies. Puffins are particularly susceptible to these muggings, as they make their way to their burrows with beaks full of fish. Seconds later the gull had pinned the puffin to the ground and stole its catch.

ATLANTIC PUFFIN

Fratercula arctica

Puffins are able to stack their fish catch using inward-facing serrations on their bill. Sandeels are favoured while chicks are small and 10 or more fish can be brought back to the nest in a single serving. As the chicks develop, larger fish such as sprats are readily taken.

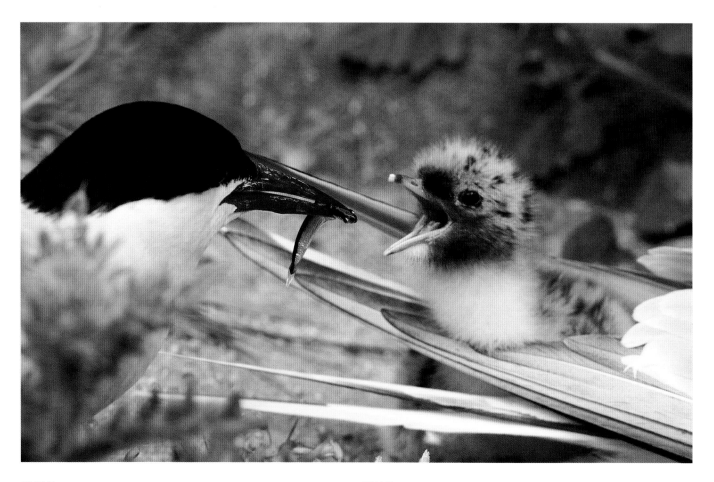

ABOVE
ARCTIC TERN
Sterna paradisaea

Once this tern chick has fledged its parents will continue to feed it for at least another month. When independent the fledged chick will migrate south and stay on its wintering grounds for two years, after which it may attempt to breed aged three or four years old.

RIGHT
COMMON GUILLEMOT
Uria aalge

Within two to three weeks of hatching, and before they are fully fledged, young guillemots take to the sea to be cared for by their fathers. The youngster launches itself off the cliff followed closely by the adult male, and they swim out to sea. This unfortunate chick, however, was pounced on by an opportunist European Herring Gull (*Larus argentatus*).

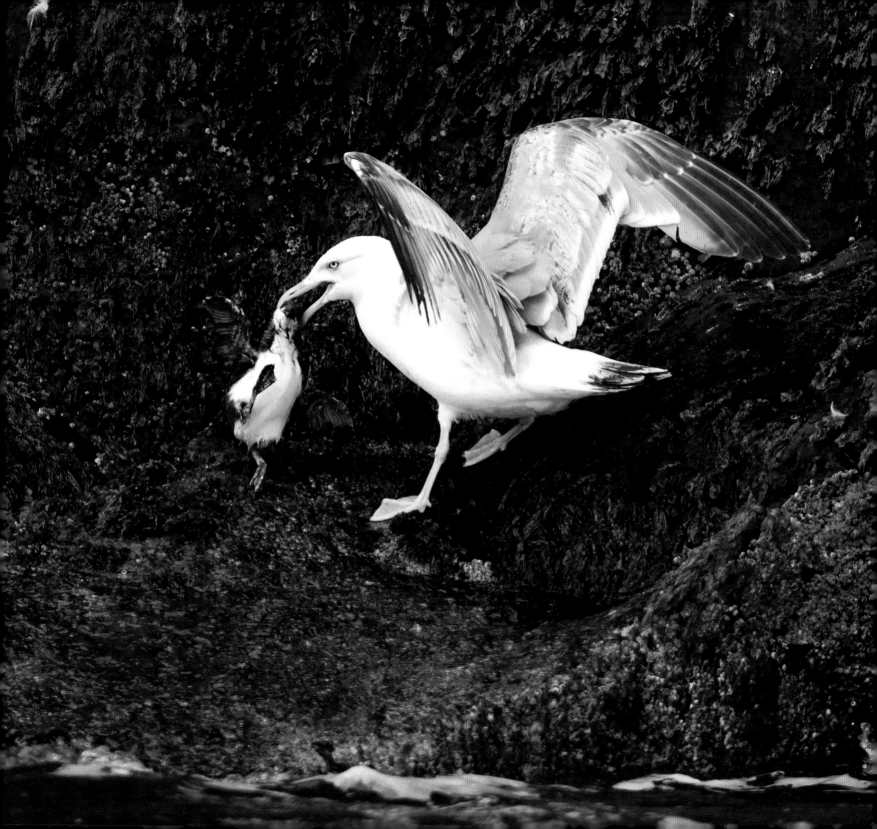

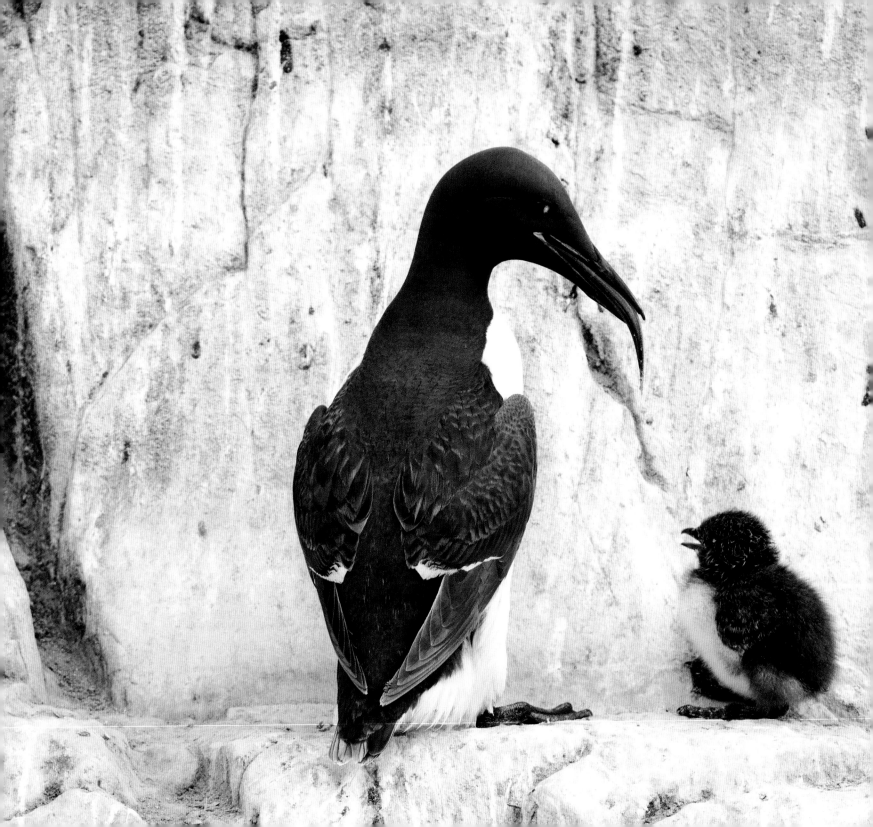

COMMON GUILLEMOT
Uria aalge

Guillemot chicks use the claws on their feet to cling to the back of the cliff ledge. This fish seemed a little large for such a small chick, yet it managed to swallow it whole.

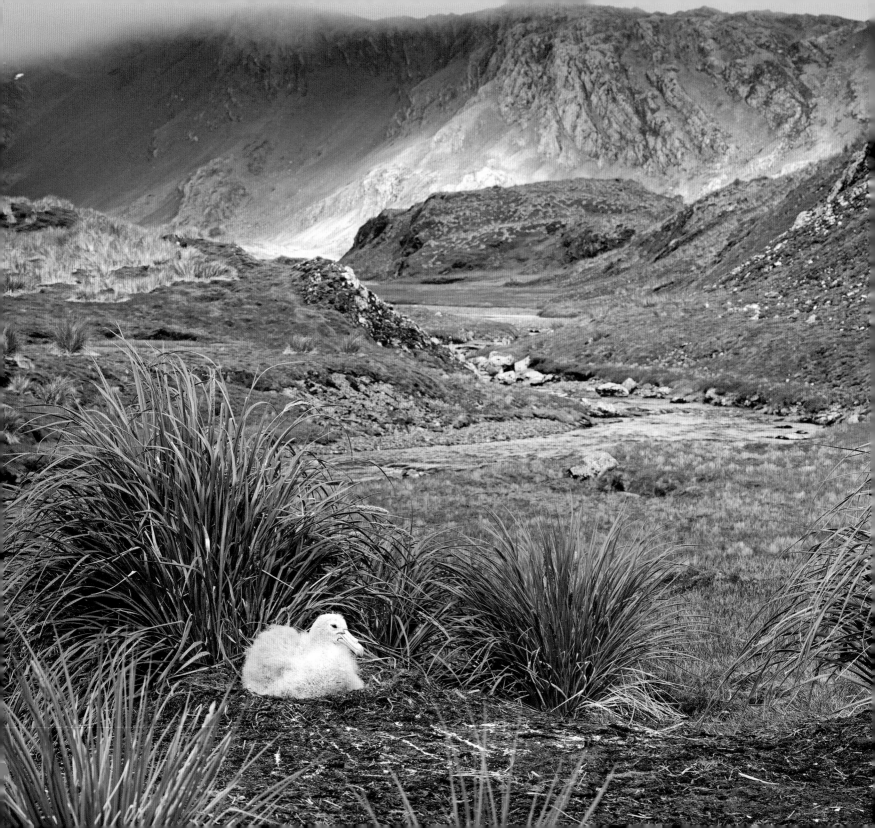

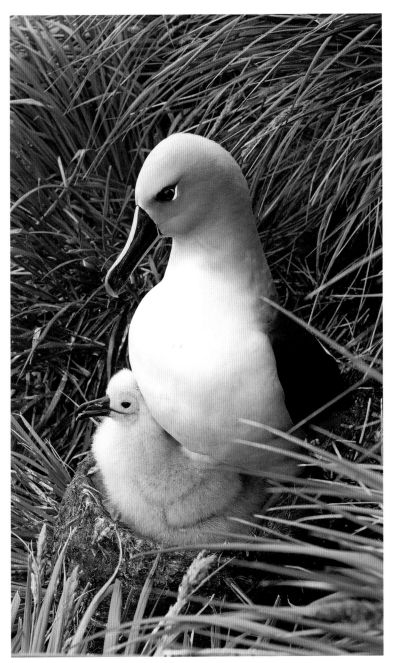

SOUTHERN GIANT PETREL

Macronectes giganteus

These giant petrels breed in loose colonies with nests often a few feet apart. This chick on South Georgia waits patiently for one of its parents to return.

LEFT

GREY-HEADED ALBATROSS

Thalassarche chrysostoma

If this albatross chick fledges, its parents will take the following year off before nesting again. On meeting two years later, both adults may have circled the planet dozens of times. Their offspring will not return for six or seven years. Even then it may be several more years before this young albatross breeds.

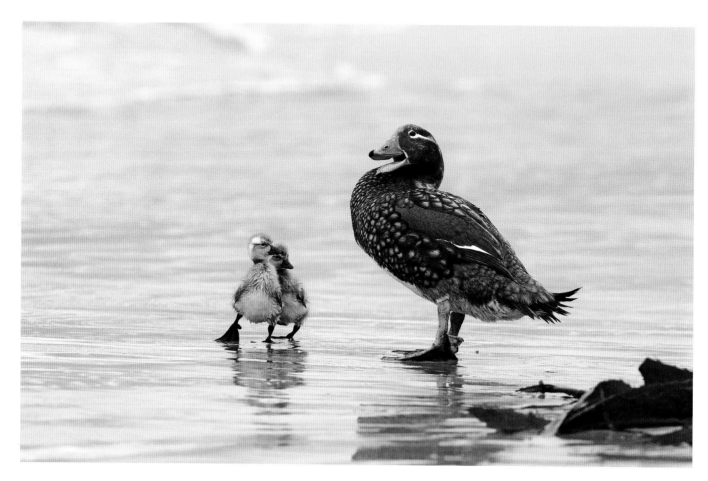

ABOVE
FALKLAND STEAMER DUCK
Tachyeres brachypterus

This flightless seaduck is endemic to the Falkland Islands, where it is widespread and numerous. The chicks are vulnerable to predation by gulls and skuas but parent steamer ducks aggressively defend their broods. I photographed this family on Carcass Island.

RIGHT
MACARONI PENGUIN
Eudyptes chrysolophus

For the first three weeks of a young Macaroni Penguin's life it is the father that stays with the chick. The mother makes feeding visits. Once old enough to wander around the colony, the chicks form small creches while the fathers go off to recuperate. They feed for around a week before joining the female to share caring duties once more.

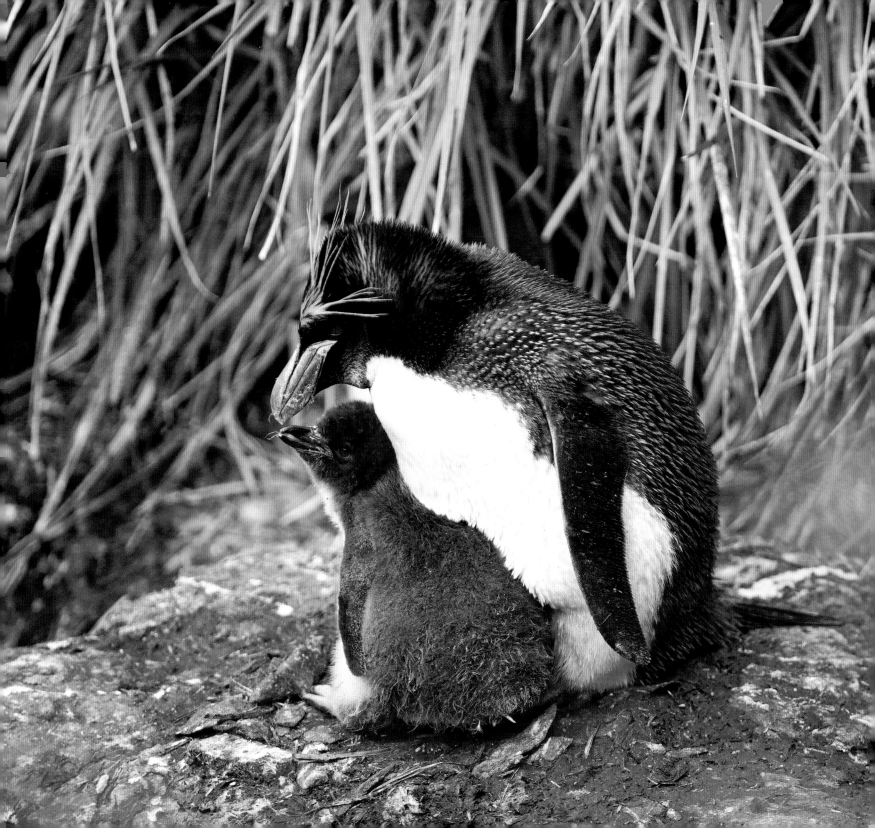

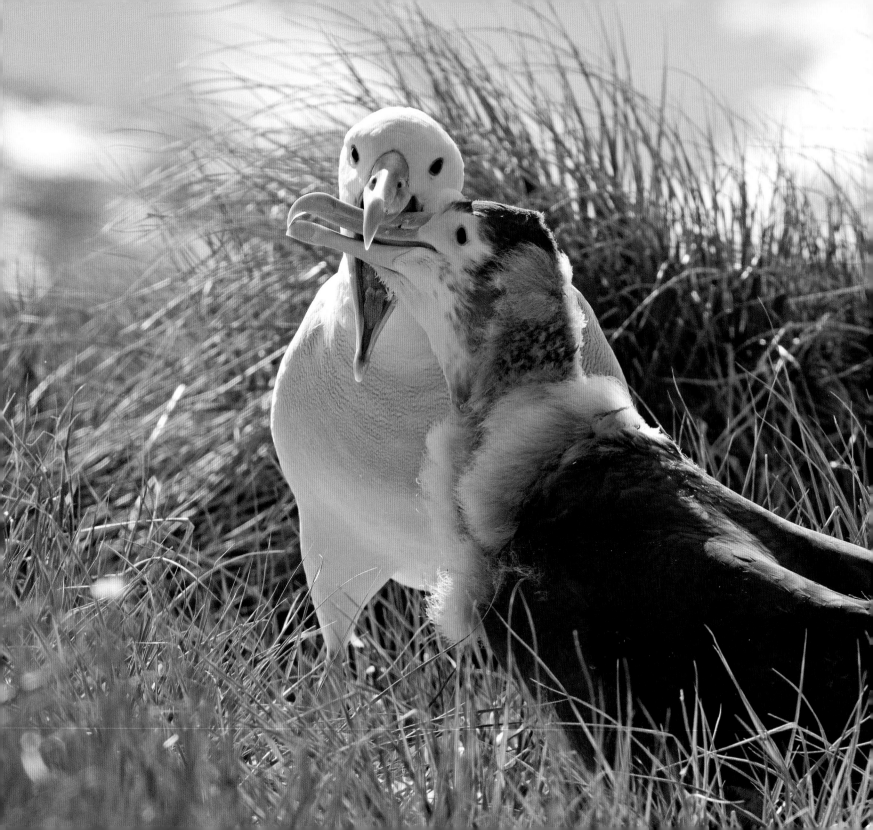

WANDERING ALBATROSS
Diomedea exulans

Nine months after hatching this chick is almost
ready to leave its place of birth at Cape Alexandra
on South Georgia. Its parents will soon cease their
feeding visits so that hunger will lure the fledgling
to the ocean after a few days. It may then return
at the age of three, but more likely it will remain
at sea until at least five years old. The first year is
the most perilous of its life since it must learn to fly
at maximum capability and also forage for all its
own food.

KING PENGUIN

Aptenodytes patagonicus

Photographing penguin colonies is surprisingly challenging, not least because they are such chaotic places. Your eye may be able to focus on specific scenes within a colony, however, the camera records everything and the challenge is to make order from chaos. One way is to use a shallow depth of field and a telephoto lens to pick out small details. This is what I have done with this young King Penguin, rendered in crisp focus against a sea of blurry adults.

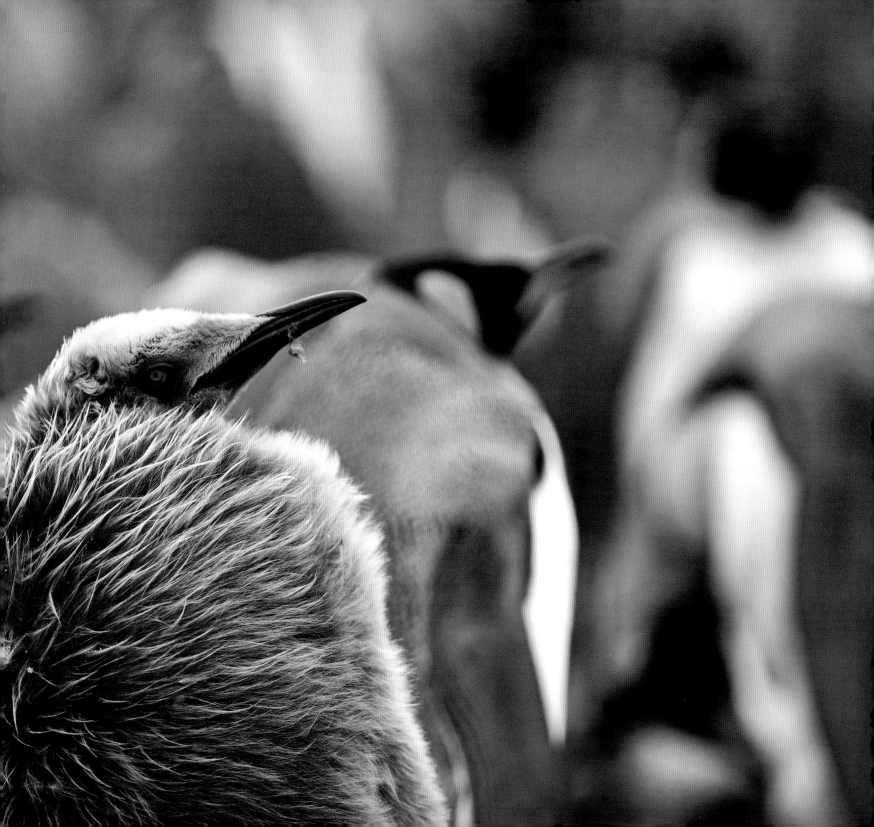

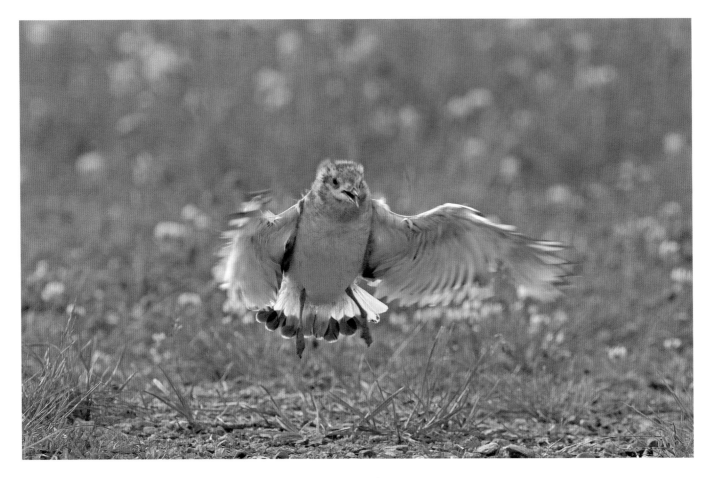

ABOVE

LITTLE GULL
Hydrocoloeus minutus

A soon-to-fledge youngster on the edge of a colony in Finland exercises, exploring its new-found ability to fly.

RIGHT

MAGNIFICENT FRIGATEBIRD
Fregata magnificens

This chick will have been in the nest for 22 weeks from hatching. The male gives up sharing parental duties after 12 weeks, leaving the female to care for the chick. Once the chick has left the nest the female will continue to tend to the youngster for up to nine months. No other species of bird cares for its offspring for so long after fledging.

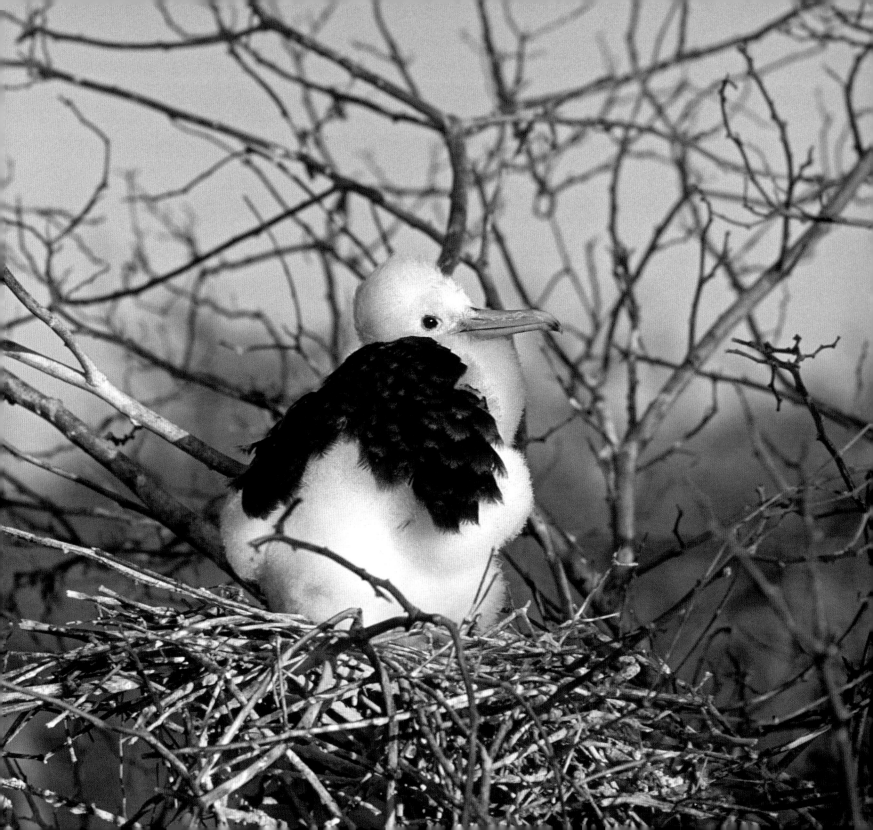

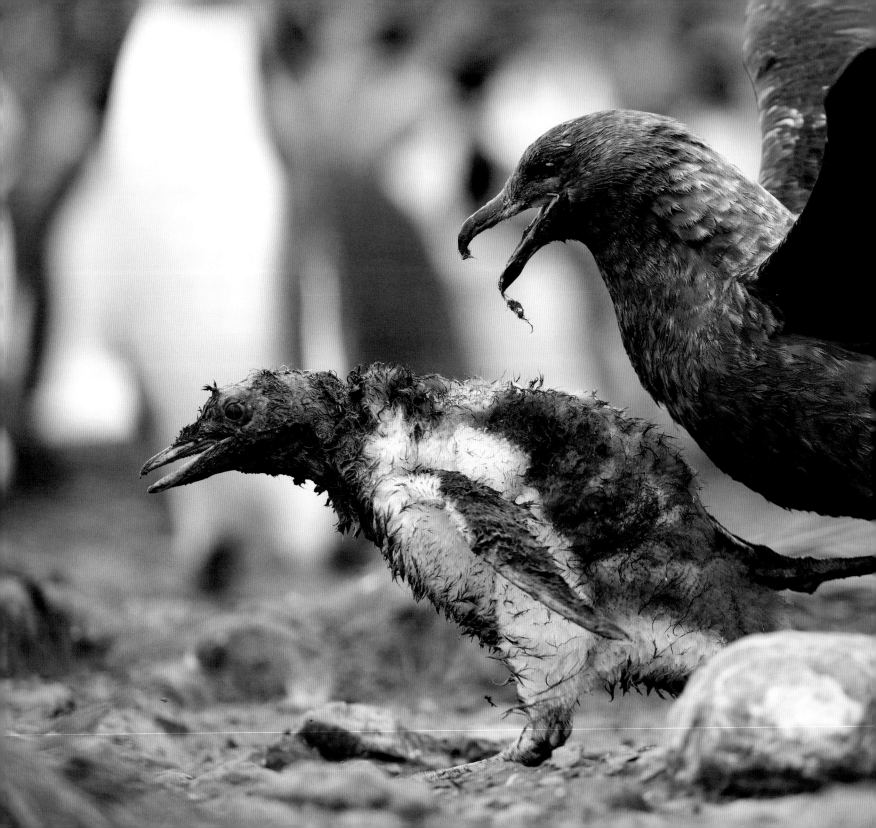

GENTOO PENGUIN
Pygoscelis papua

I have a firm policy of never intervening with any behaviour
I might witness during the course of photographing a story
or making a film. This policy was tested to the full when
this hapless penguin chick wandered away from its creche
and was immediately singled out by a pair of Brown Skuas
(*Stercorarius antarcticus*) that chased it to exhaustion. They
took 40 minutes to kill the penguin, by which time a gang
of giant petrels (*Macronectes* sp.) had gathered. They then
moved in and stole the skuas' prize.

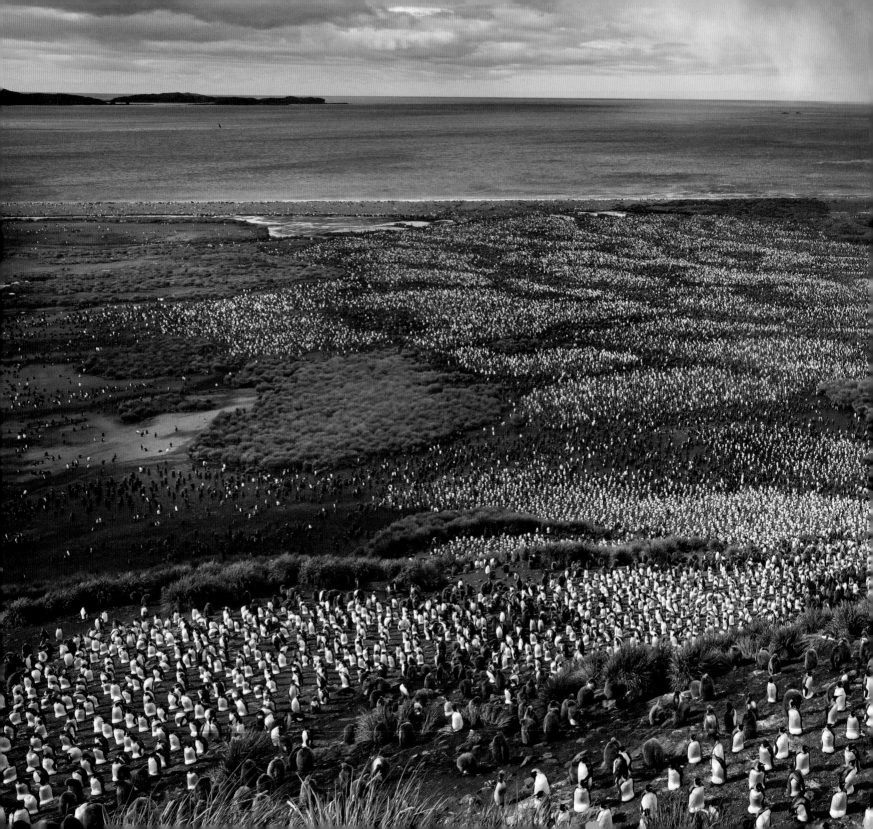

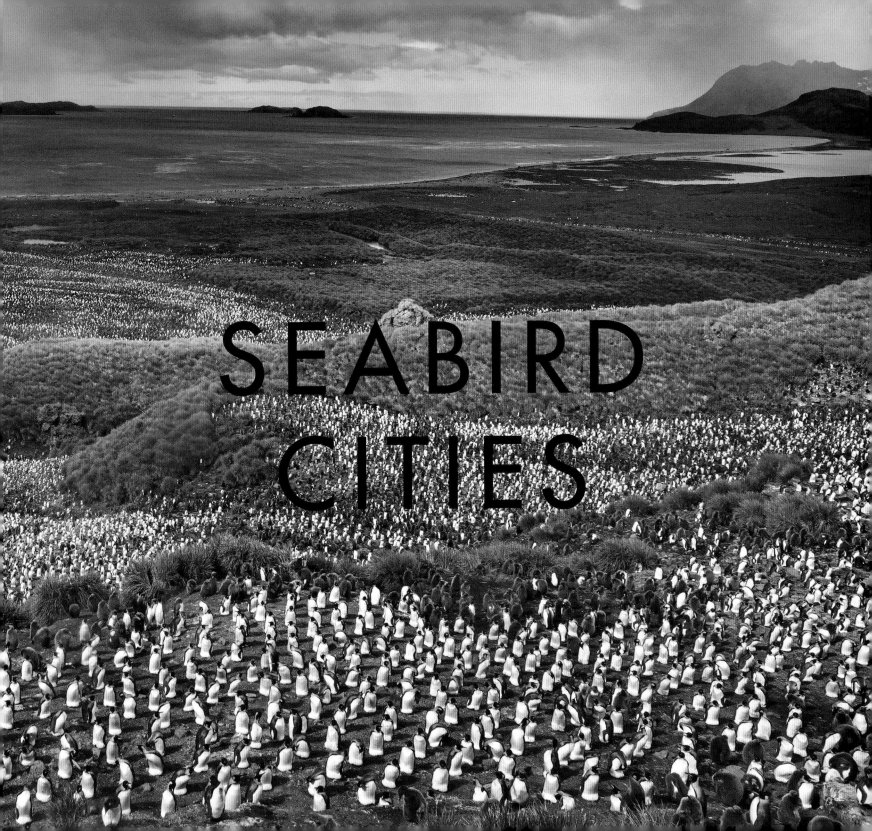

SEABIRD
CITIES

KING PENGUIN

Aptenodytes patagonicus

The sprawling penguin rookery on South Georgia's Salisbury Plain is breathtaking in its scale. Navigating through the waist-high tussock to reach my vantage point to create this image I was assaulted by the strong stench of guano and the sounds of thousands of peeping chicks and trumpeting adults. An estimated 300,000 birds crowd together here in what is surely one of Earth's most spectacular seabird cities.

KING PENGUIN

Aptenodytes patagonicus

Groups of adult King Penguins incubating eggs are interspersed with linear-shaped creches of the brown-coloured young, already a few weeks or months old. King Penguin colonies have permanent occupation owing to a long breeding cycle. It takes in excess of 14 months from laying to fledging, so there are always birds present with peak numbers during the summer months.

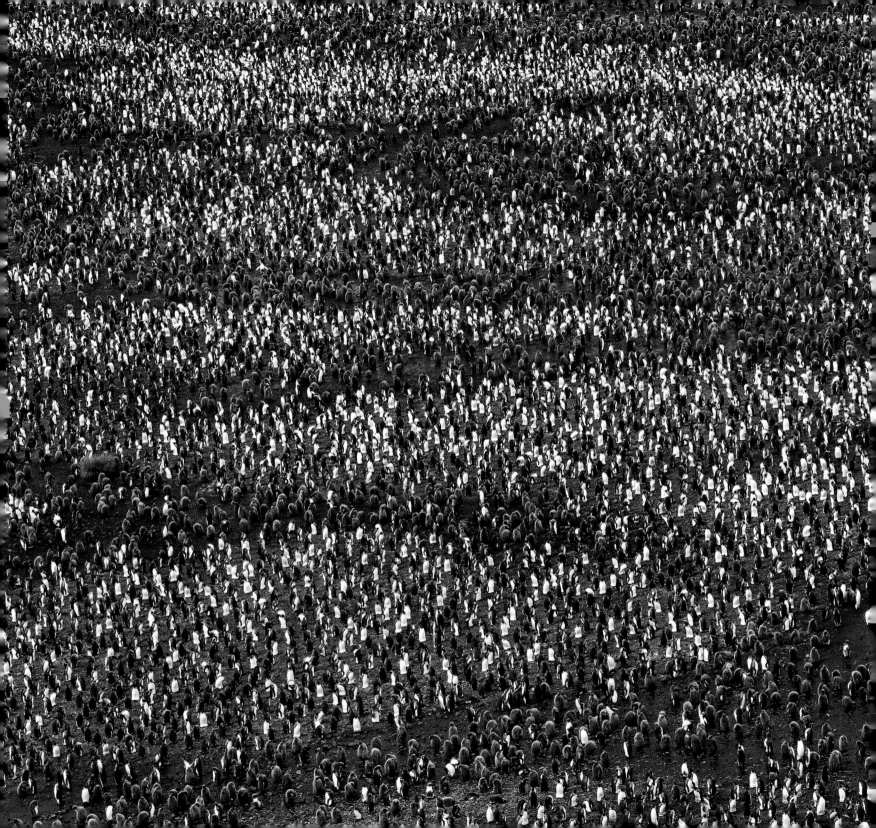

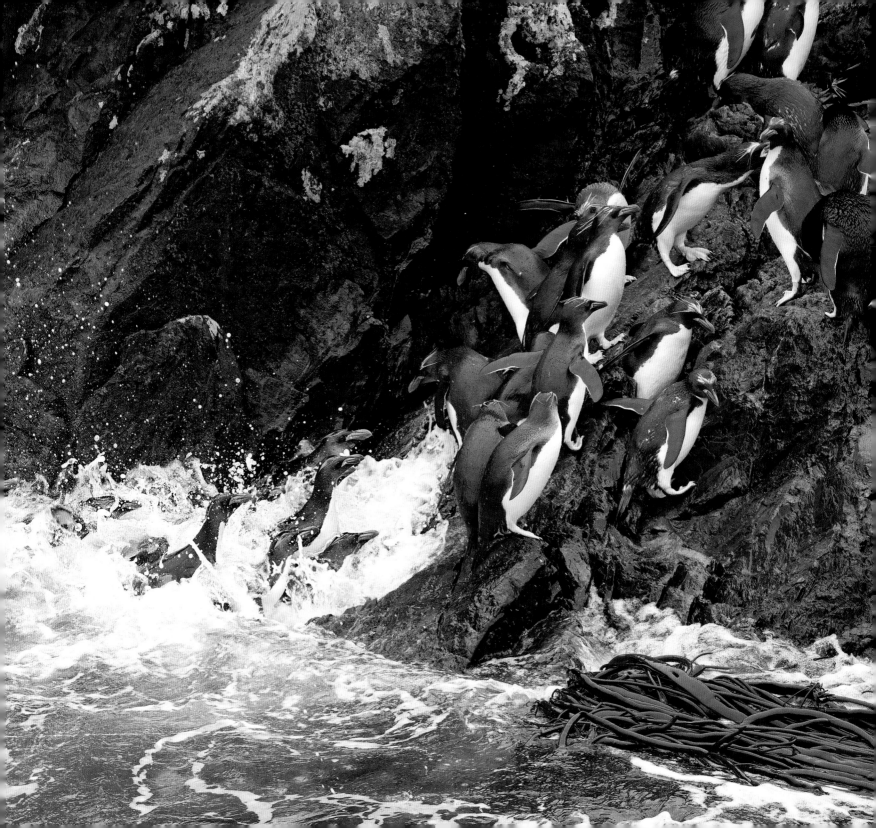

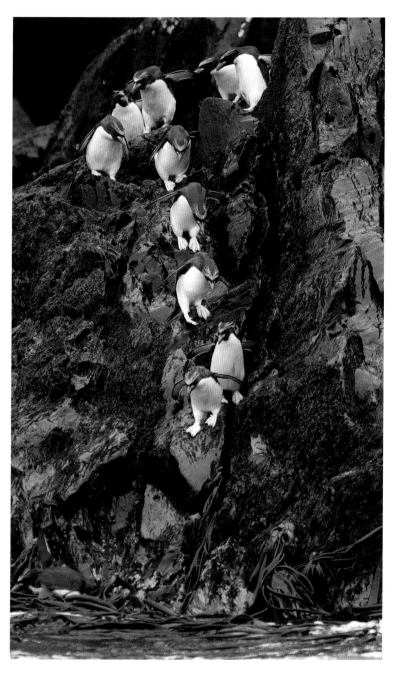

FAR LEFT

MACARONI PENGUIN
Eudyptes chrysolophus

Going down is often the easy bit. These penguins coming ashore need to time their exit from the surf as the swell rises. With bellies full of krill they march back to the colony to feed hungry chicks.

LEFT

MACARONI PENGUIN
Eudyptes chrysolophus

Steady, it's slippery! Macaroni Penguins gingerly edge down a cliff from their colony to the sea. Paths from colony to sea are traditional well-worn routes that may have been walked by penguins for hundreds of years.

OVERLEAF

KING PENGUIN
Aptenodytes patagonicus

By using a long telephoto lens with a very shallow depth of field I focused on one bird within a crowd of incubating adults to convey the very colourful plumage of this species.

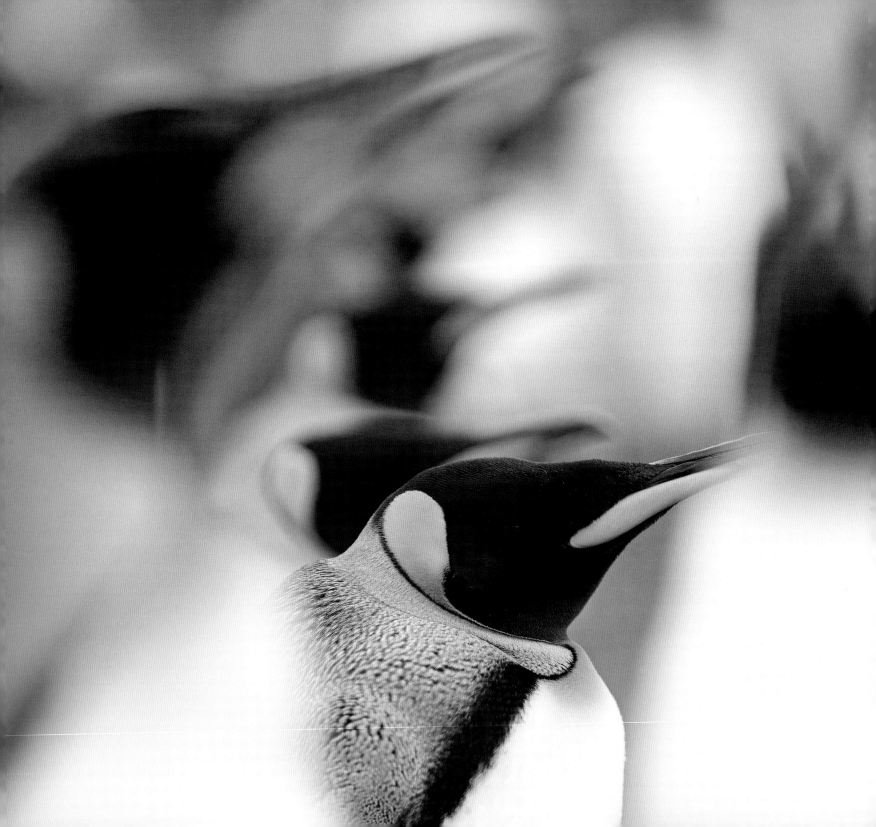

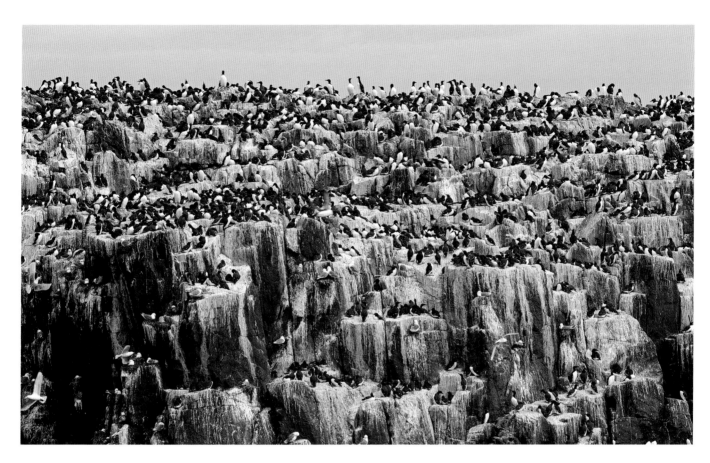

COMMON GUILLEMOT
Uria aalge

With a world population estimated to be 18 million individuals this guillemot, also known as the Common Murre, is one of the northern hemisphere's most abundant seabirds. They nest in large densely packed colonies such as this one on Staple Island within the English Farne Islands. Some cliff ledges can be so jam-packed with birds that the individuals can hardly move.

BRÜNNICH'S GUILLEMOT
Uria lomvia

As the birds swirl around an island in the High Arctic in early spring, snow still covers breeding ledges but they are keen to re-occupy. Egg-laying will not begin until early June, when the females synchronise their breeding to ensure that the young will jump from cliff ledges at roughly the same time. This minimises the losses to predators. This species is also known as Thick-billed Murre.

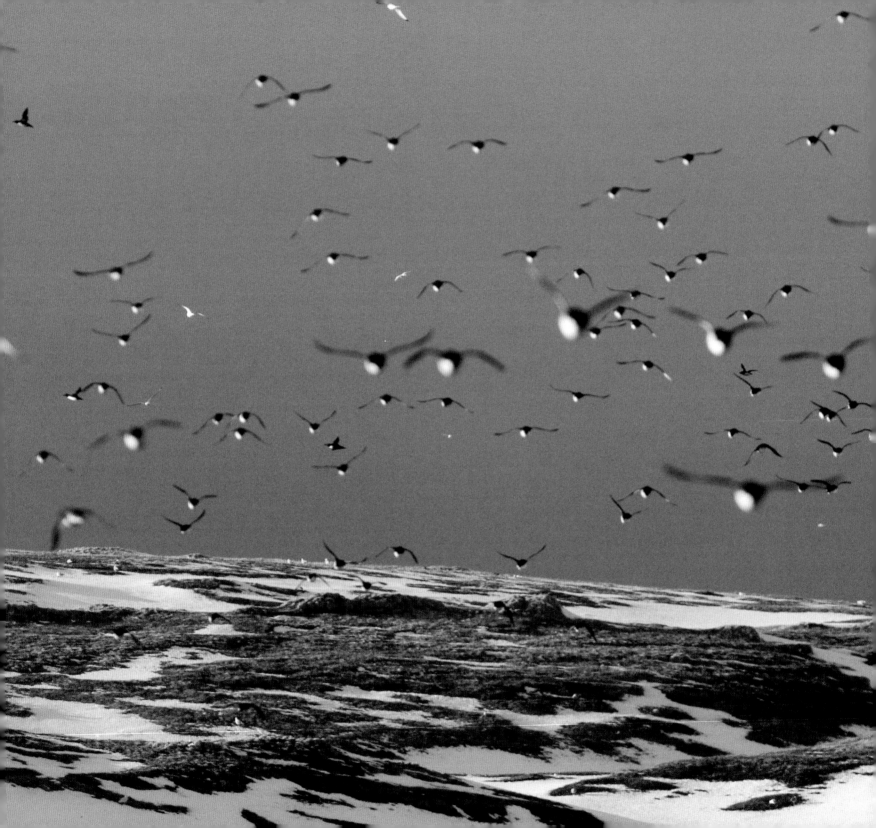

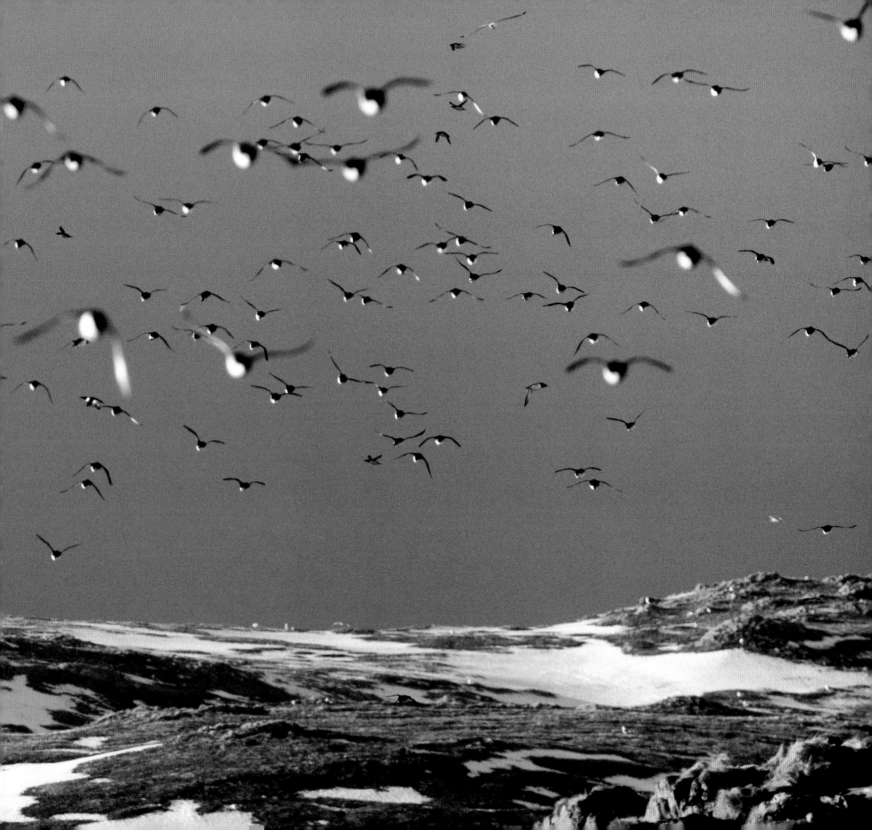

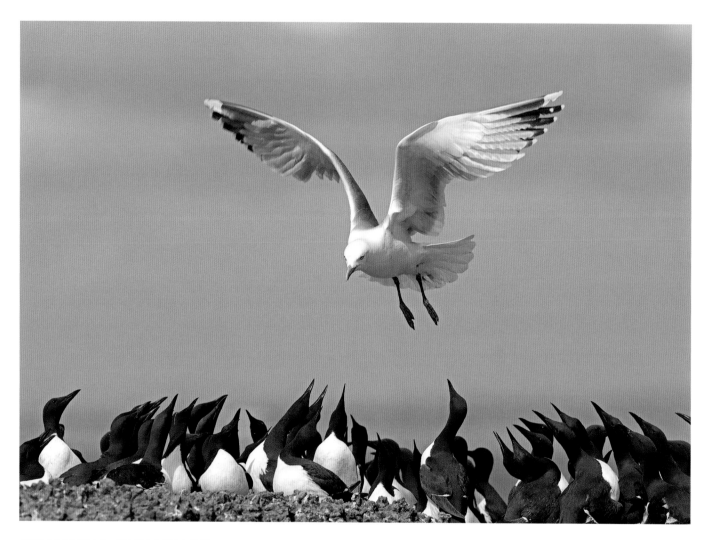

COMMON GUILLEMOT
Uria aalge

Guillemots possess sharp bills and, with breeding colonies often so densely packed, predators such as this European Herring Gull (*Larus argentatus*) can be driven away. However some European colonies have been in steady decline owing to the birds having to fly farther and farther out to sea to find food. The remaining adult incubating or tending small young will desert if they think their partner is not likely to return. Gulls and skuas will then take abandoned eggs and chicks.

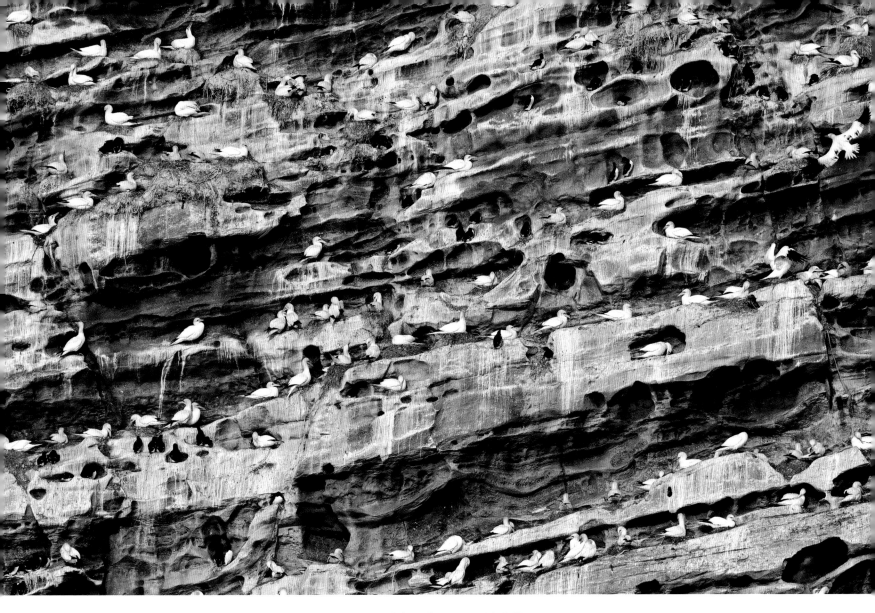

NORTHERN GANNET AND COMMON GUILLEMOT
Morus bassanus and Uria aalge

This Scottish high-rise tenement block on the island of Noss in Shetland is home to 20,000 gannets and 45,000 guillemots. Originally laid down in a desert 400 million years ago, the sandstone cliffs provide parallel ledges and miniature caves – perfect lodgings complete with a sea view.

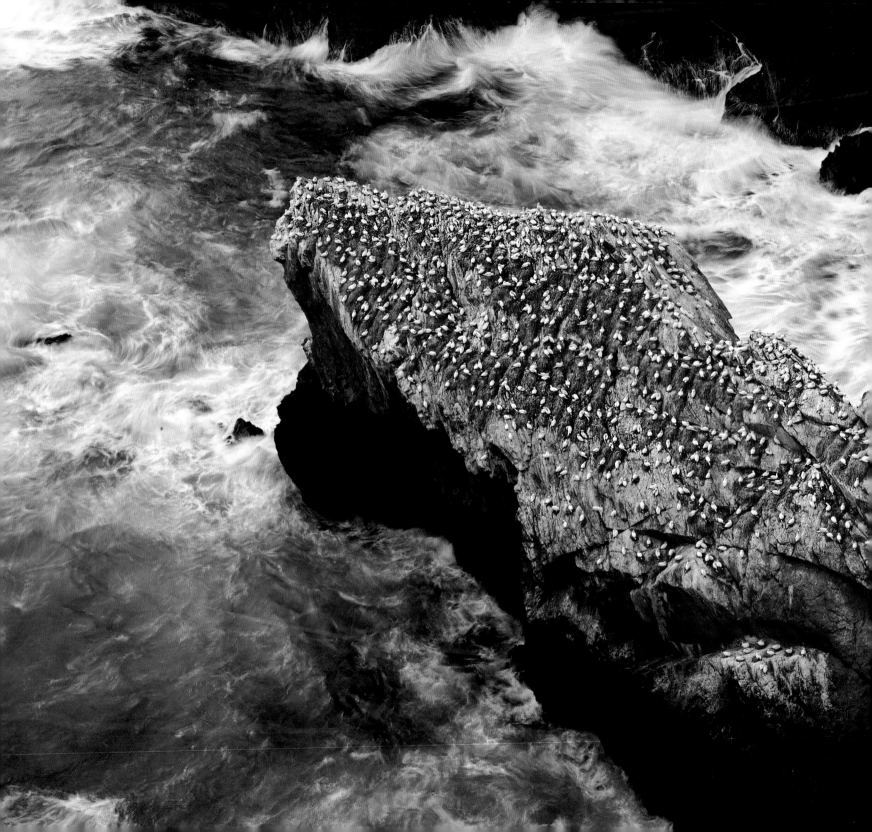

NORTHERN GANNET
Morus bassanus

Hermaness National Nature Reserve lies at Britain's most northerly point at the far tip of the island of Unst. It is a place I know well, having spent the equivalent of well over a year of my life here over the past 35 years. Its remoteness, rugged cliff scenery and spectacular seabird colonies draw me back. Gannets cram on to sea stacks and towering cliffs, making this one of the world's great seabird cities.

OVERLEAF

NORTHERN GANNET
Morus bassanus

A reasonable head for heights was needed to take this image of a gannet colony at Hermaness. I leaned over the top of a cliff to look down on rows of birds quietly incubating eggs or brooding very small chicks.

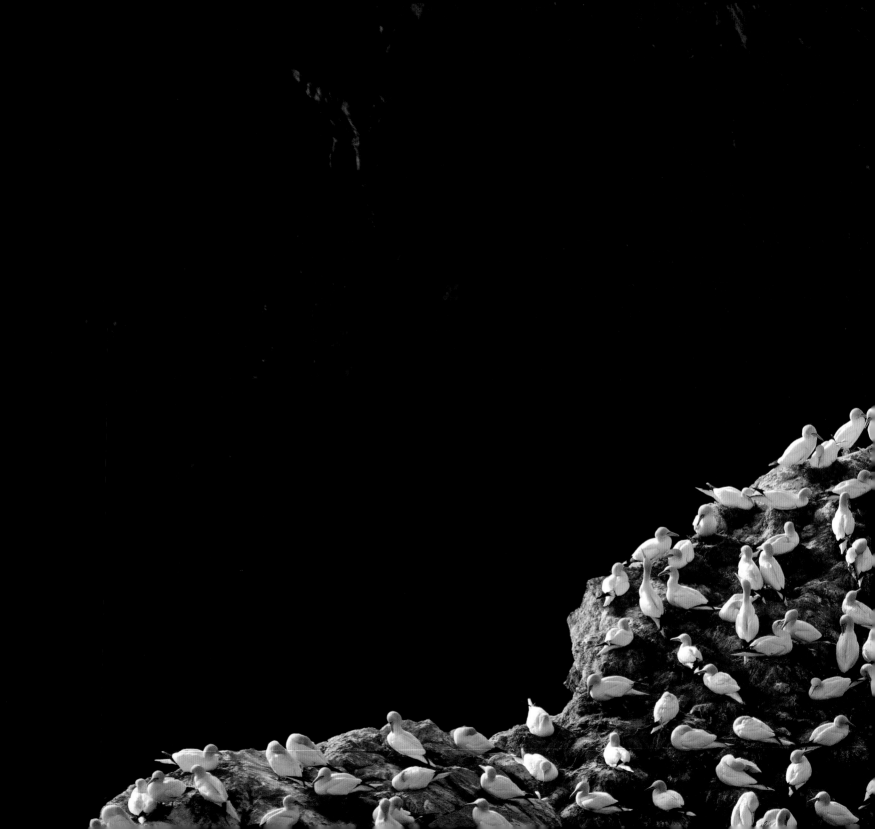

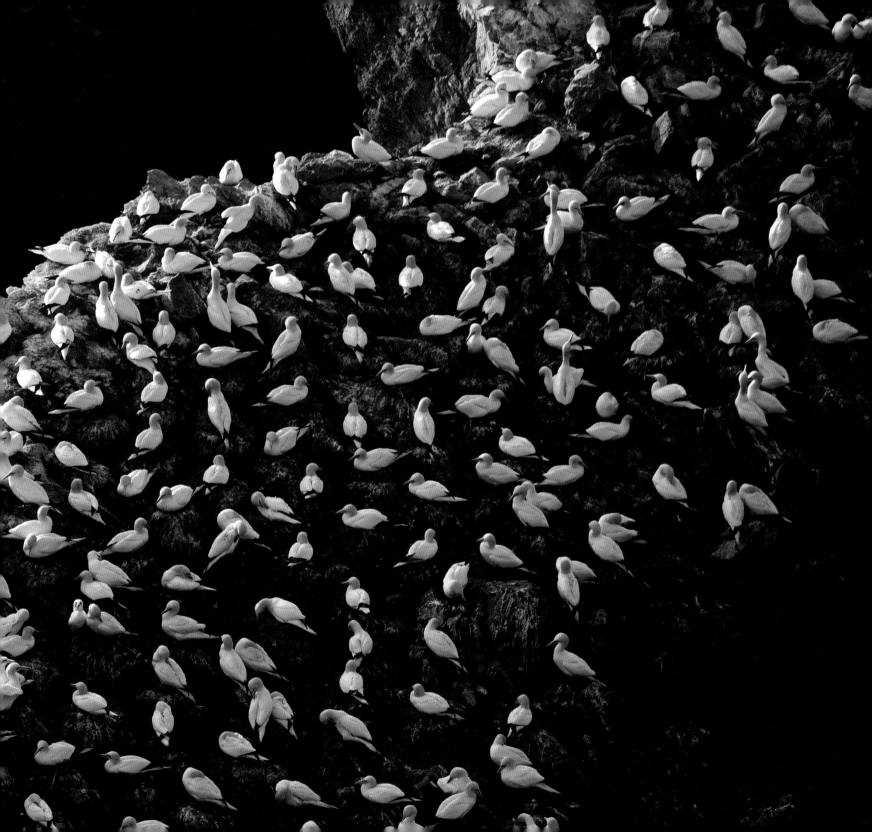

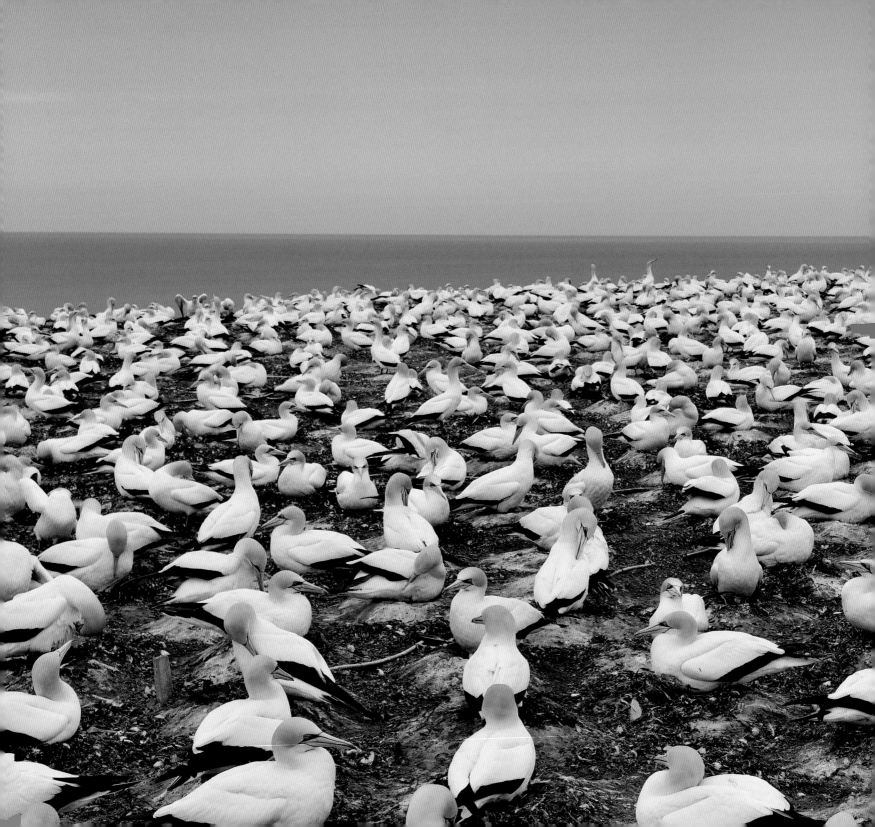

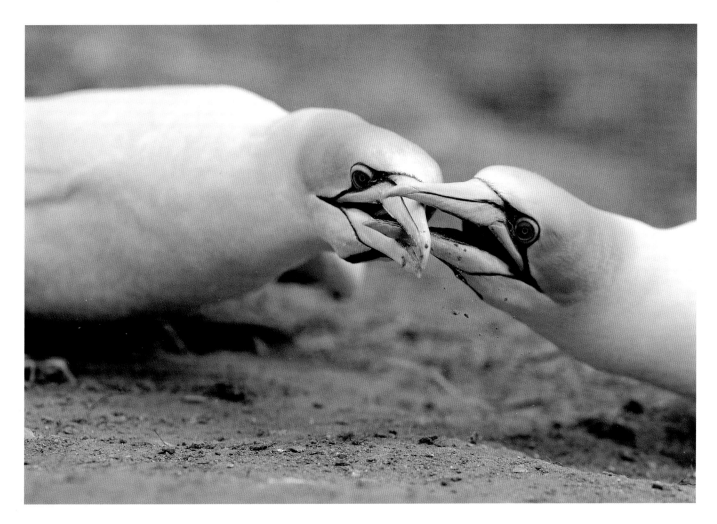

LEFT
LEFT

AUSTRALASIAN GANNET
Morus serrator

Protruding into the Pacific Ocean, the gannetry at Cape Kidnappers on New Zealand's North Island is a photographer's dream. The birds are so used to people visiting that they nest within inches of the public-viewing area.

ABOVE

AUSTRALASIAN GANNET
Morus serrator

Gannets within New Zealand's Cape Kidnappers colony have a neighbourly dispute, interlocking bills in a tugging match.

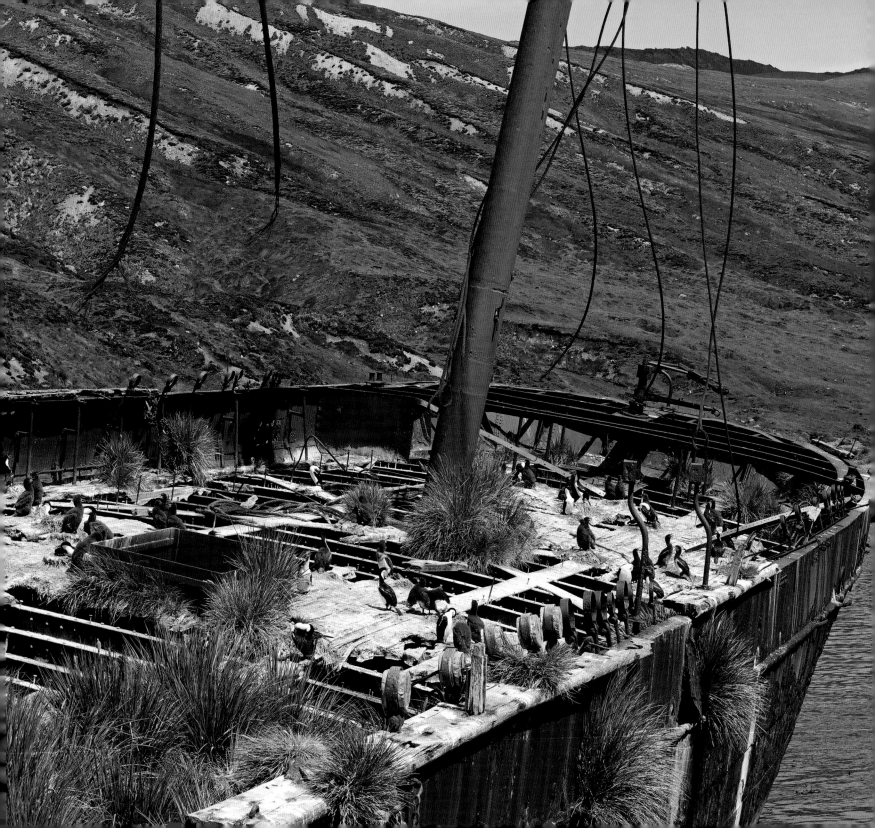

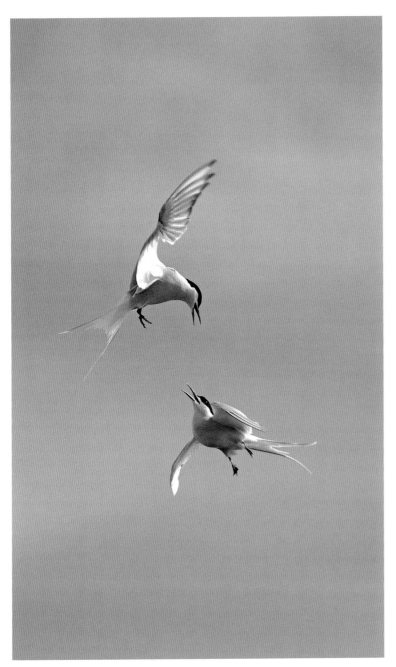

FAR LEFT

SOUTH GEORGIA SHAG
Phalacrocorax georgianus

The *Bayard* once supplied coal to whale stations on South Georgia. Wrecked in Ocean Harbour in 1911, it now hosts a shag colony that nests on its crumbling decks.

LEFT

ARCTIC TERN
Sterna paradisaea

These feisty birds readily engage with each other in aerial combat over their colonies. Males will vigorously defend territories against strangers, particularly early in the breeding season. This species often defends its colonies against predators en masse and is very successful at driving away potential trouble. So much so, that some other species of bird often nest near Arctic Tern colonies to take advantage of this protection.

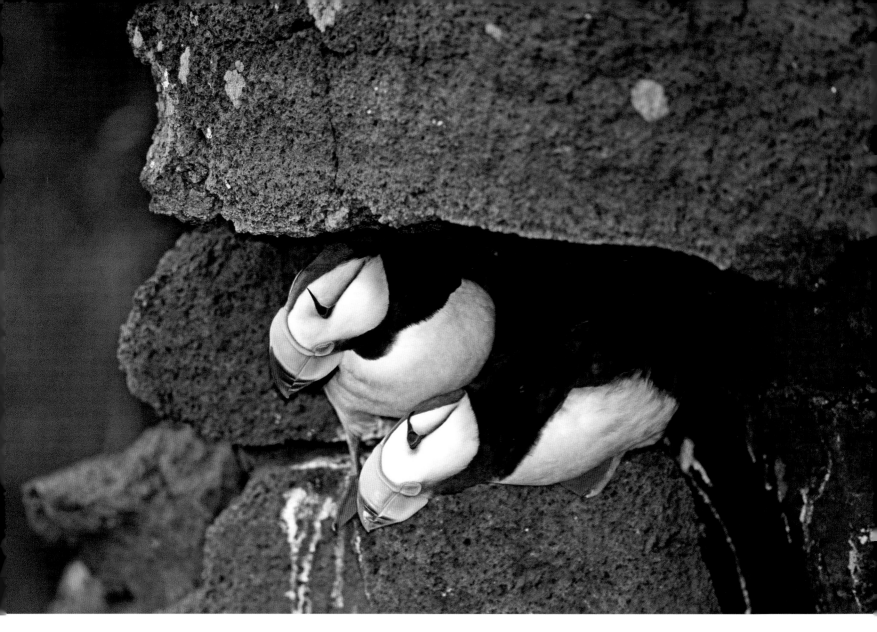

HORNED PUFFIN
Fratercula corniculata

Cliffs on the Pribilof Islands off the coast of Alaska in the Bering Sea swarm with birds in summer, yet some species remain quite hidden while nesting within cracks or crevices in the cliffs. Here a pair of Horned Puffins look out from a secluded cliff-top home on St Paul Island.

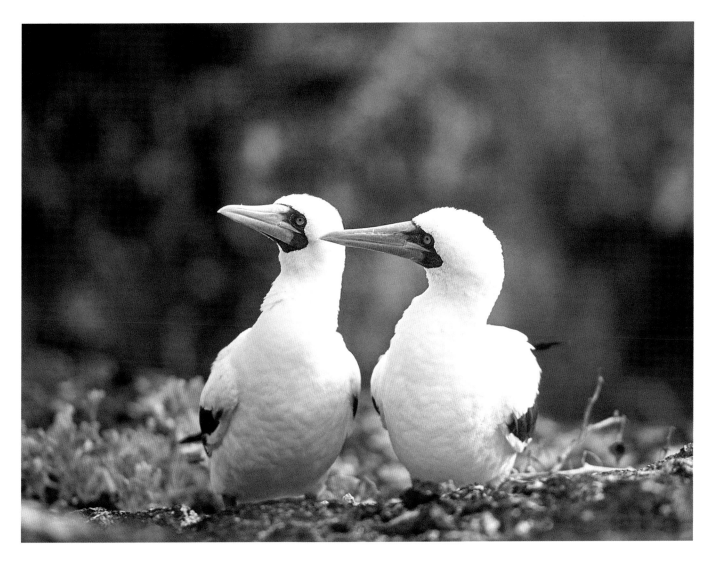

MASKED BOOBY
Sula dactylatra

These boobies possess a slightly comical look in breeding plumage. This pair was photographed on Tower Island in the Galápagos Islands.

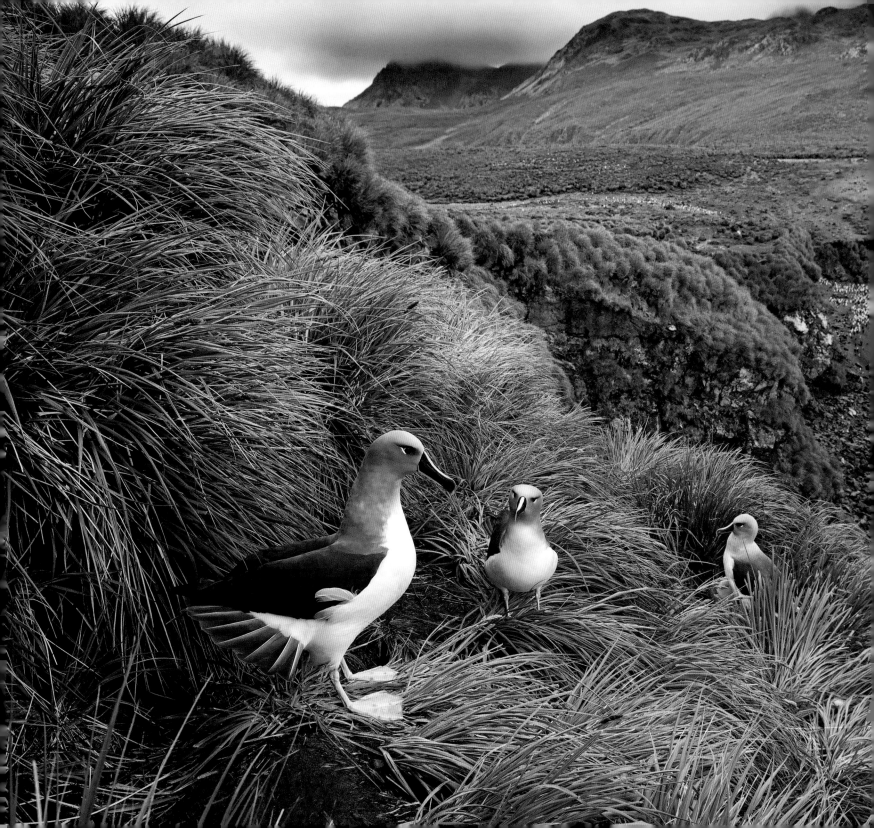

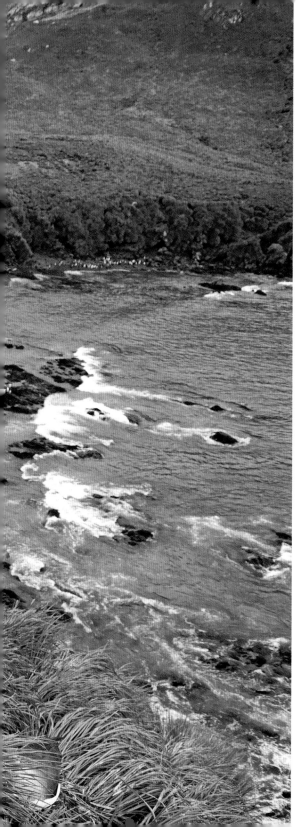

GREY-HEADED ALBATROSS
Thalassarche chrysostoma

This Grey-headed Albatross colony on South Georgia looks relatively easy to access from the image. However it was located on a deceptively steep area of cliff, covered in deep tussock, above which were hundreds of fur seals all too keen to lunge forward and give me a passing bite. So it was with great triumph that I managed to reach the site, take some images and retreat in one piece.

OVERLEAF

BLACK-BROWED ALBATROSS
Thalassarche melanophris

The largest colony of this species nests on Steeple Jason Island in the Falklands. 183,000 pairs were counted during an aerial survey in 2010. If you see it from the ground it is hard not to be rooted to the spot in wonderment at the sheer density of birds. This image, shot with a 10mm fisheye lens, was taken after spending several hours gaining the trust of these birds and slowly edging forward.

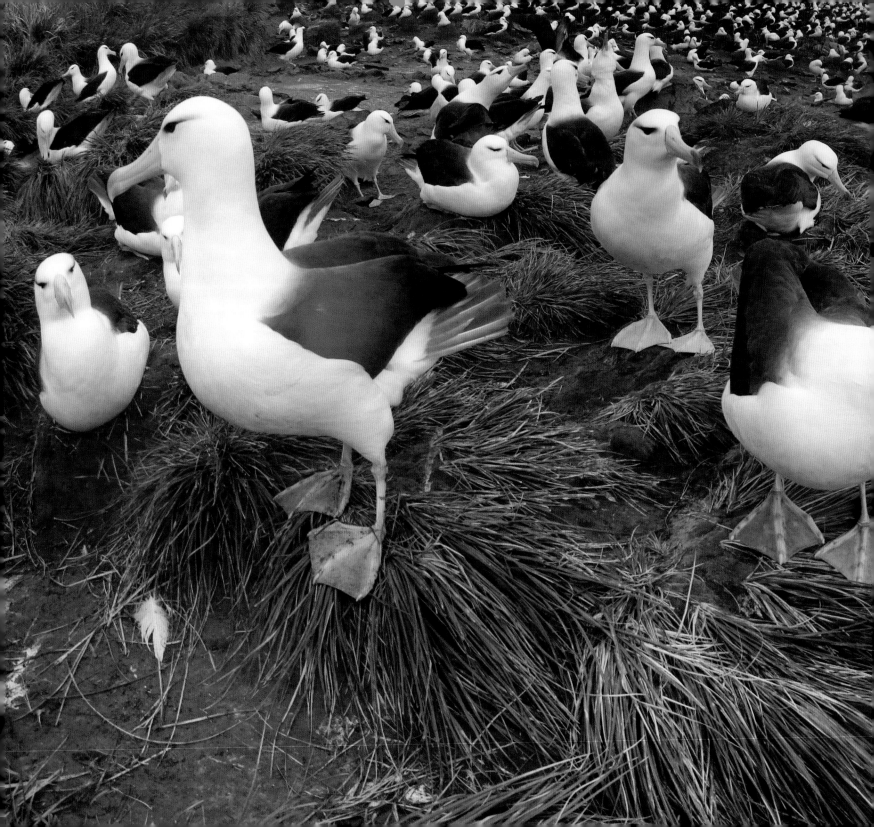

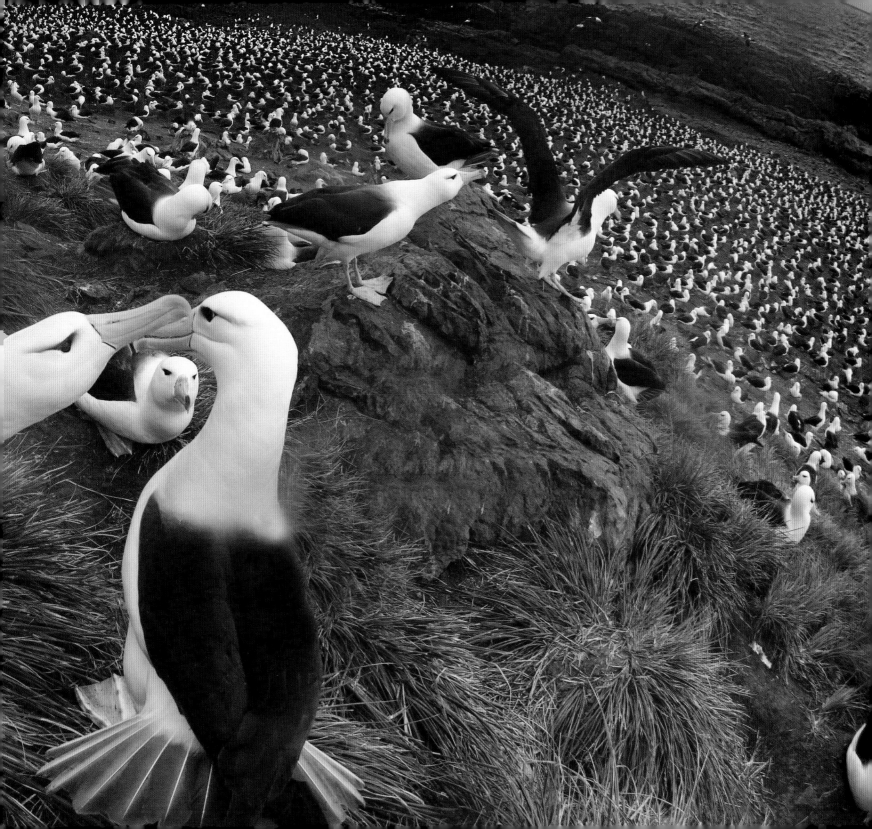

RIGHT
BLACK-LEGGED KITTIWAKE
Rissa tridactyla

These small gulls will readily set up their breeding colonies within our towns and cities. These birds were nesting on specially provided ledges fixed to the side of a building in the town of Vado on the shores of Varanger Fjord in Arctic Norway.

OVERLEAF
BLACK-LEGGED KITTIWAKE
Rissa tridactyla

This kittiwake is nesting in a loose colony on the banks of the River Tyne in the heart of Newcastle city centre, England. Locals go about their daily lives oblivious of this high-rise avian population nesting on the bridges and buildings above them.

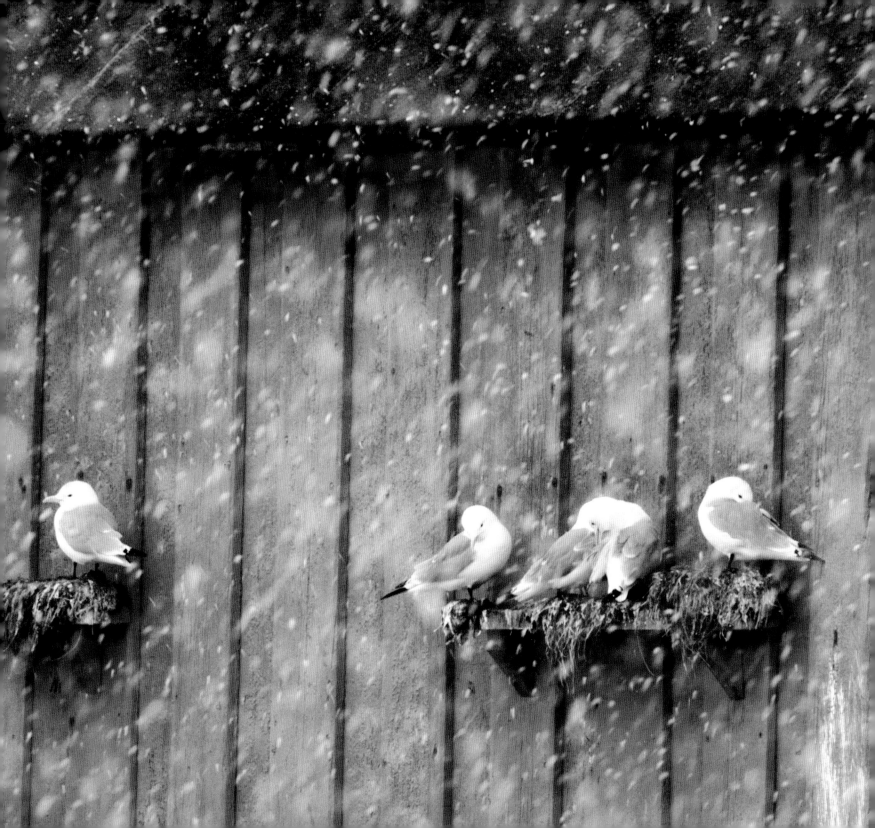

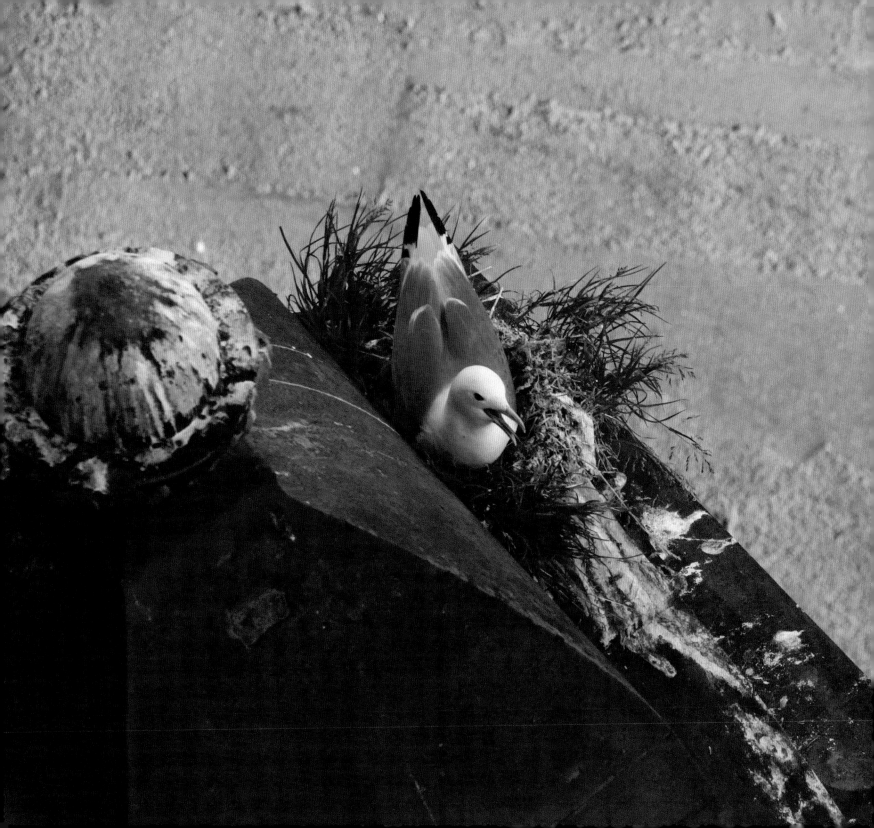

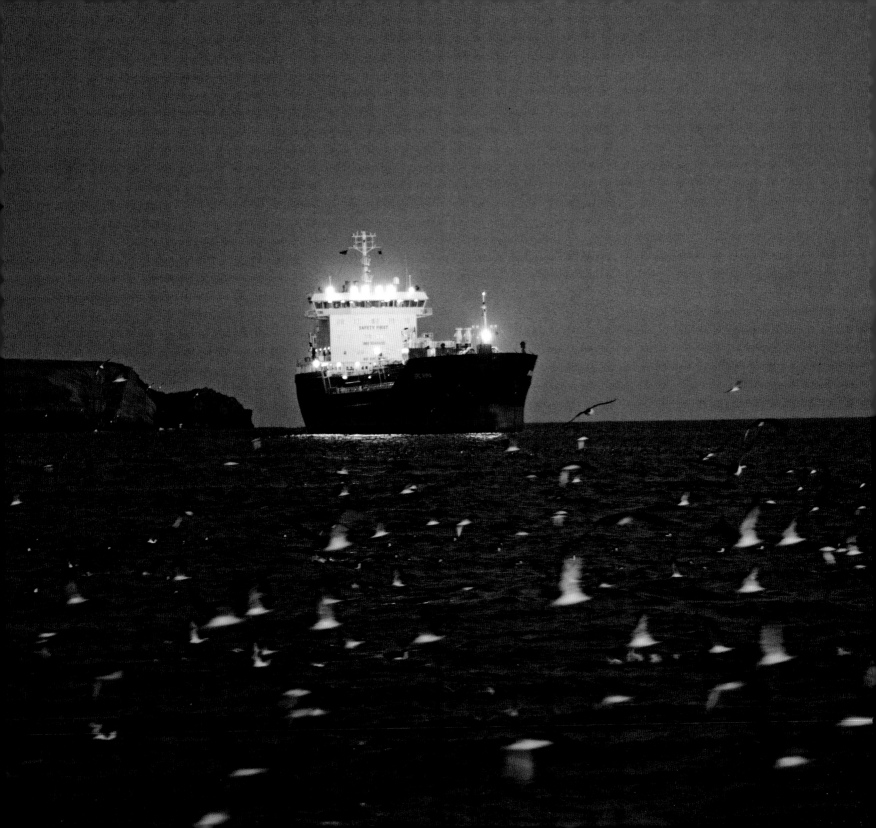

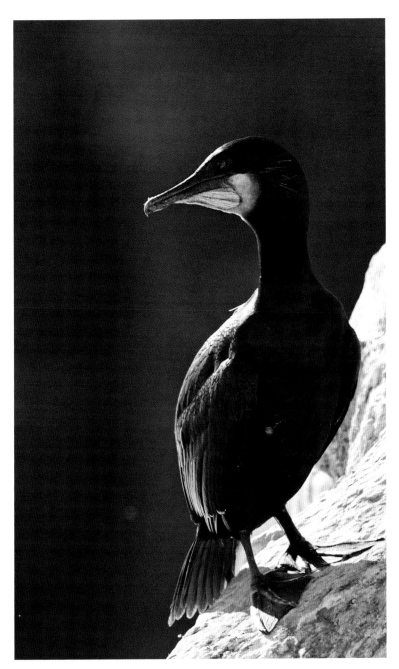

FAR LEFT
MANX SHEARWATER
Puffinus puffinus

Vulnerable to attack by predators when visiting their nesting burrows, Manx Shearwaters come ashore under cover of darkness, as do most other species of shearwater and petrel. This picture was taken off the Welsh island of Skomer just as it was getting dark. Vast rafts of shearwaters had gathered and were excitedly taking off and wheeling around the island waiting for nightfall.

LEFT
BRANDT'S CORMORANT
Phalacrocorax penicillatus

This bird was photographed at its breeding cliff close to San Diego in California. This species is restricted to the west coast of North America and breeds as far south as Mexico.

OVERLEAF
BLACK-LEGGED KITTIWAKE
Rissa tridactyla

An Arctic cliff-face teems with kittiwakes excitedly returning to their ledges after a winter at sea. The species is an abundant breeder in both the North Atlantic and the North Pacific. Their breeding haunts are characterised by their relentless 'kitt-i-wake' calls, which are so redolent of many seabird colonies in the northern hemisphere.

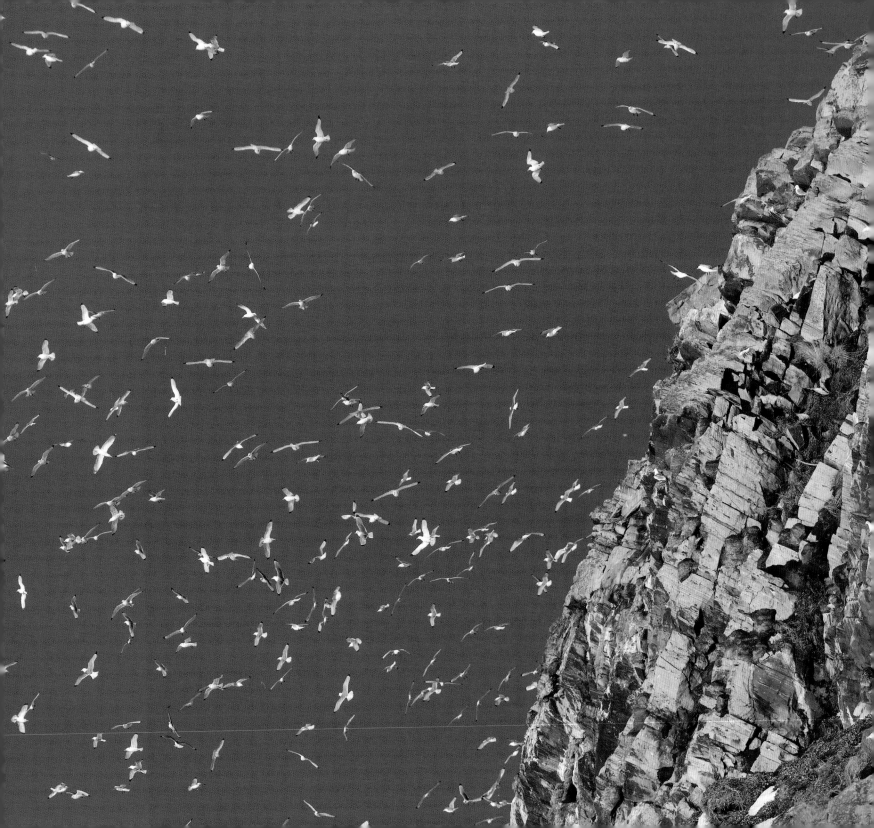

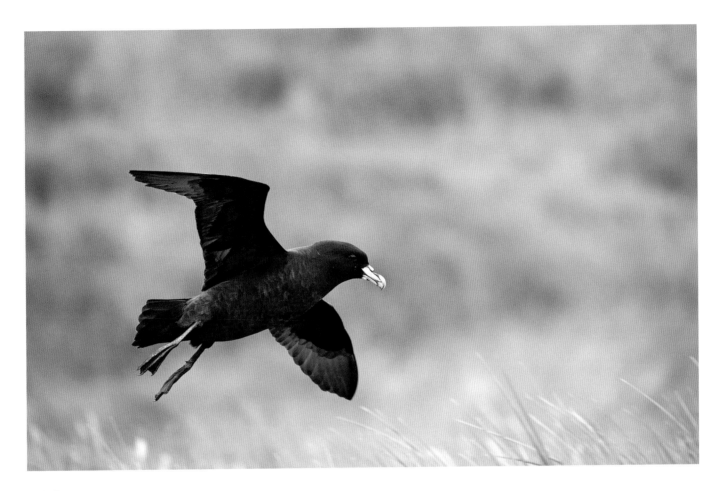

WHITE-CHINNED PETREL
Procellaria aequinoctialis

Cave Cove in South Georgia's King Haakon Bay is frequently visited by tourists, who come to see where Shackleton and his men made their first landfall after an epic sea journey in their boat, the *James Caird*. Few of those visitors are perhaps aware of the vast seabird colony hidden among the tussock on the slopes above the cove. A labyrinth of burrows belongs to White-chinned Petrels, which come ashore usually at night. Some can arrive during daylight and on a wet and windy afternoon in mid-January I sat among the tussock photographing petrels that screamed through the air low over the tussock, before landing and scurrying at speed into the sanctuary of their burrows. Some two million pairs nest on South Georgia.

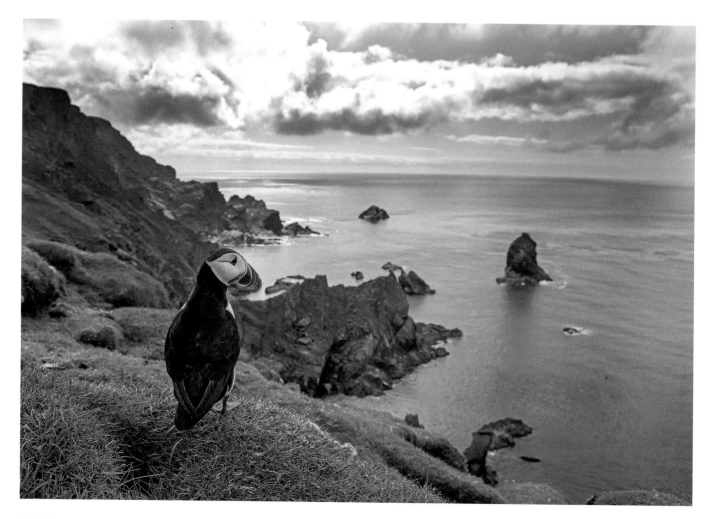

ABOVE
ATLANTIC PUFFIN
Fratercula arctica

Given an opportunity I will always attempt to show birds within the landscapes that they inhabit. Puffins are the classic models for this. Their amenable nature and spectacular surroundings make them the perfect subjects.

RIGHT
RAZORBILL
Alca torda

I used a 300mm lens at its widest aperture of f2.8 to give a very shallow depth of field for this image of a Razorbill. By compressing the picture in this way the Sea Pinks in front of the bird are turned into a pleasing out of focus wash.

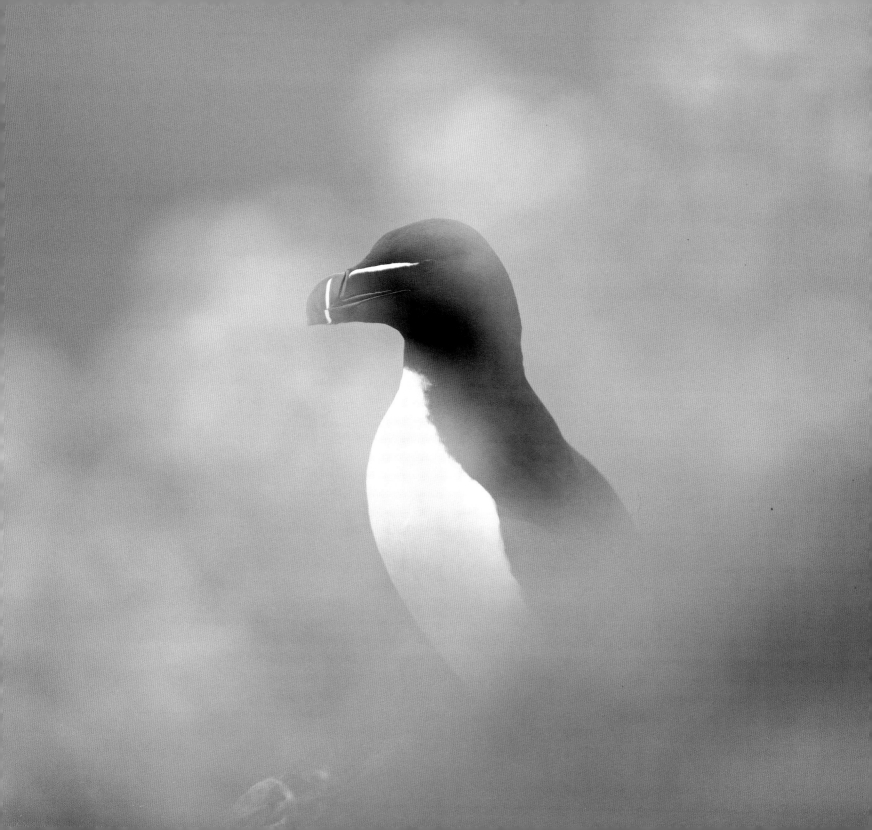

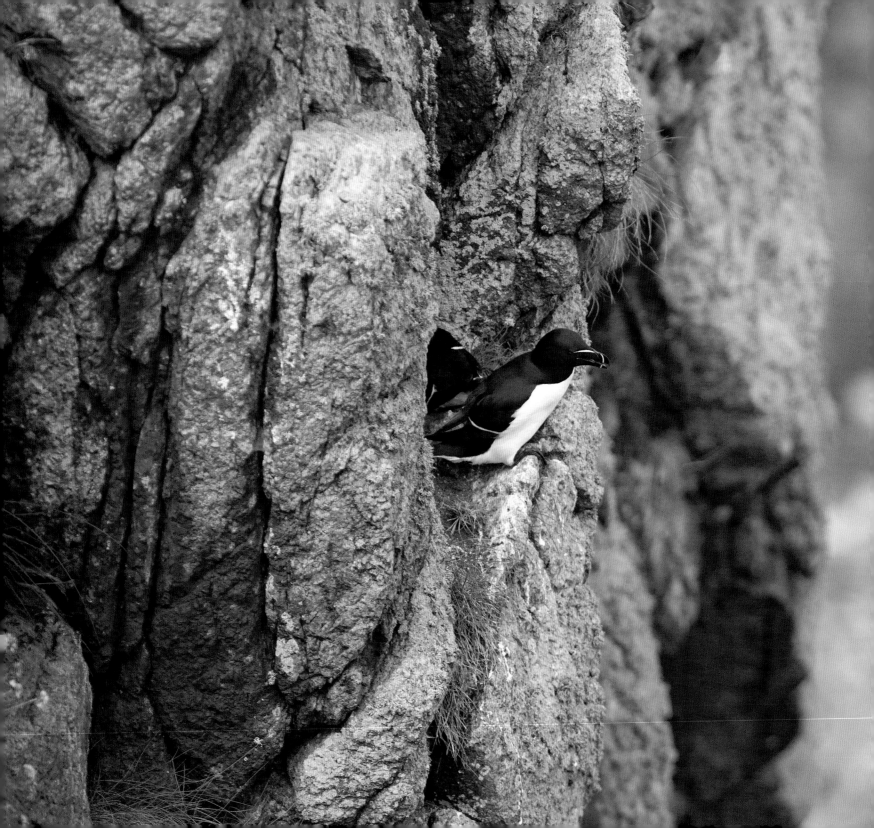

SURVIVAL

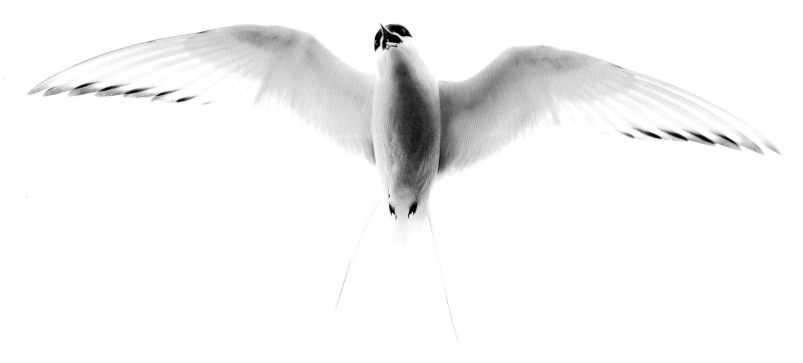

ABOVE
ARCTIC TERN
Sterna paradisaea

No other creature on Earth migrates as far as the Arctic Tern. Recent research has shown that terns nesting in the Netherlands and wintering in Antarctica make an astonishing 90,000km (56,000 mile) round trip. Some of these birds, after migrating south down the African coast, take a meandering route. They head for Australia, skirting the coast before heading to Antarctica.

PREVIOUS PAGES Razorbill (*Alca torda*) peering out from its cliff ledge above the North Sea.

RIGHT AND OVERLEAF
EUROPEAN HERRING GULL
Larus argentatus

While most seabirds live at sea outside their breeding seasons, some gulls move inland to take advantage of feeding opportunities created by human activity. This includes scavenging on landfill sites for food scraps, as with these European Herring Gulls, or the Black-headed Gulls (*Chroicocephalus ridibundus*) following the plough to feast on invertebrates exposed in the soil.

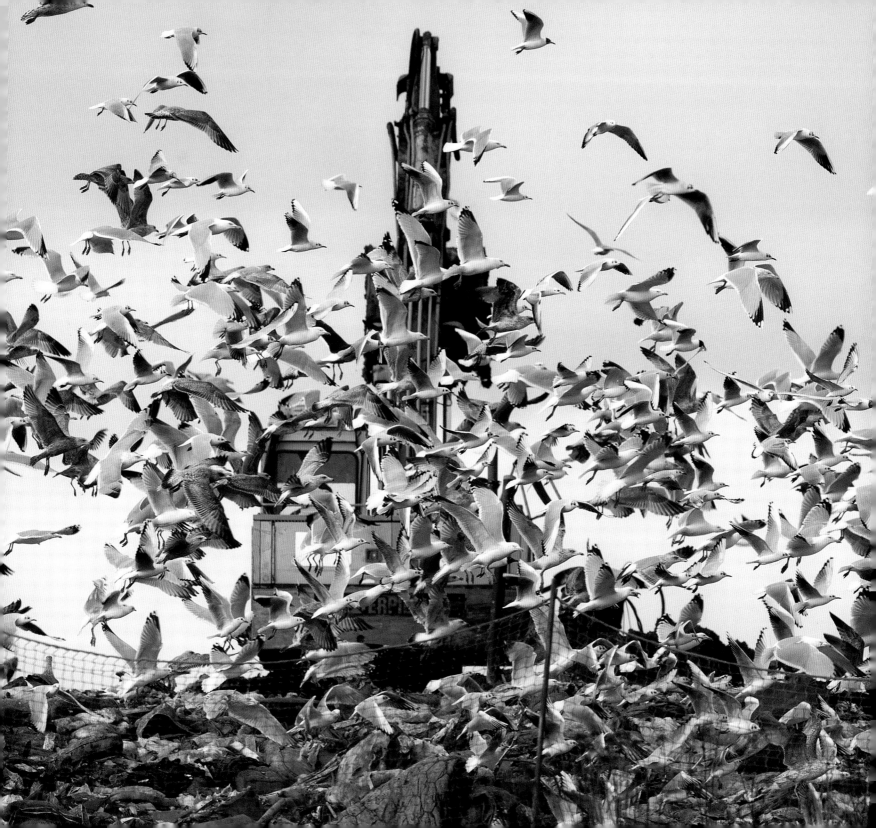

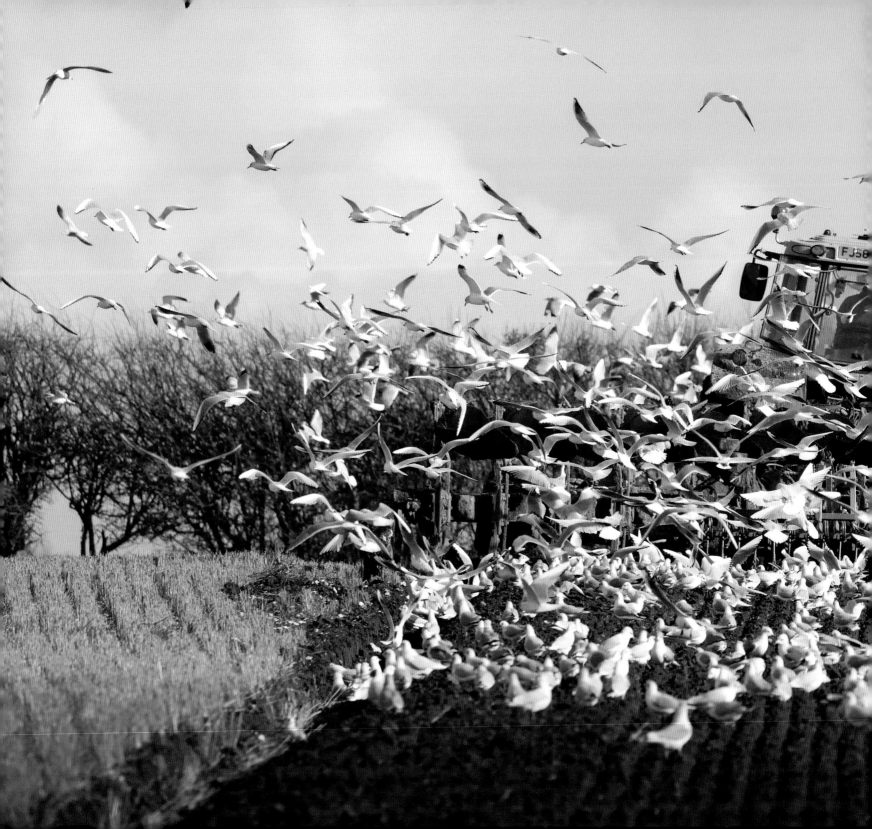

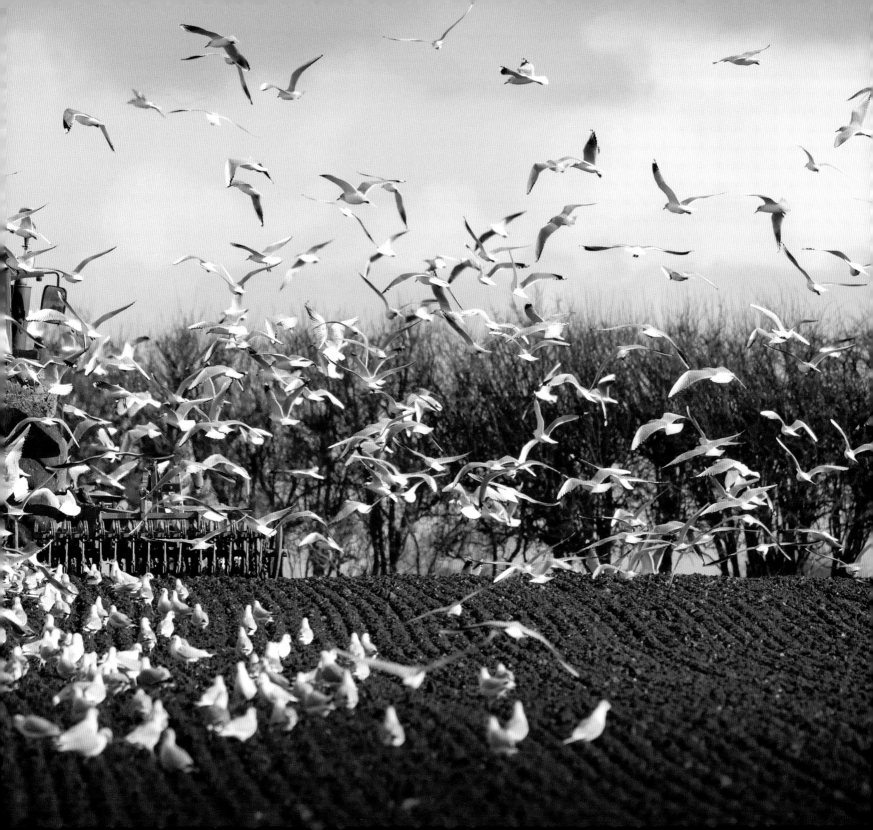

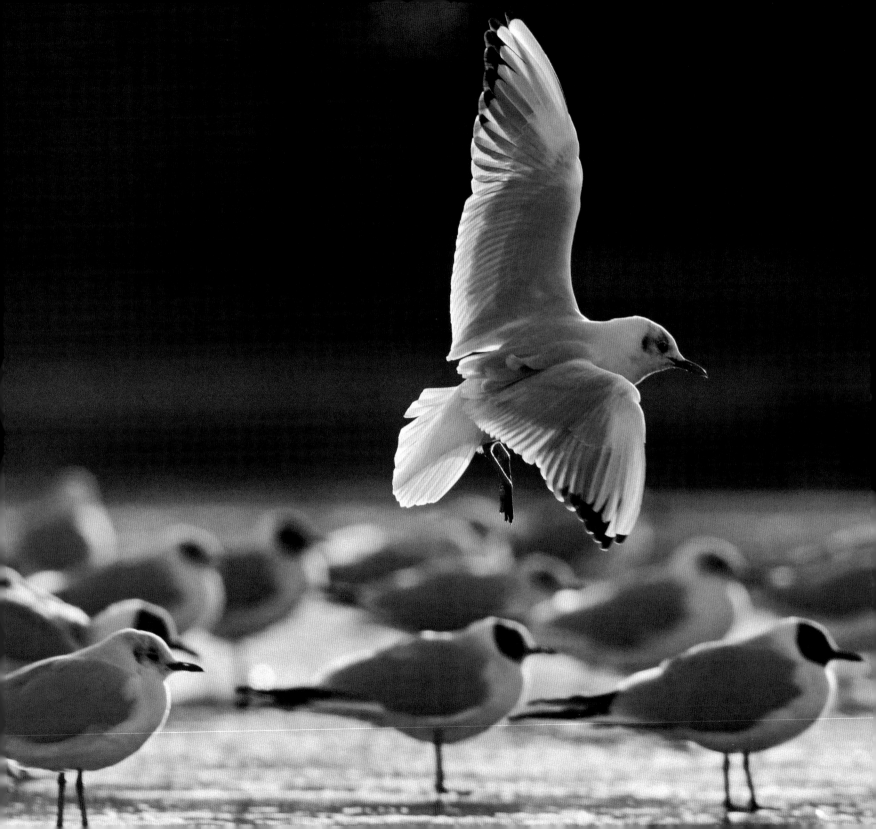

BLACK-HEADED GULL
Chroicocephalus ridibundus

Winter in the northern hemisphere can be a tough environment for gulls that typically do not migrate too far and rely on local food sources. Freezing temperatures can make it hard for them to forage and overnight roosts can freeze solid, as it has here for these Black-headed Gulls.

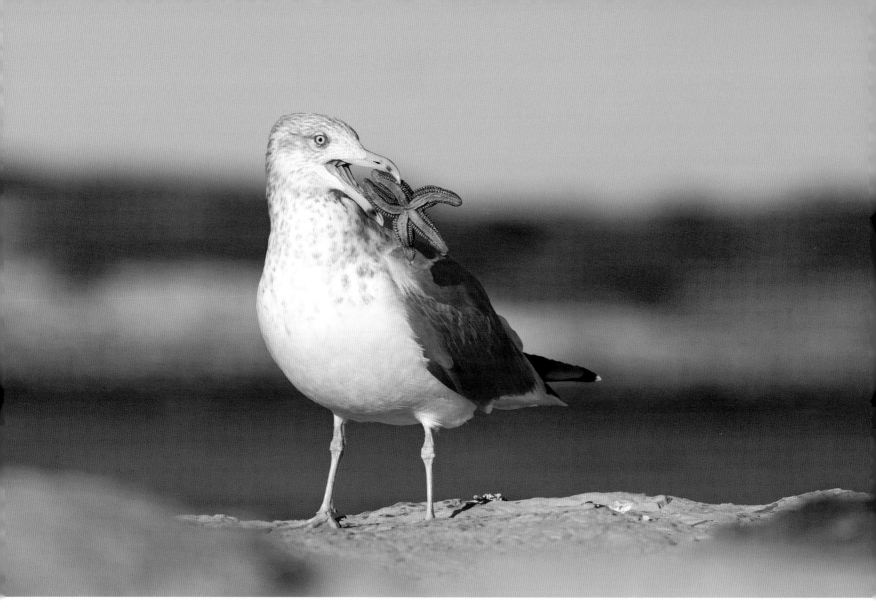

AMERICAN HERRING GULL
Larus smithsonianus

An American Herring Gull tackles a starfish washed up on the shore at Cape May in New Jersey. Gull taxonomy is a complicated affair and this gull is classified by the American Birding Association (ABA) as a subspecies of *Larus* *argentatus*. However, many other authorities now regard American Herring Gull as a separate species. One thing is for sure – there will continue to be much debate over gull taxonomy for a long time to come.

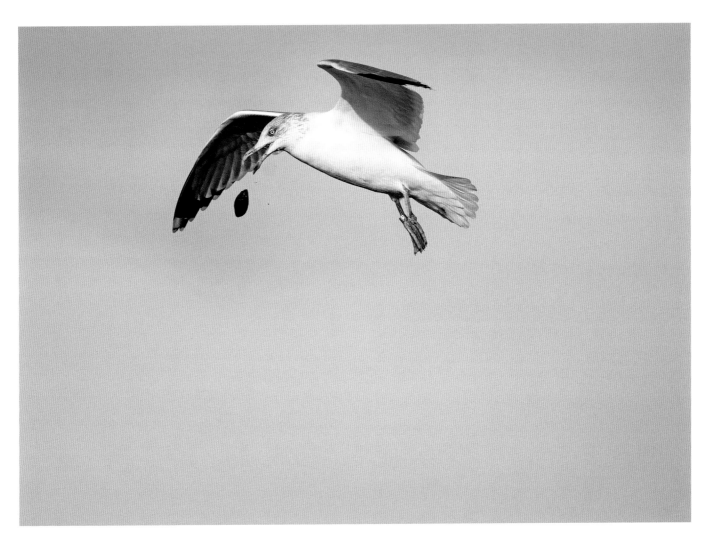

EUROPEAN HERRING GULL

Larus argentatus

This gull has learnt to scavenge from mussel fishermen in
Norfolk, UK. To get at the soft shellfish within the birds have
learnt to drop the mussels from a great height on to the
boat slipway.

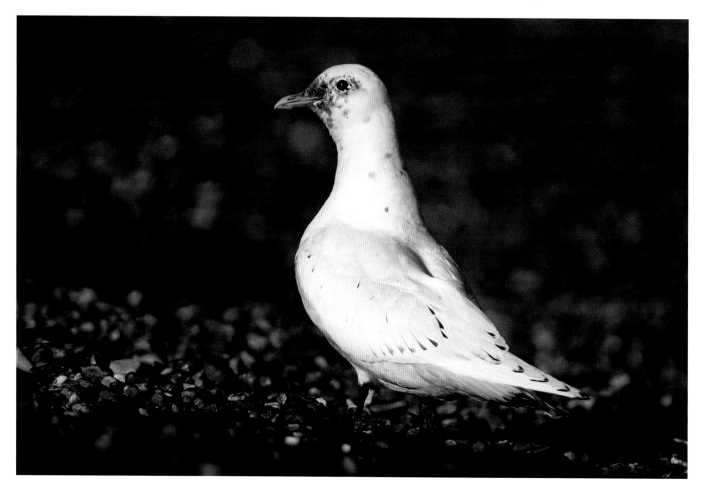

IVORY GULL

Pagophila eburnea

For birdwatchers few species get the pulse racing quite like an Ivory Gull. The bird breeds only in the High Arctic, where the total world population is thought to be less than 13,000 pairs and declining. Occasionally individuals venture far south of their normal wintering areas, which are close to the edge of the pack ice. It is especially true of juveniles, which become a big attraction when they are discovered feeding on whale or seal carcasses. These solitary wanderers are the only way that many birders ever get to encounter this Arctic beauty.

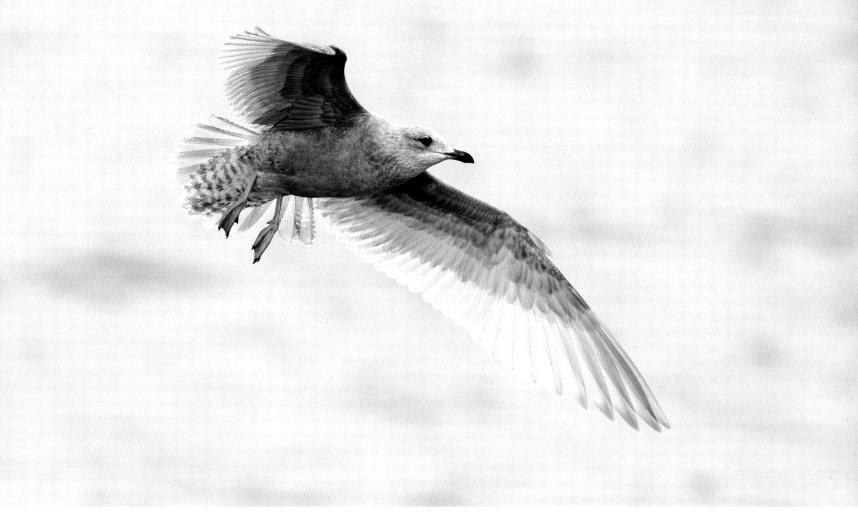

KUMLIEN'S GULL
Larus glaucoides kumlieni

Newly fledged young gulls may wander vast distances during winter and sometimes turn up where they are least expected. This Kumlien's Gull, which would have been born in Arctic Canada, spent the winter of 2012 in Ardglass Harbour, Northern Ireland. Identifying Kumlien's Gulls, however, can be tricky. It is very similar to the Iceland Gull (*Larus glaucoides glaucoides*) and most authorities believe that Kumlien's is only a subspecies of that bird. Others suggest that Kumlien's may be a hybrid population derived from Iceland and Thayer's Gull (*Larus thayeri*) parents. Whatever their origins, they have a subtle beauty.

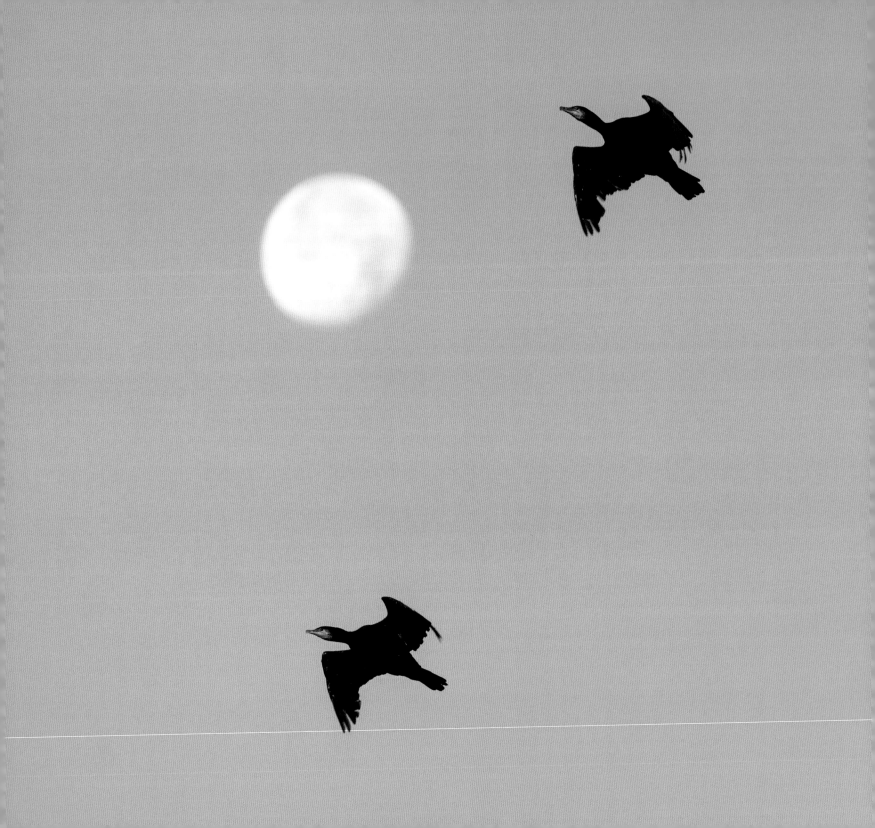

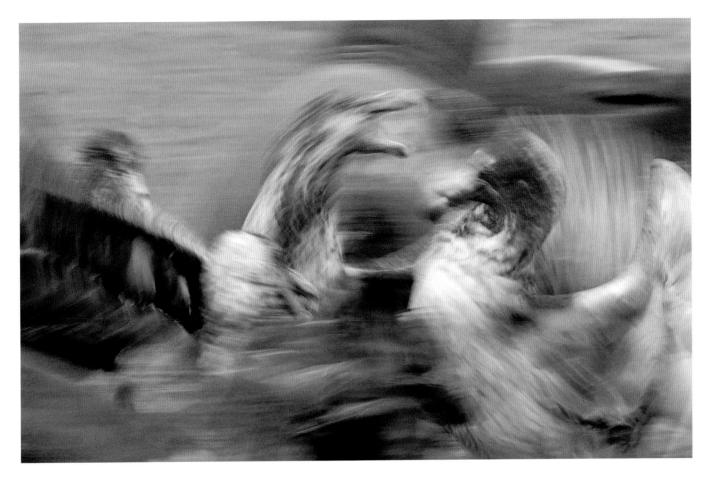

GREAT CORMORANT
Phalacrocorax carbo

Great Cormorants are relatively sedentary, with most tending not to travel too far from their place of birth. Some nest and winter inland on lakes and reservoirs. In the UK this equates to around 15 per cent of the breeding population. In winter local birds are joined by immigrants from the continent escaping the usually harsher conditions.

SOUTHERN GIANT PETREL
Macronectes giganteus

A pack of bloodied giant petrels fight over a seal carcass. When photographing action I often try to convey a sense of movement in my subject, so here I have purposely chosen a slow shutter speed to blur the action and create a more painterly effect.

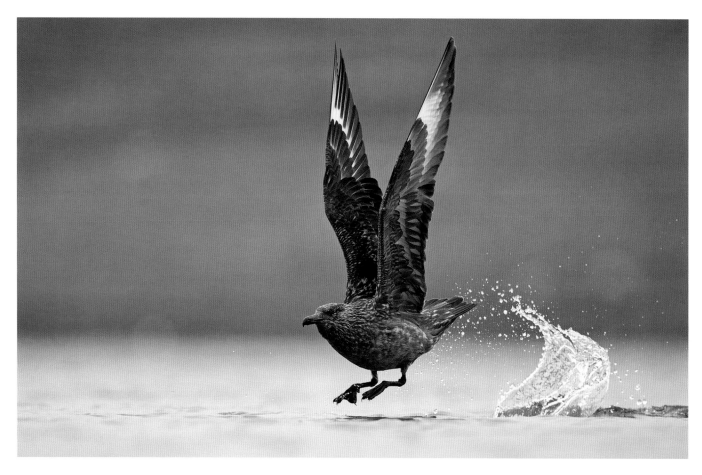

ABOVE

GREAT SKUA
Stercorarius skua

This species, which is known as the 'bonxie' in the UK's Shetland Islands, regularly visits fresh water to bathe during the breeding season. There can be a constant stream of birds arriving and departing at favoured lochs, often accompanied by a lot of social interaction.

RIGHT

SNOW PETREL
Pagodroma nivea

Strikingly white Snow Petrels can often be encountered north of the Antarctic pack ice feeding around icebergs. This bird was one of a dozen or so cruising with barely a flap of the wings along a giant tabular iceberg, frequently making agile turns and sometimes dropping to the churning ocean to pluck a morsel from the waves.

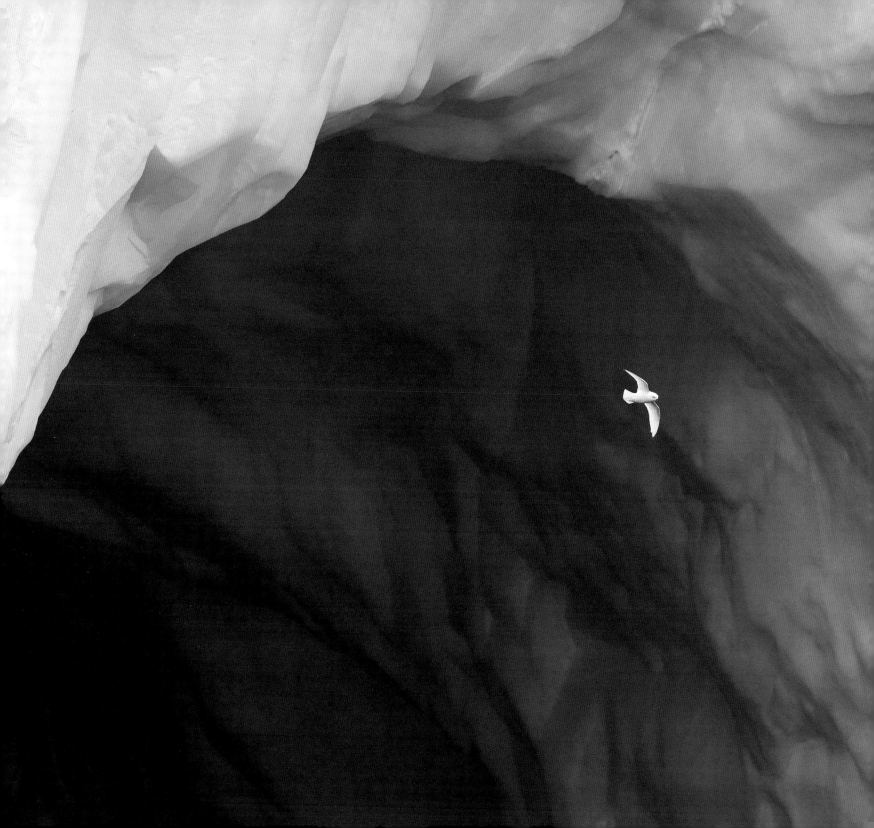

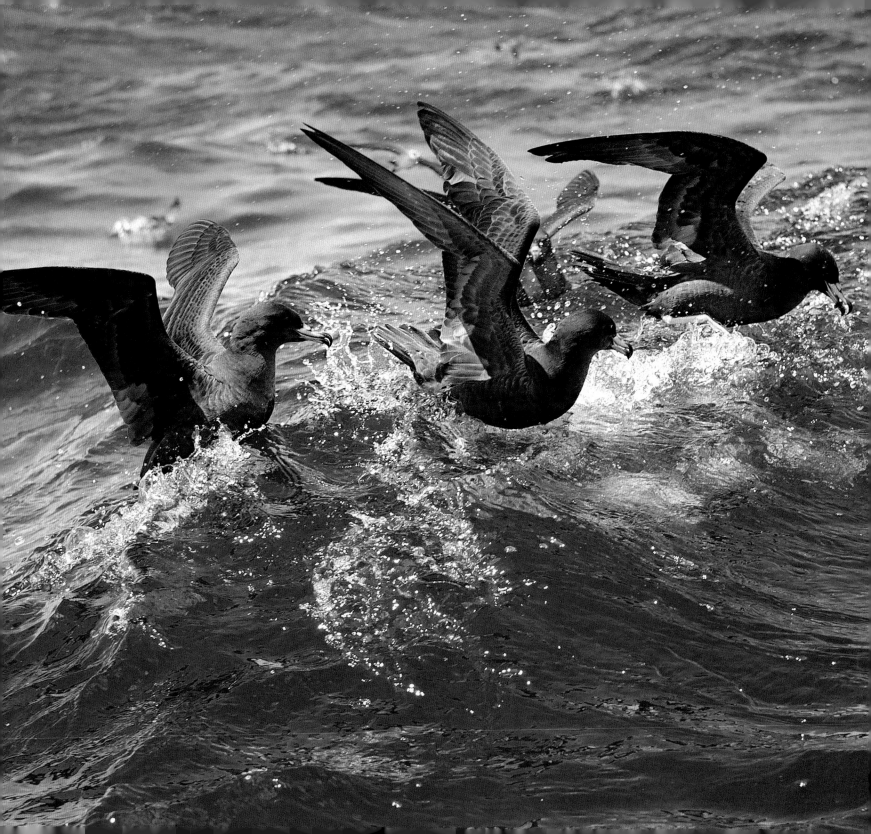

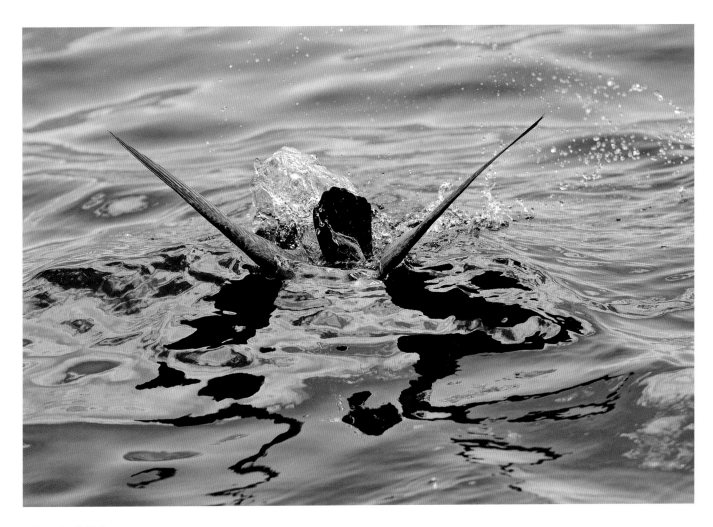

FLESH-FOOTED SHEARWATER

Ardenna carneipes

These shearwaters have gathered to feed off Little Barrier Island in New Zealand's Hauraki Gulf. Hanging in the wind low over the waves, they pluck food from the surface or dive down using their wings to swim underwater to grab discarded fish scraps. This habitat of feeding around fishing boats puts them at risk of being hooked and killed as by-catch, which may be contributing to a decline in their population.

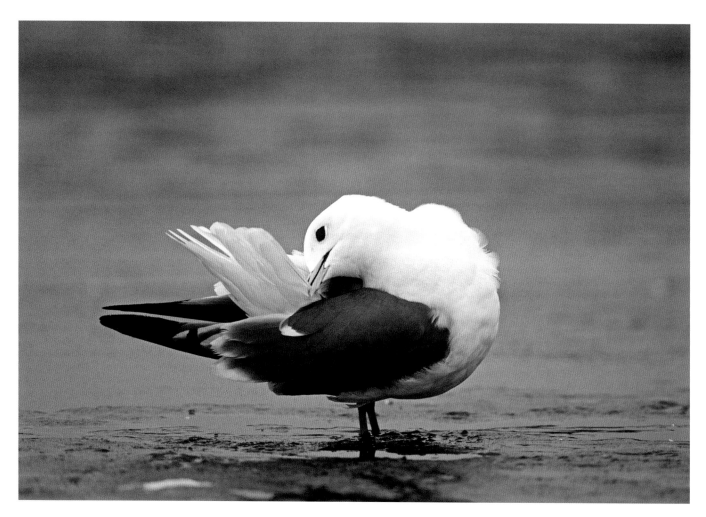

RED-LEGGED KITTIWAKE
Rissa brevirostris

The big eyes and rounded head give this small gull a very 'friendly' look. I photographed this preening individual on a lagoon on the island of St Paul in the Pribilof Islands in the Bering Sea off Alaska. This species has suffered major declines since my visit in the early 1990s. The exact causes are not known, but the effects of climate change on food availability and possibly over-exploitation by commercial fisheries in the Bering Sea may be factors. These are certainly common causes for declines among so many of our seabirds worldwide.

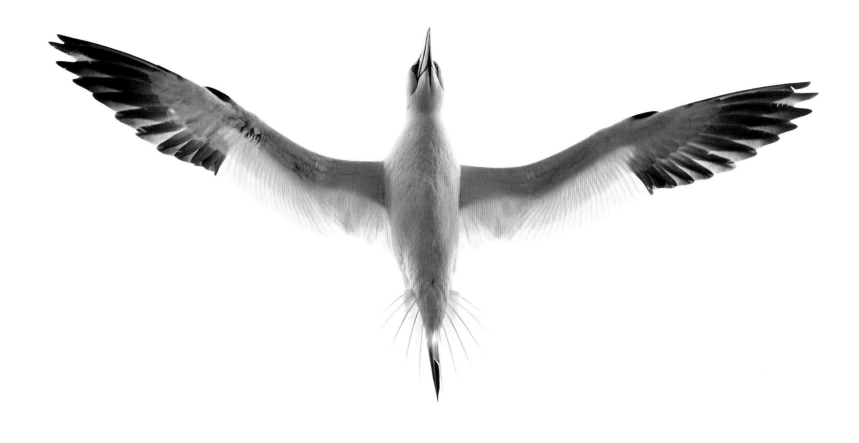

NORTHERN GANNET
Morus bassanus

Seabird colonies in the far north and far south often spend long periods under cloudy skies in summer. This can hamper the photographer. However, white cloudy skies can create a nice backdrop if using a technique known as high key for creating images of flying birds. This requires the photographer to over expose the image so any detail in the sky is bleached out. It can create some striking imagery as here with this gannet.

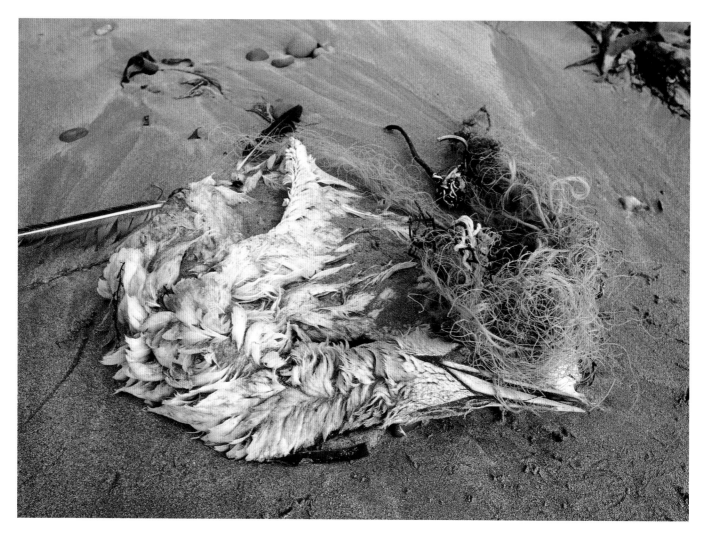

NORTHERN GANNET
Morus bassanus

Diving seabirds are very susceptible to being caught and drowned in gill nets that are anchored in fixed positions at sea. One such victim is this gannet washed up on a Norfolk beach. Little is known about how many birds die in this way, but it is widely recognised by researchers that by-catch mortality significantly affects seabird populations in many regions of the world. Best estimates suggest the annual death toll runs into the hundreds of thousands.

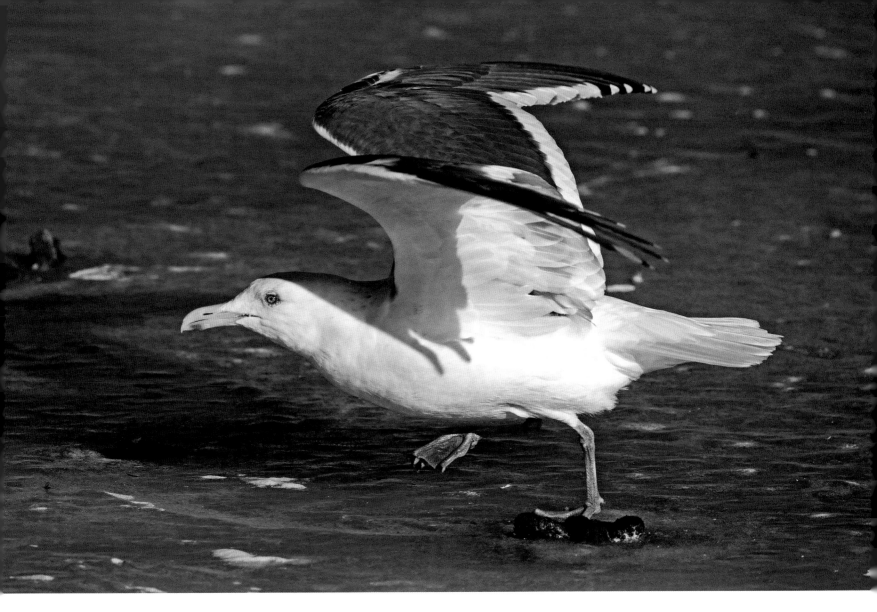

ABOVE
SLATY-BACKED GULL
Larus schistisagus

A Slaty-backed Gull on a frozen beach on Hokkaido in Japan prepares for take off. This widespread gull of the Pacific region is a common scavenger around harbours on the island.

OVERLEAF
SHY ALBATROSS
Thalassarche cauta

I photographed this Shy Albatross off Kaikoura in New Zealand. Twelve of the world's 22 species of albatross may be seen here at various times during the year.

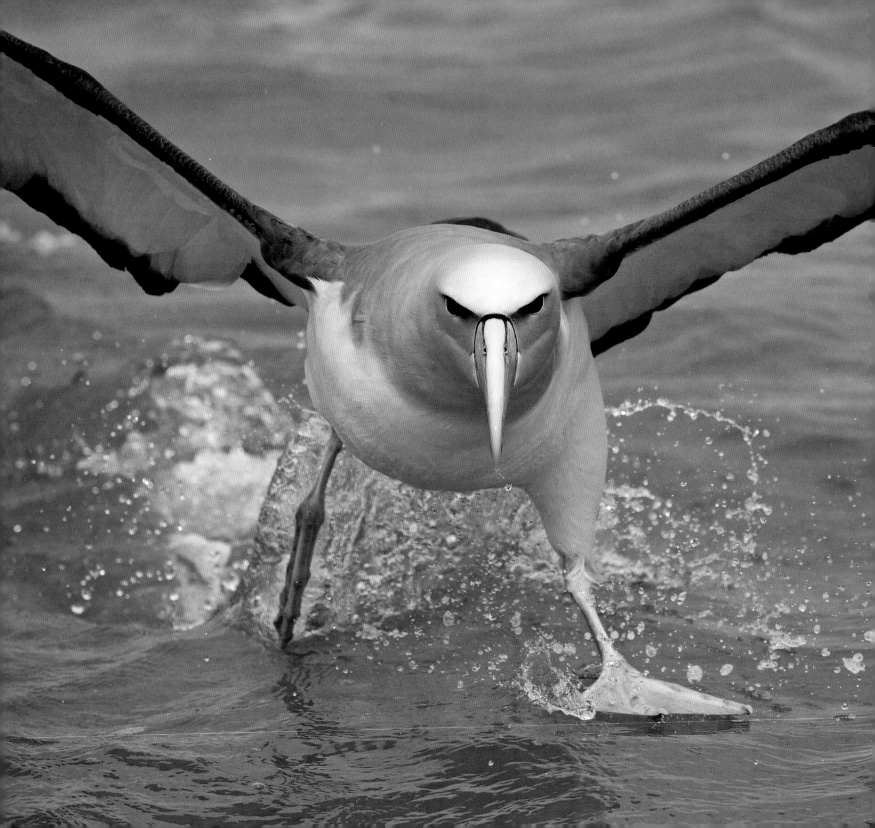

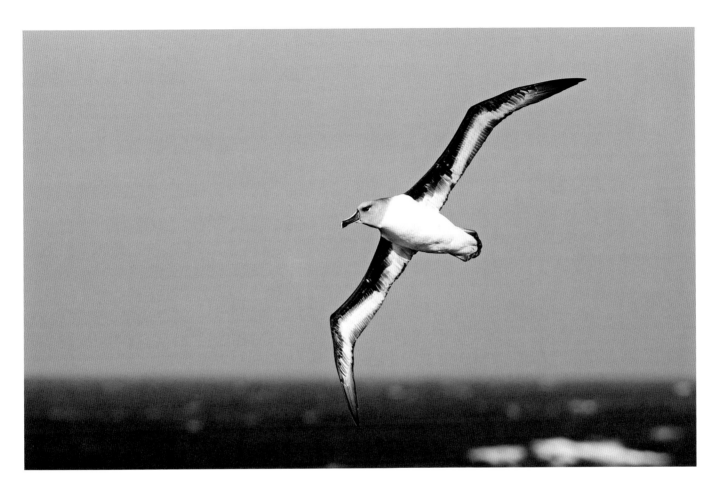

GREY-HEADED ALBATROSS
Thalassarche chrysostoma

This albatross is a great traveller and highly pelagic, often feeding over deep water far out in the Southern Ocean. Satellite tracking, which employs tags weighing just a few grams and attached to the birds on their breeding grounds, has revealed some extraordinary facts. One remarkable Grey-headed Albatross circled the globe in just 42 days. This same technology has helped researchers understand how the species locates one of its main food sources. When squid feed on oily prey they themselves release oils that float on the sea surface. It is thought the albatrosses locate these oil slicks through their well-developed olfactory system. Once they find them, a bird can dive down 7m (20ft) to capture the squid.

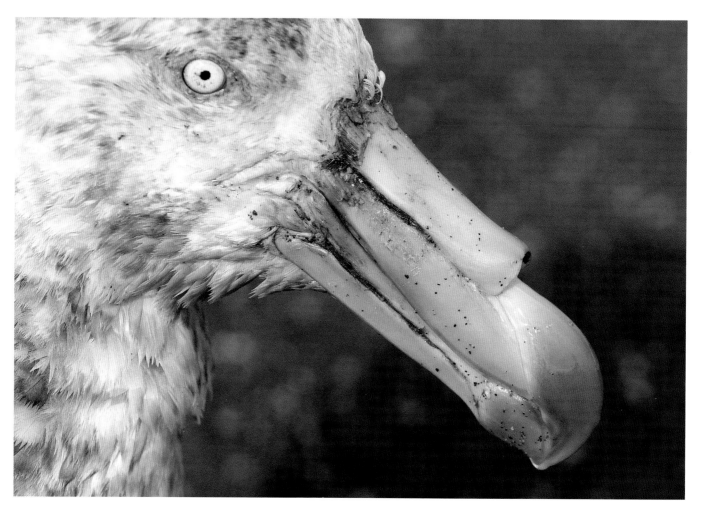

SOUTHERN GIANT PETREL
Macronectes giganteus

Seabirds that ingest salt through their diet need to excrete the excess. The drip on the end of this Southern Giant Petrel's fearsome-looking bill is doing just that. Highly saline fluid runs down the nasal tubes from glands situated close to the petrel's eyes. Salt excretion in seabirds is highly effective, as was shown in an experiment with a Great Black-backed Gull (*Larus marinus*). After drinking one tenth of its body weight in seawater the bird was able to eliminate 90 per cent of the salt ingested in just three hours.

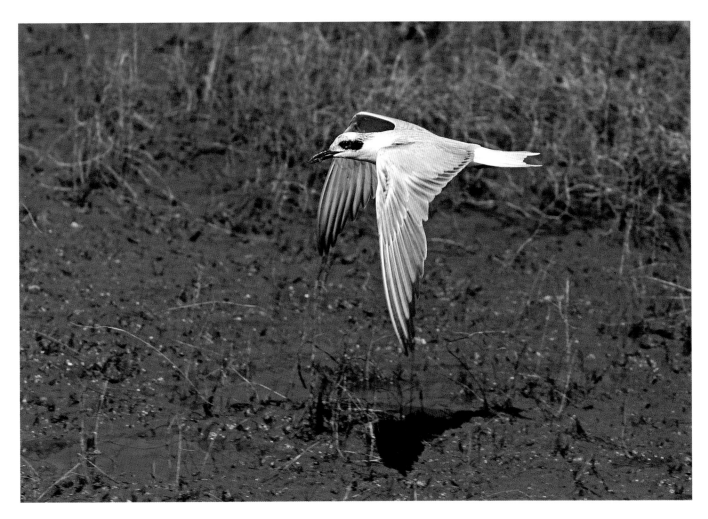

GULL-BILLED TERN
Gelochelidon nilotica

A non-breeding Gull-billed Tern flies along an Australian coastal creek hunting for food. This species is a little unusual in that it frequently feeds over land rather than water when breeding.

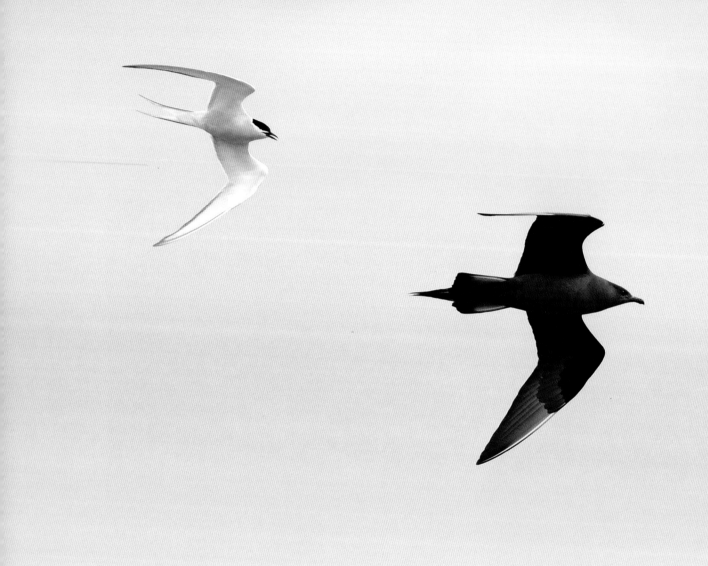

ARCTIC SKUA
Stercorarius parasiticus

These birds, as suggested by their Latin name, and their alternative common name of Parasitic Jaeger, are kleptoparasites. They breed close to colonies of Arctic Terns (*Sterna paradisaea*) and rob the smaller birds as they come ashore with fish. Here the tables are turned and a tern is chasing away a marauding skua.

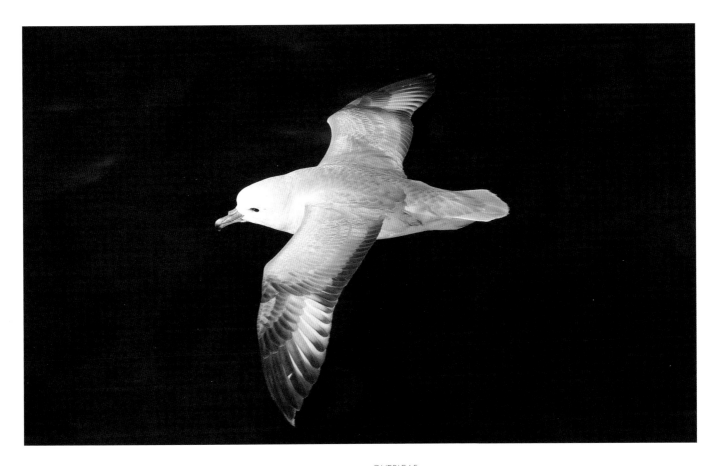

ABOVE
SOUTHERN FULMAR
Fulmarus glacialoides

When at sea I never tire of watching birds from the ship's stern, and with patience great photographic results can be achieved. The Southern Fulmar, like its counterpart the Northern Fulmar (*Fulmarus glacialis*), is a true master of the air. It rarely flaps its wings and uses wind currents of varying speeds above the waves to glide effortlessly. Unlike its northern cousin, however, this species is less inclined to follow ships.

OVERLEAF
NORTHERN FULMAR
Fulmarus glacialis

The smell from this long-dead Sperm Whale (*Physeter macrocephalus*) was something to experience. I leaned over the cliff in Shetland, UK, to capture this image of the fulmars plucking small pieces of the whale's rotting flesh from the sea's surface.

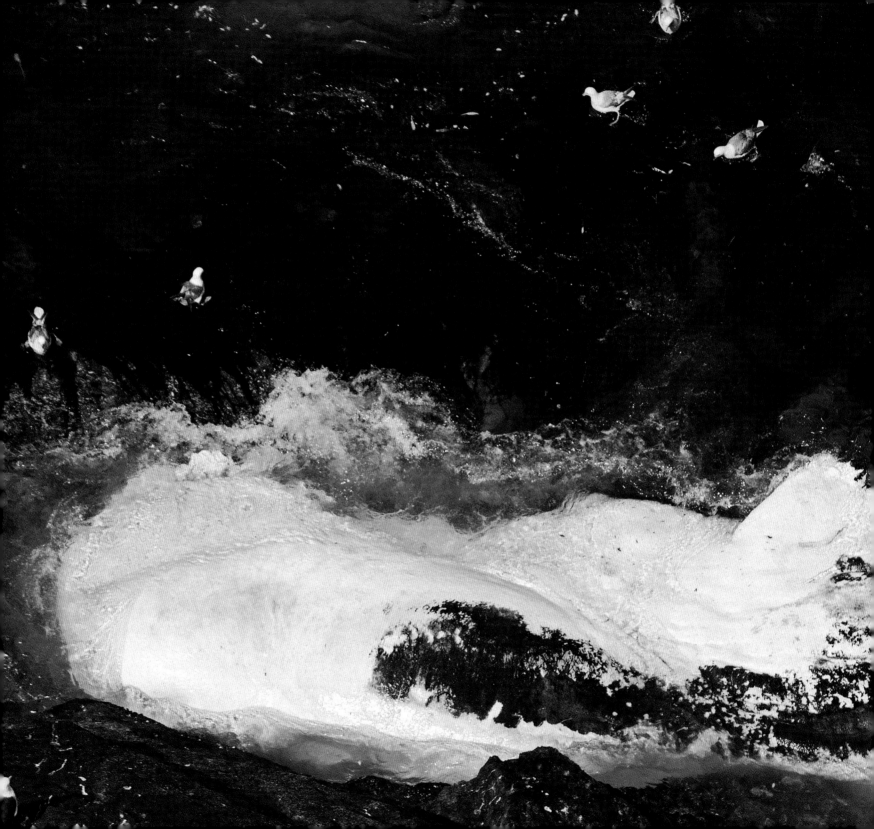

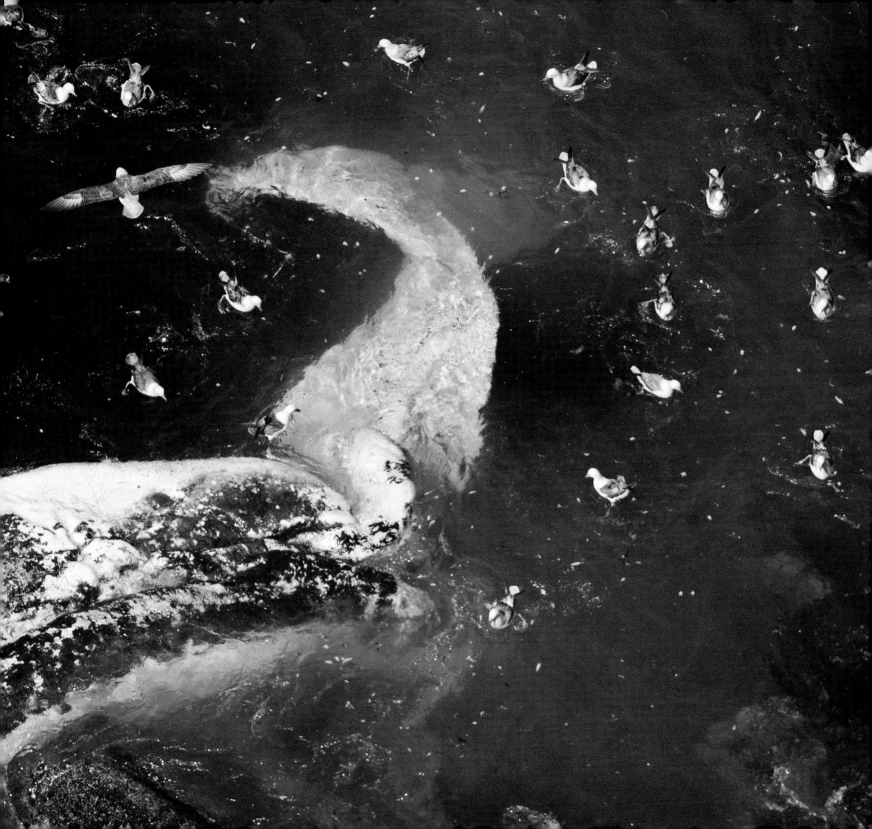

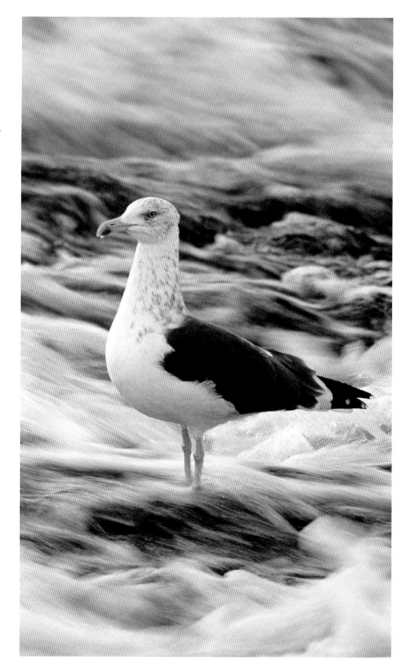

LESSER BLACK-BACKED GULL
Larus fuscus

This bird was standing patiently at a weir waiting for food. Using a relatively slow shutter speed I helped to blur the water a little while keeping the gull in sharp focus.

WESTERN GULL
Larus occidentalis

Although not endangered, this large gull has quite a restricted range along the western seaboard of North America. Colonies in California have been reduced as a consequence of development and of harvesting their eggs in the San Francisco Bay area. A colony on the island Alcatraz was affected by the construction of the island's infamous prison.

The gulls have hit the headlines in recent years by invading the stadium of the San Francisco Giants baseball team at AT&T Park, where they swoop in to feast on half-eaten hot dogs, nachos and other fast food left in the stands. Fans have complained of the birds pooping on their heads while players moaned that their aerial acrobatics are a distraction when they are trying to concentrate on the game.

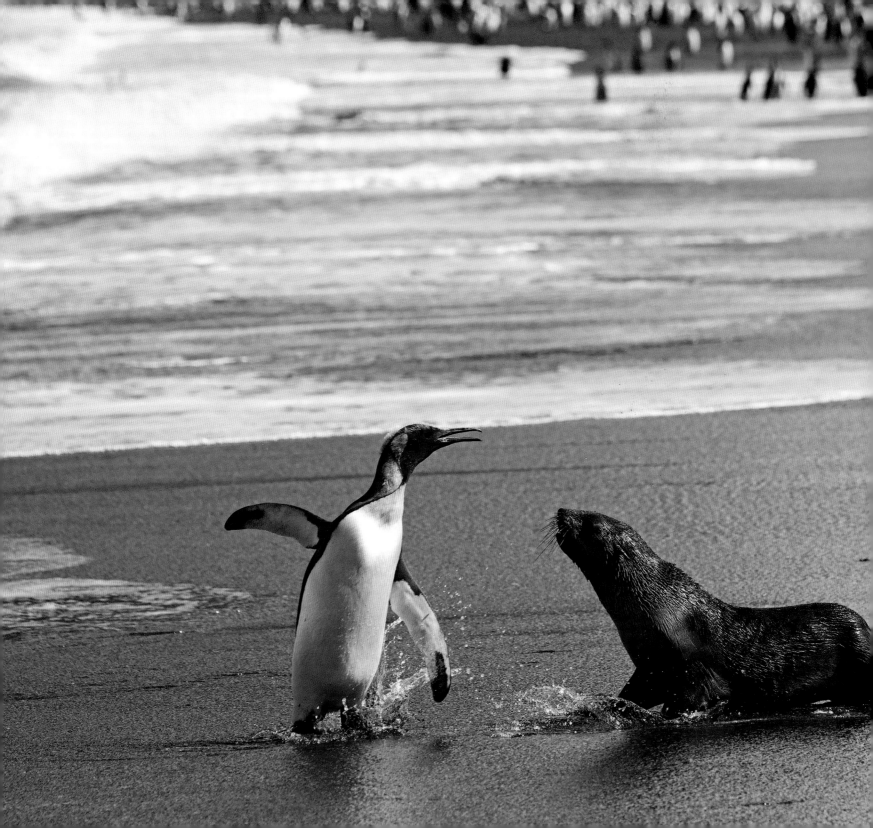

KING PENGUIN
Aptenodytes patagonicus

A young King Penguin repels a juvenile Antarctic Fur Seal (*Arctocephalus gazella*). Where these two species co-exist they appear to live in relative harmony at most colonies. Yet this is not just a playful chase. Adult fur seals do prey on blubber-rich King Penguins both on beaches and at sea. It also appears that certain fur seal populations have more of a taste for penguin than others. Perhaps this is a result of prey availability. Around the coast of South Georgia the seas are rich in fish and krill and it may be that the seals are so well fed that they have no need to expend energy on hunting penguins. Where seals do catch the birds they grab them from behind to avoid being blinded by a sharp beak. The penguin's best defence, as shown here, is to face the seal when challenged.

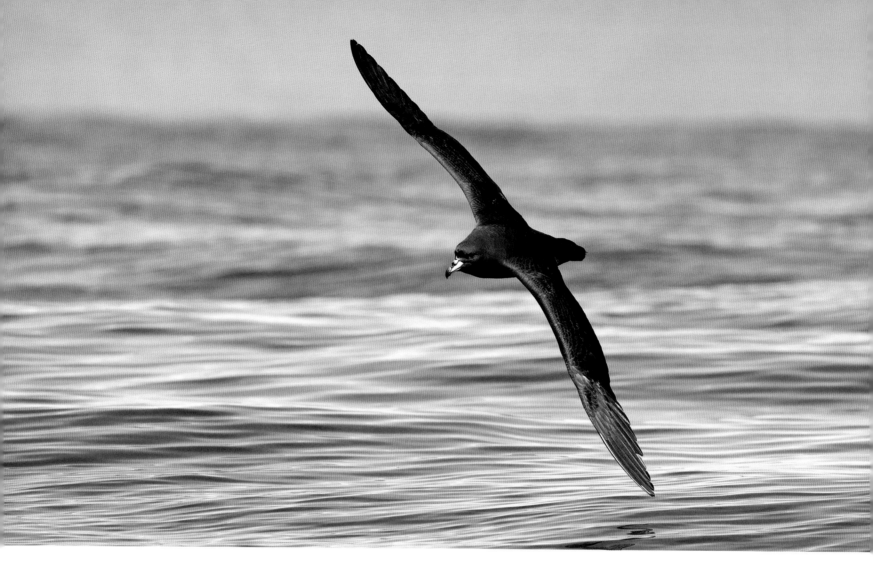

WESTLAND PETREL

Procellaria westlandica

New Zealand is home to a number of globally endangered seabirds, some of which are particularly vulnerable to predation by the many introduced mammals on the islands. Or they exist in just one or two colonies and are vulnerable to other threats. The Westland Petrel has a very limited breeding area on New Zealand and only around 2,000 pairs breed in any one year. The total population is likely to number somewhere in the region of 16,000 birds.

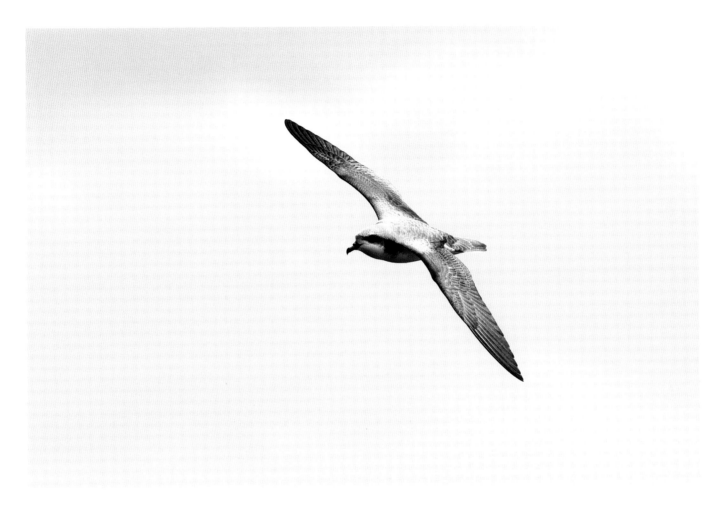

COOK'S PETREL
Pterodroma cookii

An endemic breeding bird to New Zealand, Cook's Petrel has suffered large declines owing to rat predation. Burrow-nesting seabirds like these are an easy target for a variety of mammalian predators. However, the species' fortunes have been turned around by rat eradication on Codfish Island, where the population went from around 20,000 pairs a century ago almost to extinction. Once the predators were removed, however, a recovery got underway. There are now in excess of 6,000 pairs, illustrating how given the chance a species can start to recover. On Little Barrier Island, its stronghold, well over a quarter of a million pairs breed.

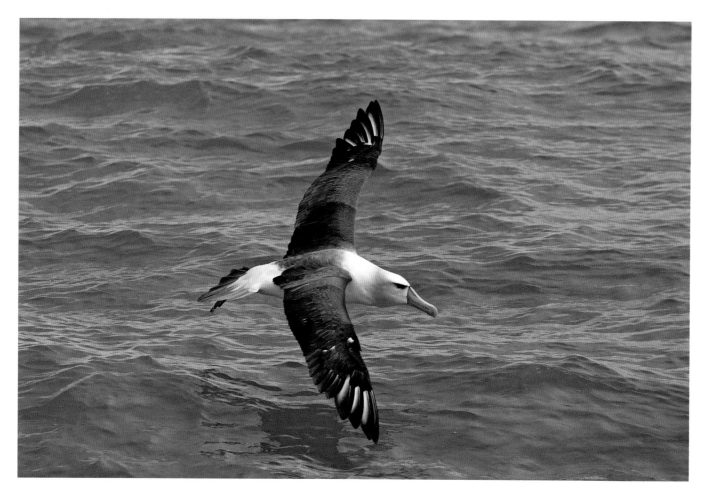

WHITE-CAPPED ALBATROSS
Thalassarche steadi

These albatrosses are highly susceptible to some fishing operations, particularly pelagic long-lining off the South African coast. Historically up to 17,000 birds were being killed annually by this fishery. Various mitigation measures by legally operated vessels are substantially reducing seabird by-catch, but overall tens of thousands of albatrosses and petrels are still dying and while population declines may be slowing in many species, birds such as albatrosses are extremely slow breeders. Pairs may produce just a single chick every two years. The ongoing pressures could eventually lead to a point where populations are no longer sustainable and these magnificent birds tip into terminal decline.

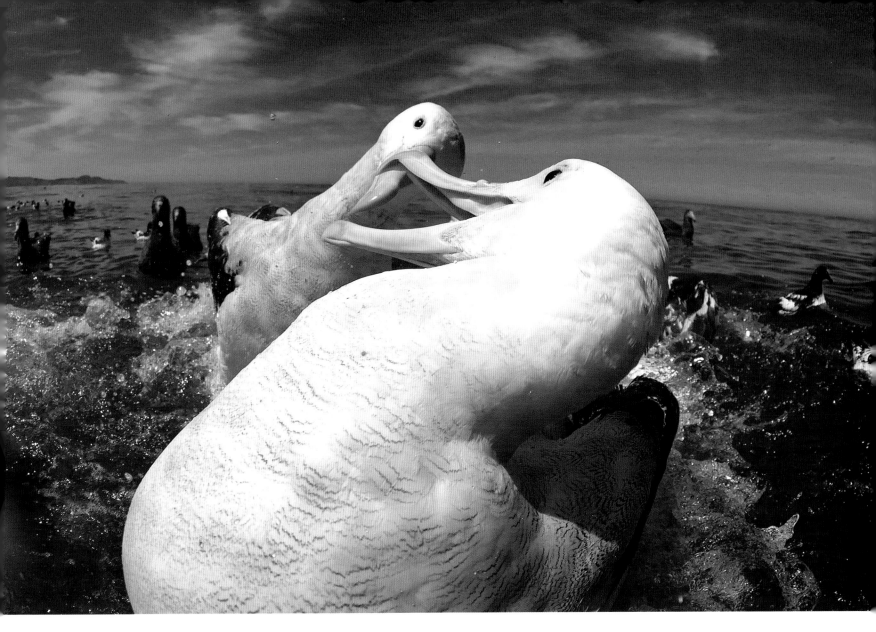

GIBSON'S ALBATROSS
Diomedea antipodensis gibsoni

These great albatrosses are usually treated as a subspecies of either the Antipodean Albatross or the Wandering Albatross. In this image two fight over food at sea. Fights between albatrosses can often look more serious than they are. There is always a lot of jousting, with frequent attempts made to get hold of each other's bills.

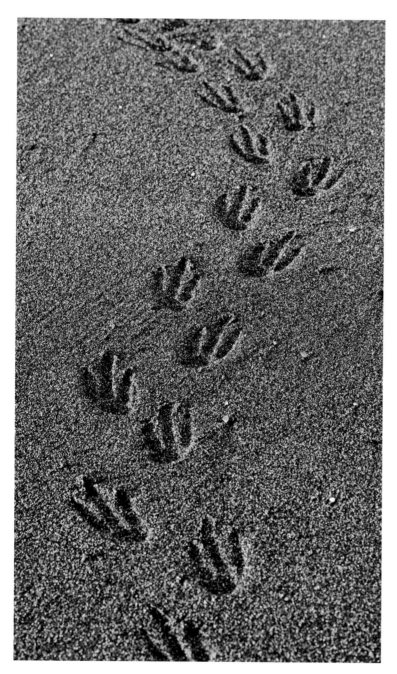

ACKNOWLEDGEMENTS

Many of the pictures on these pages have been taken on board various craft at sea. The skippers' willingness and skill to place a boat in the perfect spot for light and wind makes a huge difference to photographic opportunity. During January 2015 I had the pleasure of sailing on the *Hans Hansson* skippered by Dion Poncet and Juliette Hennequin. Our trip circumnavigating South Georgia to survey Wandering Albatross colonies was a special one and provided many unique opportunities and pictures for this book. My thanks go to them, to Sally Poncet and the rest of the survey team for the help they gave during this expedition.

Special thanks go to the following birders and photographers for invaluable assistance: Brent Stephenson, Brydon Thomasson, Roger Tidman, Jonas Lungberg, Josh Timpson, Tony Lawton, Tom Ennis and the crew of the *Nautilus*.

I am grateful to Mark Cocker for commenting on the final draft of this book.

King Penguin (*Aptenodytes patagonicus*) footprints.

TECHNICAL DETAILS

Images listed by page number. All images taken with Nikon cameras – models are listed first. Focal length expressed in mm in brackets is the focal length when a zoom lens or teleconverter was used.

1: D4, 300mm f2.8 lens, f7.1, 1/2500 sec at ISO 400

2–3: D4, 300mm f2.8 lens, f2.8, 1/2000 sec at ISO 125

4–5: D800, 400mm f2.8 lens, f22, 1/8th sec at ISO 100

6: D3s, 300mm f2.8 lens, f6.3, 1/ 800 sec at ISO 200

9: D2Xs, 500mm f4 lens, f4, 1/1000 sec, ISO 200

12–13: D3, 300mm f2.8 lens, f4, 1/1000 sec, ISO 200

14: D810, 80–400mm G lens, (350mm) f6.3, 1/800 sec at ISO 400

16–17: D810, 300mm f2.8 lens, f6.3, 1/2000 sec at ISO 200

18: D2X, 300mm f2.8 lens, f4.8, 1/1250 sec at ISO 100

19: D2Xs, 300mm f2.8 lens, f5.6, 1/800 sec at ISO 100

20–21: D2X, 300mm f2.8 lens, f5.0, 1/1000 sec at ISO 100

22: D3S, 70–200mm f2.8 lens, f5.6, 1/1600 sec at ISO 640

23: D4, 24-70mm f2.8 lens, f11.0, 1/2000 sec at ISO 800

24: D2Xs, 300mm f2.8 lens, f4.5, 1/400 sec at ISO 250

25: D2Xs, 300mm f2.8 lens, f6.3, 1/1600 sec at ISO 200

26: D7000, 10.5mm f2.8 fisheye lens, f11.0, 1/250 sec at ISO 100

27: D7000, 10.5mm f2.8 fisheye lens, f6.3, 1/1000 sec at ISO 100

28–29: D3s, 24-70mm f2.8 lens, f8.0, 1/1250 sec at ISO 400

30: D2Xs, 300mm f2.8 lens, f3.5, 1/2500 sec at ISO 100

31: D2X, 300mm f2.8 lens, f5.0, 1/1000 sec at ISO 100

32: D2X, 300mm f2.8 lens, f5.6, 1/640 sec at ISO 200

33: D7000, 300mm f2.8 lens plus 1.4 x teleconverter (630mm), f7.1, 1/1600 sec at ISO 320

34: D3S, 300mm f2.8 lens f6.3, 1/2000 sec at ISO 500

35: D3S, 300mm f2.8 lens, f7.1, 1/2500 sec at ISO 500

36–37:D3S, 300mm f2.8 lens, f7.1, 1/2500 sec at ISO 500

38: D810, 300mm f2.8 lens, f5.0, 1/1250 sec at ISO 250

39: D4, 400mm f2.8 lens plus 1.4 x teleconverter (550mm) f4.0, 1/500 sec at ISO 640

40–41: D800, 300mm f2.8 lens plus 2 x teleconverter (600mm) f29.0, 1/15 sec at ISO 640

42: D2X, 300mm f2.8 lens f4.0, 1/2000 sec at ISO 160

43: D7000, 300mm f2.8 lens, f6.3, 1/1600 sec at ISO 320

44: D3S, 300mm f2.8 lens, f5.6, 1/2500 sec at ISO 250

45: D2Xs, 300mm f2.8 lens, f4.0, 1/1000 sec at ISO 100

46–47: D810, 80–400mm G lens (400mm) f6.3, 1/1600 sec, at ISO 320

48: D810, 24–70mm f2.8 lens, f6.3, 1/400 sec at ISO 125

49: D810, 24–70mm f2.8 lens, f11.0, 1/320 sec at ISO 320

50: D810, 80–400mm G lens, (320mm) f11.0, 1/640 sec at ISO 200

51: D810, 24–70mm f2.8 lens, f8.0, 1/1000 sec at ISO 320

52–53: D2Xs, 300mm f2.8 lens f6.3, 1/500 sec at ISO 100

54–55: D2X, 300mm f2.8 lens f5.0, 1/1600 sec at ISO 200

56: D7000, 300mm f2.8 lens, f4.0, 1/1000 sec at ISO 100

57: D4, 300mm f2.8 lens, f6.3, 1/640 sec at ISO 500

58: D7000, 300mm f2.8 lens plus 1.4 x teleconverter (630mm), f5.6, 1/2500 sec at ISO 200

59: D3S, 300mm f2.8 lens plus 1.4 x teleconverter (420mm), f10.0, 1/1600 sec at ISO 250

60: FE2, 600mm IFED f5.6 lens, Fuji Velvia film at ISO 50

61: D2X, 300mm f2.8 lens, f8.0, 1/100 sec at ISO 200

62: FE2, 600mm IFED f5.6 lens, Fuji Velvia film at ISO 50

63: D800, 400mm f2.8 lens plus 1.4 x teleconverter (550mm) f7.1, 1/1250 sec at ISO 200

64: D2X, 300mm f2.8 lens f5.0, 1/1250 sec at ISO 100

65: FE2, 600mm IFED f5.6 lens, Fuji Velvia film at ISO 50

66: D2Xs, 300mm f2.8 lens f6.3, 1/800 sec at ISO 100

67: D800, 400mm f2.8 lens, f6.3, 1/2000 sec at ISO 250

68: D800, 400mm f2.8 lens, f4.0, 1/640 sec at ISO 250

69: D800, 300mm f2.8 lens plus 1.4 x teleconverter (420mm) f4.0, 1/1250 sec at ISO 400

70–71: D2X, 70–200 f2.8 lens (105mm) f6.3, 1/1000 sec at ISO 100

72–73: D3s, 14–24mm f2.8 zoom lens at 17mm, f11, 1/800 sec, ISO 200

74: D800, 300mm f2.8 lens plus 1.4 x teleconverter (420mm), f4.0, 1/1600 sec at ISO 400

75: D2Xs, 300mm f2.8 lens, f5.6, 1/1000 sec at ISO 100

76: D800, 300mm f2.8 lens plus 1.4 x teleconverter (420mm) f5.6, 1/1250 sec at ISO 400

77: D300, 300mm f2.8 lens f5.6, 1/400 sec at ISO 400

78–79: D4, 300mm f2.8 lens, f7.1, 1/800 sec at ISO 400

80–81: D810, 24–70mm f2.8 lens (24mm), f5.6, 1/100 sec at ISO 320

82: D810, 80–400mm G lens (380mm), f8.0, 1/400 sec at ISO 400

83: D2Xs, 10.5mm fisheye lens f7.1, 1/500 sec at ISO 200

84: F3, 24mm lens, Kodachrome 64 film

85: D2Xs, 300mm f2.8 lens, f5.6, 1/400 sec at ISO 100

86: F4, 85mm f1.8 lens, Fuji Velvia 50 film at ISO 50

87: D810, 80–400mm G lens (400mm) f7.1, 1/500 sec, at ISO 250

88: F4, 300mm f2.8 lens, Fuji Velvia 50 film at ISO 50

89: FE2, 300mm f2.8 lens, illuminated by lamp, Fuji Sensia 400 film pushed to 800 ISO

90: D4, 24mm f1.8 lens, Fuji Velvia 50 at 50 ISO

91: D4, 500mm f4 lens, Fuji Velvia 50 at ISO 50

92: D2X, 300mm f2.8 lens, f6.3, 1/1600 sec at ISO 160

93: D4, 500mm f4 lens, illuminated by lamp, Fuji Sensia 400 film

94: D2X, 70–200mm f2.8 lens, f5.6, 1/1000 sec at ISO 125

95: D2X, 500mm f4 lens, f4.0, 1/1000 sec at ISO 160

96: D2X , 300mm f2.8 lens, f9.0, 1/400 sec at ISO 200

97: D2X, 300mm f2.8 lens, f2.8, 1/1000 sec at ISO 100

98–99: D2X, 300mm f2.8 lens, f6.3, 1/1250 sec at ISO 200

100: D810, 80–400mm G lens (80mm) f13.0, 1/250 sec at ISO 250

101: D810, 24–70mm f2.8 lens (62mm) f7.1, 1/400 sec at ISO 200

102: D2Xs, 300mm f2.8 lens, f5.6, 1/640 sec at ISO 100

103: D810, 300mm f2.8 lens, f2.8, 1/1250 sec at ISO 160

104–105: D2Xs, 300mm f2.8 lens, f8, 1/1250 sec at ISO 100

106–107: D810, 300mm f2.8, f2.8, 1/500 sec at ISO 125

108: D4, 500mm f4 lens, Fuji Velvia 50 film at ISO 50

109: D4, 300mm f2.8 lens, Fuji Velvia 50 film at ISO 50

110–111: D810, 300mm f2.8 lens, f4.5, 1/1250 sec at ISO 250

112–113: D810, 20mm f1.8 lens, f16.0, 1/320 sec at ISO 200

115: D810, 80–400mm G lens (112mm) f16.0, 1/200 sec at ISO 200

116: D810, 300mm f2.8 lens, f2.8, 1/1000 sec at ISO 400

117: D810, 300mm f2.8 lens, f4.0, 1/500 sec at ISO 400

118: D810, 300mm f2.8 lens, f2.8, 1/800 sec at ISO 200

119: D800, 400mm f2.8 lens f11.0, 1/400 sec at ISO 200

120–121: D2Xs, 300mm f2.8 lens, f5.6, 1/1250 sec at ISO 200

122: D800, 400mm f2.8 lens plus 1.4 x teleconverter (550mm), f7.1, 1/2000 sec at ISO 200

123: D2X, 300mm f2.8 lens, f6.3, 1/640 sec at ISO 125

124–125: D810, 24–70mm f2.8 lens (70mm), f22.0, 1 sec, ISO 31

126–127: D810, 80–400mm G lens (290mm), f6.3, 1/640 sec at ISO 320

128: D3S, 24–70mm f2.8 lens (60mm), f14.0, 1/500 sec with -2.33 exposure compensation at ISO 200

129: D3S, 300mm f2.8 lens, f7.1, 1/600 sec at ISO 200

130: D810, 24–70mm f2.8 lens (70mm), f11.0, 1/250 sec at ISO 100

131: D4, 300mm f2.8 lens, f7.1, 1/2500 sec at ISO 400

132: FE2, 600mm IFED f5.6 lens, Fuji Velvia 50 film at ISO 50

133: F4, 300mm f2.8 lens, Fuji Sensia 100 film at 100 ISO

134–135: D810, 24–70mm f2.8 lens (24mm), f7.1, 1/400 sec at ISO 200

136–137: D2Xs, 10.5mm fisheye lens, f5.6, 1/500 sec at ISO 100

138–139: D2Xs, 300mm f2.8 lens, f7.1, 1/100 sec at ISO 200

140–141: D2X, 70–200mm f2.8 lens (80mm) f5.6, 1/200 sec at ISO 200

142: D3, 70–180mm f4.5–5.6 lens (180mm), f5.6, 1/60 sec at ISO 800

143: D300, 500mm f4 lens, f5.6, 1/800 sec at ISO 400

144: D2Xs, 300mm f2.8 lens, f5.6, 1/1250 sec at ISO 200

145: D810, 80–400mm G lens, (350mm), f6.3, 1/800 sec at ISO 400

146: D800, 24–70mm (24mm), fill flash from on camera flash, f7.1, 1/640 sec at ISO 400

147: D800, 300mm f2.8 lens, f2.8, 1/1000 sec at ISO 400

148–149: D800, 300mm f2.8 lens, f2.8, 1/1000 sec ISO 200

150: D4, 300mm f2.8 lens, f8.0, 1/1000 sec at ISO 800, over exposed by two stops.

151: D3, 500mm f4 lens, f6.3, 1/800 sec at ISO 200

152–153: D3, 500mm f4 lens, f8.0, 1/1000 sec at ISO 400

154–155: D2X, 500mm f4 lens, f5.6, 1/800 sec at ISO 200

156: D2Xs, 300mm f2.8 lens, f6.3, 1/1000 sec at ISO 100

157: D800, 500mm f4 lens, f5.6, 1/600 sec at ISO 400

158: F4, 500mm f4 lens, Fuji Velvia 50 film at ISO 50

159: D7000, 300mm f2.8 lens, f5.6, 1/1250 sec at ISO 320

160: D2X, 300mm f2.8 lens, f5.6, 1/800 sec at ISO 160

161: D2Xs, 300mm f2.8 lens, f22.0, 1/15 sec at ISO 100

162: D3S, 500mm f4 lens, f5.6, 1/1600 sec at ISO 800

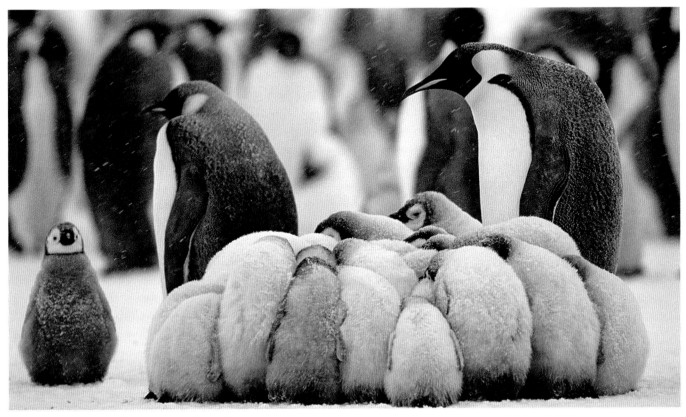

Emperor Penguin (*Aptenodytes forsteri*) chicks huddle in a creche in Antarctica.

163: D810, 300mm f2.8 lens, f7.1, 1/1600 sec at ISO 200

164: D3S, 24–70mm f2.8 lens (70mm) f7.1, 1/1250 sec, ISO 500

165: D3S 300mm f2.8 lens, f7.1, 1/2500 sec at ISO 500

166: FE2, 600mm IFED f5.6 lens, Fuji Sensia 100 film at ISO 200

167: D800, 70–180mm f2.8 lens (155mm), f4.0, 1/1000 sec at ISO 400

168: F4, 24mm f1.8 lens, Fuji Sensia 100 film at ISO 100

169: D3, 500mm f4 lens, f7.1, 1/2500 sec at ISO 400

170: D3S, 70–200mm f2.8 lens (200mm), f7.1, 1/2000 sec at ISO 400

171: D2Xs, 300mm f2.8, f4.5, 1/1600 sec at ISO 100

172: D2Xs, 300mm f2.8 lens, f7.1, 1/1000 sec at ISO 100

173: D3, 300mm f2.8 lens, f6.3. 1/1600 sec at ISO 200

174: D4, 300 f2.8 lens plus 1.4 x teleconverter (420mm), f7.1/2500 sec at ISO 640

175: D2Xs, 300 f2.8 lens, f5.6, 1/800 sec at ISO 100

176–177: D4, 300 f2.8 lens, f11.0, 1/2500 sec at ISO 800

178: F4, 600mm IFED f5.6 lens, Fuji Sensia 100 film at ISO 100

179: D300, 500mm f4 lens, f6.3, 1/1000 sec at ISO 400

180–181: D810, 80–400mm G lens (220mm), f8.0, 1/1250 sec at ISO 200

182: D3S, 300mm f2.8 lens, f6.3, 1/3200 at ISO 250

183: D3S, 300mm f2.8 lens, f7.1, 1/2500 sec at ISO 500

184: D3S, 70–200mm f2.8 lens (200mm), f6.3, 1/2000 sec at ISO 400

185: D3S, 10.5mm fisheye lens, f6.3, 1/1600 sec at ISO 400

186: D810, 24–70mm f2.8 lens, f16, 1/400 sec ISO 400

189: FE2, 135mm f2.8 lens, Fuji Provia 100 film

190: D4, 300mm f2.8 lens, f7.1, 1/1000 sec ISO 400

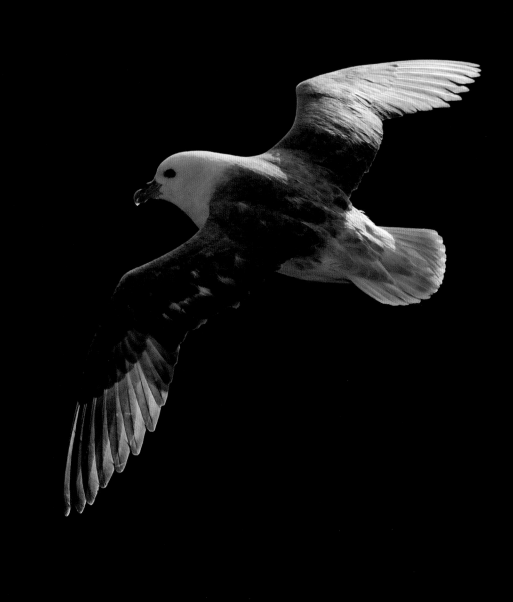

INDEX

LEFT A Northern Fulmar (*Fulmarus glacialis*) drifts past a Scottish cliff as the sun sinks on a summer evening.

OTHER TITLES

Other books by Reed New Holland include:

Bugs in Close-Up
Colin Hutton
ISBN 978 1 92151 738 9

Butterflies of the World
Adrian Hoskins
ISBN 978 1 92151 733 4

Creatures of the Night
Joe and Mary Ann McDonald
ISBN 978 1 92151 736 5

Extreme Animals
Dominic Couzens
ISBN 978 1 92151 734 1

Meerkats
Grant Mc Ilrath
ISBN 978 1 92151 765 5

Owls of the World
James Duncan
ISBN 978 1 92151 764 8

Slater Field Guide to Australian Birds.
 Second edition.
Peter, Pat and Raoul Slater
ISBN 978 1 87706 963 5

Top Wildlife Sites of the World
Will and Natalie Burrard-Lucas
ISBN 978 1 92151 759 4

Volcano Discoveries
Tom Pfeiffer and Ingrid Smet
ISBN 978 1 92151 735 8

Wildlife Under the Waves
Jürgen Freund and Stella Chiu-Freund
ISBN 978 1 92151 739 6

For details of these and hundreds of other Natural History titles see www.newhollandpublishers.com

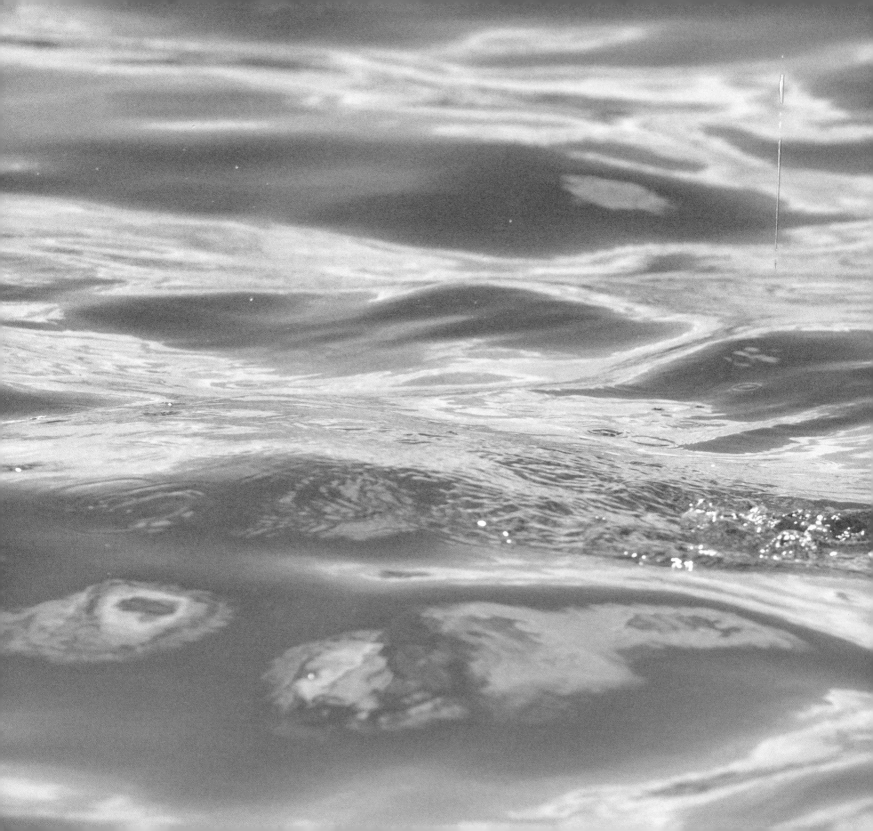